Textile Perspectives
in Mixed-Media
Sculpture

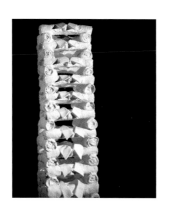

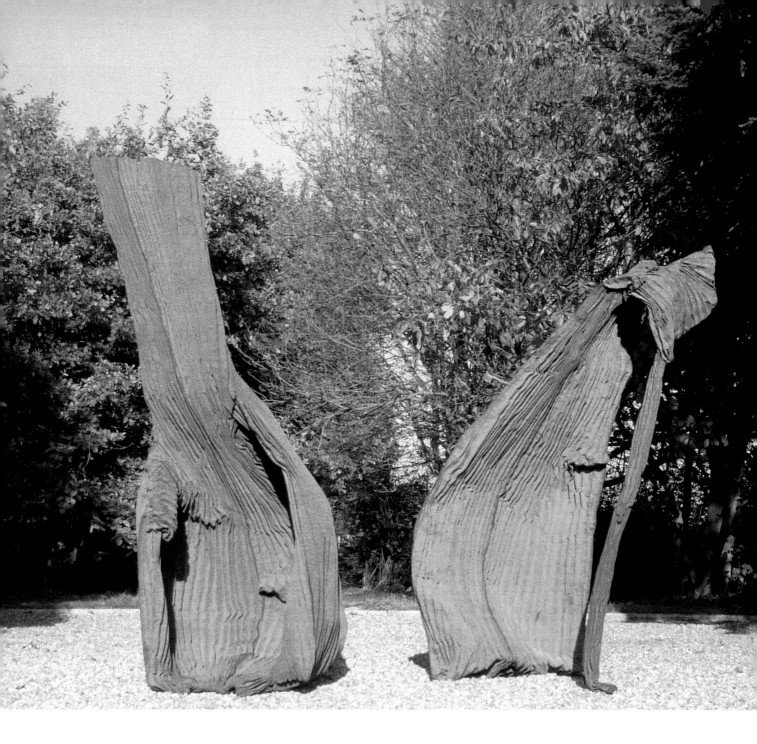

The true work of art continues to unfold and
create within the personality of the spectator.
It is a continuous *coming into being*.

MERVYN LEVY

Textile Perspectives in
Mixed-Media Sculpture

Jac Scott

The Crowood Press

First published in 2003 by
The Crowood Press Ltd
Ramsbury, Marlborough
Wiltshire SN8 2HR

www.crowood.com

British Library Cataloguing-in-Publication Data
A catalogue record for this book is available from the British Library.

ISBN 1 86126 578 6

Acknowledgements

Textile Perspectives in Mixed-Media Sculpture is first and foremost a celebration of the prodigious
sculpture that is created by artists who function on the interface between mixed-media sculpture
and textile art. It is the generosity of the artists themselves that has made this book possible, and
I am indebted to each and every one, for they were all magnanimous in supplying beautiful and
inspiring visual material, personal statements full of insight that reveal the nature of their
practices, and technical information about their specialist subjects. I would particularly like to
thank them for extending the hand of friendship, and for having faith that I would profile their
work in a sensitive and sympathetic manner. Most of all I want to thank them for sharing all
those amazing sculptures that continue to enthuse me.

 Thank you to Northern Arts for their assistance to the author in the production of this publication.

 A very special thank-you must go to my husband, Michael Slaney, whose sustained
enthusiasm for my work and untiring support from a practical standpoint has meant that I have
never had to compromise my own creativity.

 Researching and writing this volume has been an extremely rewarding experience, from both
a cerebral and practical perspective, and one that I will always cherish. It is now my hope that
this book will liberate others to free their creative souls.

'The work of art is a scream of freedom.'
CHRISTO

Photographic Acknowledgements

All the photographs in this book were taken by the artists themselves, unless otherwise credited.

Photograph previous page: Carole Andrews, 'PUPATE', 1999. Materials: pleated roofing felt over
steel armature. Height 2.5m.

Typefaces used: text, Stone Sans; headings, Frutiger; chapter headings, Rotis Sans.

Typeset and designed by
D & N Publishing
Lowesden Business Park, Hungerford, Berkshire.

CONTENTS

PREFACE

The rationale for researching this book arose out of my personal requirement for a distillation of the thought process that sought to situate my own practice in the world of contemporary art. The nature of most artists is to resist categorization, and it is only those outside the immediate practising circle that demand, for their own convenience, a naming of what artists do, and in what context they practise. Caroline Broadhead also expressed her annoyance on this matter in an interview in *[A-N] Magazine* 2002:

> I hate being asked to categorize myself – you can talk yourself
> round and round about what it is you do, but I don't think the
> audience has the same obsession about what it is called; a lot of
> people go and see both art and craft work and don't tend to
> make such a great distinction. The most important thing is to
> keep working and to get your work out there, have it seen.

Knowing that my own idiom balanced on the interface of sculpture and textile art, the opportunity to research a book presented a way not only to discover other practitioners who also fell into this void, but also to give precious time to contextualizing the work in a wider discourse. The absence of any publication that discussed these crossovers further awakened my interest to investigate and document a burgeoning area of art.

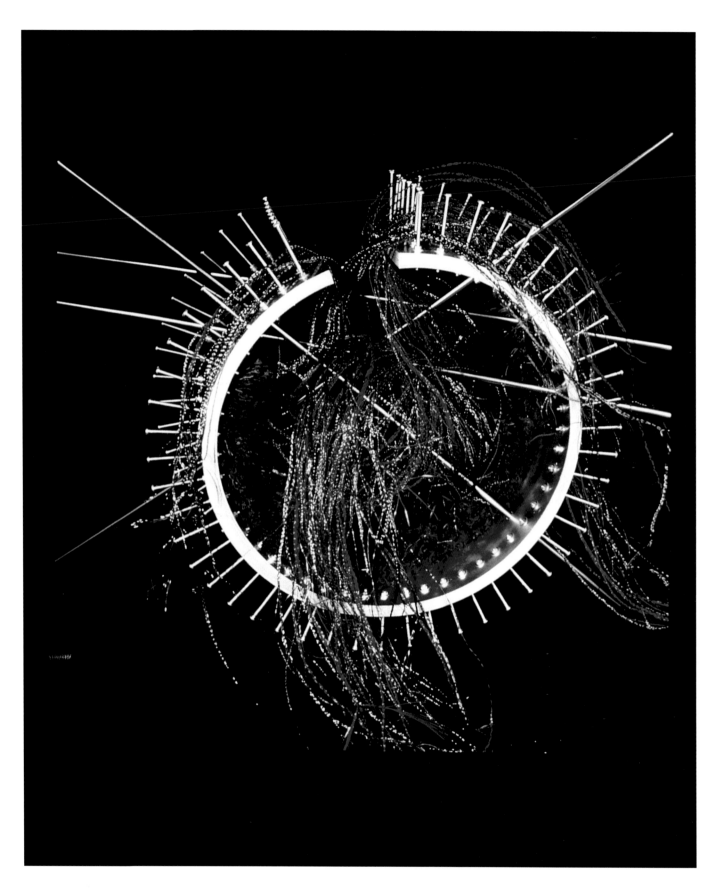

Helen Weston, 'FAMILIAL DISJUNCTURE SERIES', 1999.

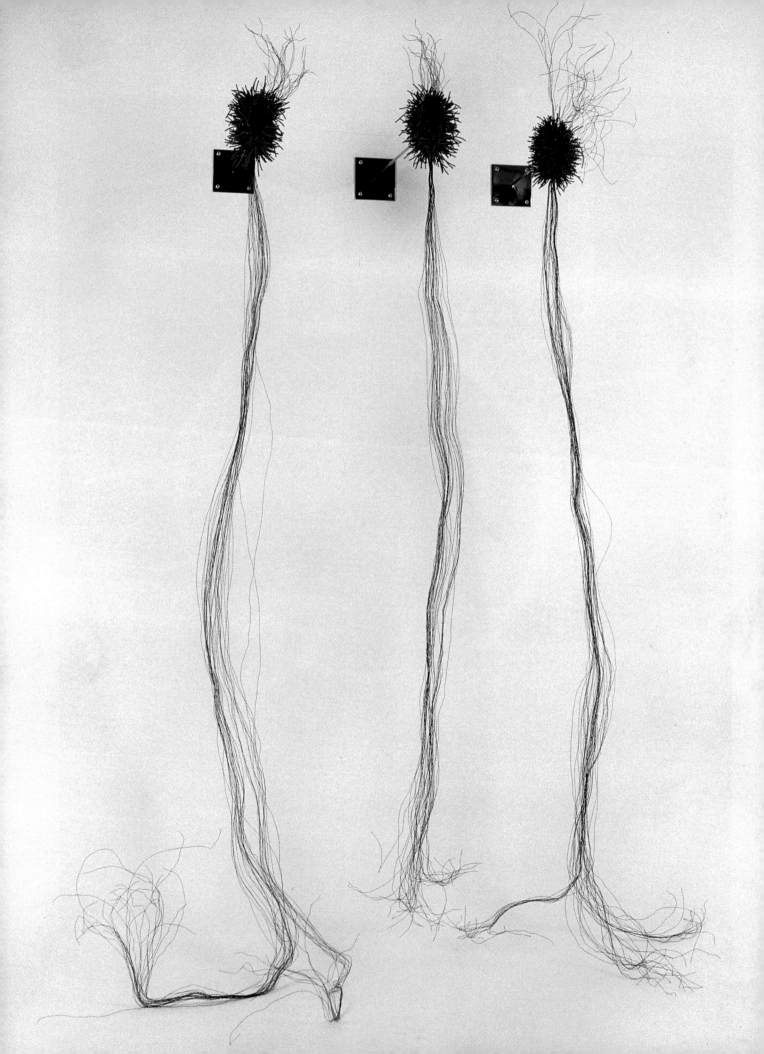

MATERIAL SPACES

Sculpture has played a commanding role in the many meta-morphic definitions of contemporary art. Its strength and its anchor is its refusal to lapse into a homogenized, complacent, vegetative state, preferring to question the cerebral and the physical elements of its discourse. The discarding of arbitrary language and verbal restraint has embraced a dialectic response, which continually challenges hierarchies and orthodoxies both in concept and material. The encouragement of interdisciplinary practice has blurred the boundaries of conventional visual media and led to new dynamic interfaces. It is one such interface that this book aims to examine: that of mixed-media sculpture and three-dimensional textile art.

The primary aim of this book is to present a unique contemporary vision of mixed-media sculpture that will inform and stimulate debate. The objective is to create a beautiful and inspiring statement that is of lasting relevance. The thread that links all the artists featured is their relationship to textiles and sculpture – that is, either they employ a textile content, with alternative media, in their three-dimensional work, or they utilize techniques normally associated with textiles, but with other materials. Their own title classification is diverse and has not influenced my editorial role: rather I have sought to present a potent mix that profiles the eminent, the established and the emerging, to show the prodigious breadth of sculpture at the start of the twenty-first century. Collectively, the selection illustrates the powerful dynamics of contemporary sculpture with a mixed-media remit, whilst as individuals, the artists reveal their journeys to find a personal aesthetic language in work that is conceptually rich, innovative and apposite. The mode of expression common to all is their meticulous execution of craftsmanship. Geographically, the focus is a celebration of work from British-based artists.

**Anniken Amundsen, '1-09 GROWTH CONES', 2001.
Photographer: Kjartan Proven Hauglid.**

The Employment of Textiles in Art

Perhaps more than any in other discipline, artists who work with textiles have struggled to receive due recognition because cloth is usually categorized with domesticity and womanhood. Paradoxically, cloth is a powerful material that has a central influence in our lives from our very first breath, which leads to a tacit knowledge; yet its force in the hierarchy of acceptable fine art materials has yet to gain a similar status to the traditional palette. The employment of textiles in art continues to confront embedded preconceptions. Theorizing to legitimize is a questionable practice, but it is illuminating that the lack of documentation on the history of textile art has not benefited the discipline. History exposes a crucial interdependence of theory and practice for the evolution of art forms. This idea negates the situation that most artists are reluctant to write, preferring to articulate their creativity through practice, rather than theory. The adopting of another discipline, that of writing, to my own portfolio was acknowledged as a challenge, but also as essential to my progress, rather than something that would detract from it, to strengthen and deepen my commitment to my own practice. The dialectic challenge I would recommend to all artists, as the benefits reaped are manifold.

Over the last fifty years, significant numbers of respected artists have adopted textiles into their repertoire of materials precisely because of the familiarity everyone has with cloth. Cloth's accessibility stems from its integral role throughout our lives: as protector, comforter and image-maker. The twentieth century was characterized as a period of questioning and of reassessing materials. Since the 1950s there has been a particularly robust debate, in both the fine art and craft world, as to the acceptance of unconventional materials. A mixed-media seminal work made in 1955 by Robert Rauschenberg, 'Bed', involved the appropriation of a traditional patchwork quilt with the embellishment of thick paint. He referred to such works as 'combines', and went on to utilize every conceivable material in his assemblages. He was not alone in his adventure with unconventional media, and emancipation from the conventional

palette is still evolving and maintains a polemic discourse; however, before we discuss the last fifty years, we need to glance briefly at the preceding artistic climate.

The History of Textile Art

The remit of this book is to consider sculptures that possess a link with textiles, so in order to appreciate this fully, we must examine a breadth of history that encompasses both sculpture and textiles. The history of textile art is scant and patchy, and inextricably intertwined with craft. Without digressing into the fashionable debate between what constitutes art and craft, suffice it to say that most documentation of textiles has a strong making bias, and certainly a preponderance of two-dimensional work; therefore it has been difficult to research in depth and maintain relevancy.

The nature of cloth negates longevity, hence there are few examples of ancient fragments; but if you embrace the concept that in fact all paintings on canvas are actually pieces of textile art, then the evidence can be traced back to the twelfth dynasty in Egypt (c. 2000–1786BC). The Bayeaux Tapestry, embroidered by English needlewomen in the eleventh century, is the most famous textile antiquity. The Arts and Crafts Movement nurtured a renaissance in needlecrafts, with The Royal School of Needlework being founded in 1872. The school encouraged the students to approach their handiwork as an art form.

During the first quarter of the twentieth century, artists across Europe challenged the rules of sculpture. In Germany in 1919 Walter Gropius founded the Bauhaus, and at the inauguration spoke of his objective: 'We seek to form a new body of craftsmen who no longer know that pride of class that erects a high wall between artisans and artists' (Constantine and Reuter, 1997).

Anni Albers, modernist weaver of the Bauhaus, also advocated an openness to materials: 'Neither preciousness nor durability of material are prerequisites... Any material, any working procedure, and any method of production, manual or industrial, can serve an end that may be art' (Rowley, 1999).

This German directive paid recognition to the artistic potential of all matter, and especially redefined textiles as a worthy medium. Meanwhile, in other parts of Europe and the United States of America, artists such as Marcel Duchamp were challenging the rules of sculpture by constructing art from mundane materials, such as his 'Cycle Wheel' in 1913 and 'Fountain' in 1917; his famous 'Readymades' were landmark pieces in the history of art. Kurt Schwitters, too, made his art from the unconventional: bus tickets, news cuttings, metal and wooden fragments and fabric scraps – he was particularly drawn to waste matter, preferring to use debris from the streets rather than traditional materials. Schwitters' contemplative sculptures and assembled reliefs are imbued with cultural and political references that reflect the turbulent times in Europe. Schwitters wrote in 1926: 'New art forms out of the remains of a former culture' (Celant, 1995).

A notable American Surrealist sculptor, Joseph Cornell, utilized the quotidian object in his assemblages to endow them with an enchantment that reflected a reverential regard for the commonplace. Many of his works form potent symbols in his own life's story. Cornell was originally a textile designer who juggled his job and his art practice with domestic demands from his family. His famous 'boxes' are said to have originated as toys for his disabled brother.

The Surrealists' philosophy extended beyond its period, giving inspiration to many who followed, and was particularly influential on the development of 'soft sculpture' in Pop Art in the 1960s. Claes Oldenburg, the founder of the 'soft sculpture' movement, exploited material and scale to create audacious work that balanced on the interface of the real and the representative. His sculptures were parodies of quotidian symbols of American culture set to question our view of the ordinary and the everyday. He fully explored the soft/hard dichotomy with giant sculptures of objects such as fast food, telephones, toilets and typewriters, replicated in cardboard, soft vinyl, or canvas stiffened with plaster or polyester resin. He wrote:

> I found that by interpreting ordinarily hard surfaces as being soft I arrived at a new kind of sculpture and a stock of new symbols...The possibility of movement in soft sculpture, its resistance to any fixed position, its life, all stand in relation to the idea of time and change.
>
> (Celant, 1995)

In this idea he focuses on the corporeality of objects, and how manipulation of that materiality, coupled with scale changes, could make 'sensitive' what society had become desensitized to. His vision embraced cloth as a sculptural expressive media on a level that had not been seen before – this is expressed by Oldenburg in 1963:

> The cloth work is decidedly 'sculptural', by which I mean that it emphasizes masses, simple and articulated. It de-emphasizes colour. What the period of 'sculptural' painting has left is the fluidity of the surface, which in these works is actual because they are sculpture: the unillusory, tangible realm. The dynamic element here is flaccidity, where in the paint it was the paint action and the sparkle of light – that is the tendency of a hard material actually to *be* soft, not to look soft (so it is a concretization of a naïve translation of painting).
>
> (Celant, 1995)

Meanwhile, during this same period, there was momentous action taking place directly with those that worked predominantly with textiles. The positive move to take textiles off the wall and into space was an action that signified the 'fibre arts movement' as 'coming of age'. The Polish artist, Magdalena Abakanowicz, transformed weaving into a dynamic sculptural technique for creating monumental forms. Her revolutionary use of fibre and her innovative approach to technique made her a dominant force during the 1960s and 1970s: she exploited the properties of sisal, jute and burlap to produce sculptural analogies for animal, plant and mineral forms. Her fundamental appreciation of fibre and the natural world is conveyed in her writing:

I see fibre as the basic element constructing the
organic world on our planet,
as the greatest mystery of our environment.
It is from fibre that all living organisms are built –
the tissues of plants, and ourselves.
Our nerves, our genetic code,
the canals of our veins, our muscles.

We are fibrous structures.
Our heart is surrounded by the coronary plexus,
the plexus of most vital threads.

Handling fibre, we handle mystery.
A dry leaf has a network reminiscent of a dry mummy.

What can become of fibre guided by the
artist's hand and by his intuition?

What is fabric?
We weave it, sew it, we shape it into forms.
When the biology of our body breaks down
the skin has to be cut so as to give access to the inside.
Later it has to be sewn, like fabric.

Fabric is our covering and our attire. Made with our hands,
It is a record of our souls.
(Constantine and Reuter, 1997)

It seems apt to mention the German artist Joseph Beuys at this point, for his ambition was to unify mankind with nature. Beuys is credited with being one of the most influential artistic figures in the last century; consequently, no book on textiles in sculpture is complete without his inclusion, for Beuys famously worked with felt and fat to express his creativity. The story of how he 'found' his materials is legendary, and in brief emerged from the protection from the elements he was given by the Tartars, after being shot down from his plane during World War II. From this near-death experience he adopted felt and fat as his

material mode of expression, not for autobiographical statements, but as ones that expanded the metaphor, because he communicated an 'expanded theory of sculpture'.

The French-born artist Louise Bourgeois has been another influencing force in mixed-media sculpture during the last fifty years. Her work resonates a tense and surreal relationship between the sexes, which manifests itself in autobiographical visual statements, in sculptural and installation formats. The artist constructed her work from a strange concoction of matter, including rubber, plaster, textile and many other constituents – work that revealed its roots in Surrealism. Sculptors like Bourgeois, through their long careers, have a sustaining effect on the discipline as a whole.

Taking Sculpture out of the Gallery and into the Environment

Sculptors have sought to liberate their art from a decorative, gallery-based role to one that questioned not only the concept and material, but also the siting of sculpture. Hence from the 1960s the avant-garde took their work out from the sanctum of the gallery and into the environment. Movements emerged that reflected a revolution in the sculptor's tenet: Pop Art, Conceptual Art, Minimalism, Land Art, Performance Art, Installation Art and Environmental Art; and artists such as Christo Javacheff, a Bulgarian artist who, with his wife Jeanne-Claude, has achieved an international reputation for passionate involvement with wrapping extravagant yardage of cloth around landmarks and landforms. Christo began with what now appears as quite humble wrappings, of banal objects; this later translated to the powerful, yet temporary statements situated in the outdoors.

During the 1970s and 1980s environmental art, such as Christo's work, redefined the acceptability of material and scale, and the situation of sculpture. Projects such as 'The Pont Neuf Wrapped' not only '...transformed a four-hundred-year-old Parisian bridge into a glowing cloth waterfall' (Constantine and Reuter, 1997), but also expanded the sculptor's remit to include skills of fundraising on an unprecedented scale, the management of hundreds of staff, and the tenacity to plan ten-year projects. But Christo is not remembered for the scale of his management, but the amazing aura of theatrical grandeur created within the location of the installation. It has been stated of Christo and Jeanne-Claude's work:

The artists' brilliance lies in their ability to define
precisely both the natural and the architectural world
in terms of modulating line. Whether they encompass a

volume, such as the Pont Neuf, or define the rolling
hills of California with their 'Running Fence', one is
always struck by the elegance of the resulting line.
Their predilection for working large, either in mass or
in numbers of repetitions, only emphasizes their
gorgeous sense of line in space.
(Constantine and Reuter, 1997)

Defining Sculpture

With the mention of the sculptural terms, line and volume, it
now seems pertinent to discuss briefly what elements are of par-
ticular relevance to modern sculpture. The fact that these defin-
itions are continually evolving makes any attempt at clarification
only correct at that moment in time: therefore the response is
fluid and flaccid. To start with, as previously illustrated, the def-
inition of what sculpture actually is, has undergone incredible
reinterpretations during the last century. Traditionally the term
referred to work that was three-dimensional, but since the
1970s it has been expanded so that now it includes almost all
work that is not a painting. For example, the work of the British
artist Richard Long focuses on the dimensions of time and space
– journeys across land and records on maps – and he calls it
sculpture. This embracing of space into a harmonious relation-
ship with the material form, significant for its symbiotic implica-
tions, has stretched to value space as a 'material' in its own right.
Naum Gabo, the Russian 'Constructivist', transformed the
notion of solid volume in sculpture to networks of lines in space.
This concept is encapsulated in his writings in which he consid-
ers space to be a structural part of the object: an element which
can also convey volume.

This school of thought has led to work that has occupied
space not in terms of mass, but more through implication and
allusion. From an architectural viewpoint, space is defined by
determining boundaries, but for some artists the relationship is
blurred and hence space is designed as integral, and not as an
adjunct. The understanding of space in Japan is perceived as an
active space for the imagination, allowing interaction on a more
involved level. This reading of space relies on the additional
reading of light. Light is considered in respect of its own pow-
erful dynamic that can transform sculpture not only as a con-
trolling device for its interpretation, but also as a penetrating
substance that is incorporated into the form. This bilateral ethos
underpins the work of many respected Japanese textile artists,
who marry the concept with material to create evocative
abstract statements that paradoxically possess a positive physi-
cal affirmation. These spatial materializations involve both the
virtual and the visual, and thus the form delivers a captivating
experience for the audience.

Sculptural Materials

The element of material is discussed at length throughout this
book, so suffice it to say that any material, virtual or actual,
appears to be acceptable in sculpture in the twenty-first century.
Traditionally, sculptural materials could be broken down into
four groups in terms of technique: malleable, castable, carvable
and constructional; however, in today's climate we must add vir-
tual. John Mills in his *Encyclopedia of Sculpture Techniques* writes:

It is now not unusual to see sculptures made of rolls of
linoleum or foodstuffs, so perhaps the need to assess a
new material according to its potential as a facsimile
medium for traditional and more expensive materials is
passing. We should regard a material's worth according
to its inherent qualities when seen in relation to the
overall definition of sculpture, as three-dimensional
form in the round or in relief.
(Mills, 1990)

Materials are selected with regard to different rationale, some-
times as means, sometimes as metaphor, sometimes both; but
of equal importance is the consideration of the physical prop-
erties of the material. The properties affect both the way a
sculptor can work with the material, and the range of possible
creations that can be made from them. Physical properties are
those that are inherent to the material itself, and include factors
such as strength, ductility and hardness. Inextricably linked
with material is the understanding of the importance of struc-
ture, weight, balance and scale. These have always been of pri-
mary importance in sculpture, and their role has not dwindled
in the light of other elements being introduced. Different mate-
rials pose alternative considerations, and in respect of this book
these elements will be discussed at length in the chapters on
materials.

Tactile Values

One aspect of mixed-media sculpture that is intrinsic to materi-
alization of the form is that of haptic knowledge. Vision is highly
valued in Western society, but generally our sense of touch is
undervalued – though for most sculptors this is not the case. In
touching objects our bodies investigate the surface and the
form, silently absorbing the information. Herbert Read, the
notable critic, believed the notion of touch to be an essential
experience, and wrote in his text *The Art of Sculpture*:

For the sculptor, tactile values are not an illusion to be
created on a two-dimensional plane: they constitute a
reality to be conveyed directly as existent mass.

Sculpture is an art of palpation – an art that gives
satisfaction in the touching and handling of
objects…The only way we can have direct sensation of
the three-dimensional object is to let our hands move
over it, to get the physical sensation of touch, and the
essential contrasts of shape and texture.

(Causey, 1998)

Touching is often a less 'controlled' act than seeing, and therefore often informs the evaluation without being acknowledged. The corporeity of the form connects and is measured by the bodily presence of the viewer, even if positive physical contact has not taken place. Therefore when it has, the effect is more affirming. Artists who choose to work in a mixture of materials are further exploiting this theory by engaging a complement that demands a more complex interaction – physically and visually. Artists drawn to textiles usually have a strong dependency on the sense of touch, and in textiles they can fully indulge their passion. The wide variety of textured surfaces available provides an ideal complement to other materials.

Textiles as Powerful Communicators

Textiles are powerful communicators of information in the domestic and artistic sphere. However, textiles do not have their own material chapter in this book, as the material is common to all the sculpture featured; furthermore, there are many excellent books already available that deal with the subject in detail, and so I wish to make only a few pertinent points.

The nature of textile has maternal associations instigated by that first wrapping in cloth at birth, and it continues to be a central force in our lives. Textiles in daily life form our second skin: for protection and modesty, and as material semantical vehicles that signal identity, status and ownership. Beyond the relationship with the body, textiles have numerous roles, including creating warmth and decoration in our homes and in various industrial applications. The use of textiles expands with each generation as the vocabulary of the use of cloth grows with each new product. The character of the material allows for an artistic freedom that few other materials allow; coupled with its relative cheapness, it has expanded the horizons of many artists to extend the scale of their work beyond what would otherwise be unpractical, both structurally and financially. Christo is obviously

the most eminent ambassador of this practice. The associations of textiles and its techniques may originate from the domestic arena, but conceptually this can act as a forceful vehicle in art.

Works of art can evoke aesthetic emotions and deeper instinctive responses that flow from the inner world of ourselves if the strength of that work resonates with the viewer. Work of vitality and integrity alone can develop a dialogue with the audience, but the most memorable art is that built on conceptual foundations that ignite our inner core. During the 1960s the critic Lucy Lippard conceived the expression 'dematerialization': although never clearly defined by her, it was acknowledged as meaning the shift in focus from the material to the concept. Her article 'The Dematerialization of Art' argued that in contemporary art, whatever the art form, artists were losing their attachment to objects – studios were becoming studies rather than places of manufacture. An interesting point in part related to the early theorization of Conceptual Art also has some relevance in the sphere of this book. This is not to say that any of the work in this book is considered Conceptual Art, just that for many of the artists, the importance of initial concept provides the steering for the creative journey.

The selected artists have all established a personal material language that encompasses and illuminates their ideas and motivations, and the concepts energize them to be creative. The intellectual and the material content have a symbiotic relationship creating work from a myriad of themes and a wide repertoire of materials. Their discourse may focus on the more mainstream themes: the environment and natural forms, journeys or mythical creatures, while others stretch beyond this realm to examine other issues – rites of passage, the politics of gender and domestic roles, genetic engineering, waste management, medical and metaphysical concerns. The execution of those themes ranges from the humorous to the austere.

In summary, it can be said that the parameters of sculptural practice have changed beyond recognition in the second half of the twentieth century. There are many artists who could be drawn from the history books and contemporary documentation to illustrate the value of mixed-media sculpture, but limited space has dictated a strict editing; however, there are more artists discussed with regard to relevance of material in each of the more practical chapters. The selection should present an overview that provides an insight into the journey of the discipline over the last hundred years. In respect of material, five key materials have been selected and discussed, the intention being that this should act as a springboard for further investigation, both from a theoretical and a practical perspective.

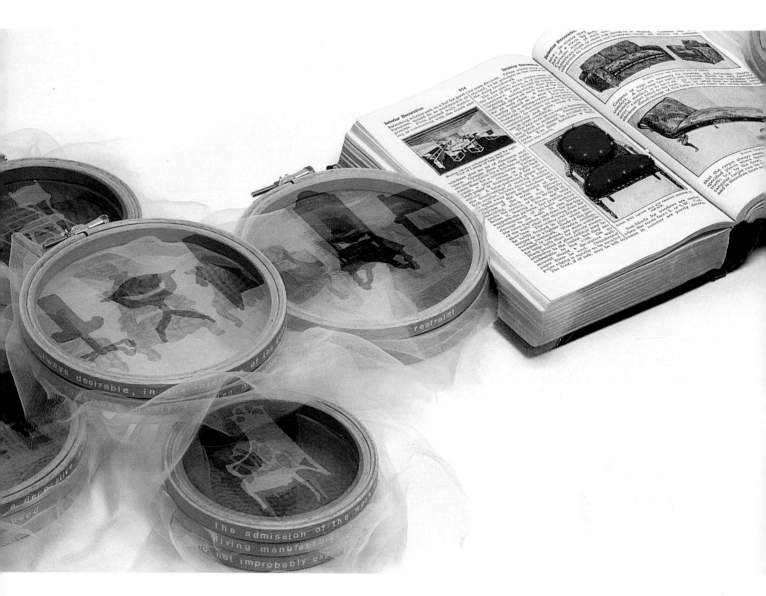

Caroline Bartlett, 'BODIES OF KNOWLEDGE VOLUME 5 – ARBITERS OF TASTE', 2002. Photographer: Michael Wicks.

CREATIVE JOURNEYS

'The faculty of creating is never given to us all by itself.
It goes hand in hand with the gift of observation.
And the true creator may be recognized by his ability to find about him,
in the commonest and humblest thing, items worthy of note.'

IGOR STRAVINSKY (1882–1971)

Sculpture presents itself as the most readily accessible form of communication with an audience, as its physicality demands interaction. Even on the most basic levels of engagement, the corporal form of such artworks relates to the bodily presence of the viewer – a basic understanding is acknowledged, that all humans relate to three-dimensional forms with their own body, even if this only manifests itself in the perfunctory avoidance of a collision with the object. Sculpture is concerned with the dichotic balance of the conceptual and the physical demands of art in the 'round'. Whilst the concept is important, many sculptors remain frustrated, as the physical restraints, imposed due to material constraints, prevent designs being realized. Thus the understanding of practical requirements is essential to deliver a successful outcome, with particular attention to elements such as mass, volume, weight, balance, scale, form, angle, viewpoint and material. These fundamentals make for exciting dynamics, not only with the relationship between the sculpture and the audience, but also between the sculptor and his own creativity. Each artist adopts a path on which to travel towards his creative destination, whether through training or instinct, in order not only to realize the outcome but also to satisfy a need to explore both concept and material. The creative journey chosen by the individual is quite revelatory in nature, illuminating an intimate form of personal expression, and is therefore worthy of examination.

The Design Process

The creative journey prescribed by many educational establishments is referred to as the 'design process'. This process is simply a set of stages which when followed should result in a thoroughly researched, well planned, inspirationally designed and executed piece of work. Many contemporary, professional artists, designers and craftsmen adopt this process of research methodology as a worthwhile framework on which to base their practice; however, many others doctor the prescribed format to meet their own needs. To illustrate the design process dictum and its many manipulated formulas, this chapter will reveal the creative journeys of some of the artists featured in this book: their inspirations, influences and process of exploration, from a two-dimensional foundation to a three-dimensional work of art. It will also investigate and discuss their search to develop a personal aesthetic language, coupled with a need to challenge their own preconceptions with traditional materials and alternative media.

What is a Work of Art?

In simplistic terms, a work of art is the materialization of a concept by an artist. Artists have the capacity and ability to develop their abstract ideas into tangible statements. This translation controls the quality of the finished piece both in concept and in craftsmanship. The artists in this book engage

on varying degrees of intimacy with the relationship between the cerebral and the physical: some find inspiration in the material itself, whilst others are led more by concept, searching out materials to answer the needs of their design. The eclectic mix is unified by the common link that they all have a positive interaction to materials – that is, they make the work themselves, and they all interact with textiles, either through the material, or by the adaptation of a technique normally associated with textiles.

There has been much written about the quality of seeing – the 'ways of seeing' – and the virtues and insight that this brings to creativity. Donald Irving, an American sculptor and author, expressed most eloquently in his book *Sculpture – Material and Process* (1970) his approach to work:

> Our environment abounds with provocations to sensitive visual response. Every aspect of our surroundings – the usual, often overlooked, even the mundane – holds a potential for enriching our lives and expressions in direct proportion to our ability to perceive them and share in their existence. Each of us functions simultaneously as censor, evaluator, selector and organiser of the visual world. The prospective artist must expand and enrich his vision through development of his perceptual awareness. To create forms which transcend banal stereotypes, he must exercise his individual sensibilities, formulate unique and personal interpretations, and remain open to new experience – develop, in short, the qualities which we marvel at in children.

> We are constantly confronted with things as they are, not as we wish them to be. But to see things as they are, to perceive the subtleties which distinguish each object and moment, requires a process of visualising which does away with preconceptions. We become, then, aware of relationships, rather than objects and moments in isolation, and we bring order and meaning to vision. The act of seeing in this sense is a creative one, a process of relating, arranging and structuring visual images.

> The visual and dimensional environment through which the sculptor moves has a direct and significant impact upon his work. Sculpture is dependent upon structuring visual experience and the ancillary sensations of touch and movement. Three-dimensional experiences are directly related to physical make-up: sizes of objects are understood in terms of our dimensions; the tension of angles and balance are measured against our own equilibrium. There are no

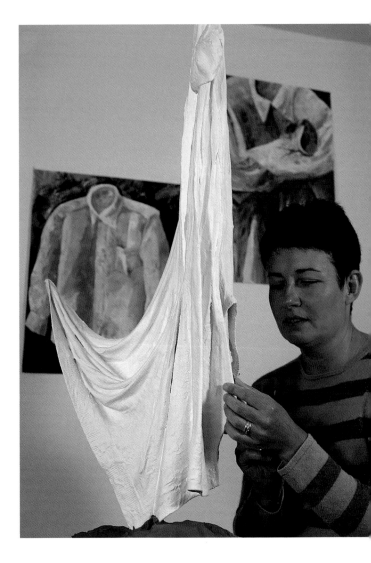

**The author working in her studio.
Photographer: Vince Bevan.**

boundaries in space, only guideposts, and the sculptor who attempts to define and structure it must refine his spatial judgements and establish interpretations from his own experience and explorations.

Research for the Artist

If we fully embrace this idea of receptivity, then research for the artist begins at birth – and yet none of us includes formative events on our *curriculum vitae*. There is always a significant gap between the day that one enters the world, and the date of the first qualification or appointment – and yet for the artist, his

whole life informs and inspires his work. But would inclusion of such history reveal the drives and impulses behind an individual's work, or would it just compile into a tedious catalogue of mundane events? Perhaps the concept is one for contemplation as opposed to literal action. Linked to this idea of keeping in touch with the true self (and the acknowledgement of one's history) is also the questioning of the relationship of the modern world and its conveniences, and their importance in our own philosophies. Anthony Padovano raises such questions in his book *The Process of Sculpture* (1981):

> One of the important functions of an artist is to constantly
> assert his humanity, even if it means rejecting technology.
> This is important not only to the artist, but to society.
> The creative artist in the performance of his work
> reasserts those values that are important, if not
> essential, to the survival of mankind. Values
> such as imagination, culture, education and ideas
> are nurtured by society's artists, not by its technicians.

> Technology can give us many things, but it cannot give us ourselves. It
> can in fact swallow us up in its power to make
> life easy. A certain amount of difficulty keeps us fit and keeps
> us in tune with reality. Reality is not a big red machine speeding down
> a highway with blazing lights and stereophonic sound.
> The artist is one who still enjoys a walk, who can listen to
> the wind or observe an insect.

This school of thought has traditional roots, and in the twenty-first century would be challenged by many contemporary artists. However, if we look beyond the immediate implication of the statement we can appreciate that Padovano is not advocating neglecting the 'unnatural', man-made side of our existence, just acknowledging the importance of maintaining our connections with the natural world. The consideration of such approaches is integral to the all-encompassing philosophy exposed in this book. However, to move forward on the creative journey is to examine ways of researching for artistic endeavour.

Research for the artist is executed in many formulations depending on the brief, but always there is a consideration from the self as already discussed. The return of the focus on the self emerged out of post-modernist thinking in the 1980s. The generation felt liberated after the strictness of the formalist tenet, and validated by the change in the political and cultural climate that advocated the importance of self-worth and personal indulgence. Without digressing into social commentary, it is, however, a poignant observation that the artist's embracing of ontology is tacit knowledge, that fashions in art only exaggerate, and do not control, on a fundamental level. By the very character of the individuals who choose to be artists, or are driven to be artists, and by the nature of the work, it is unavoidable

that the personality and experience that that individual brings to the task is what makes the work unique. However, the amount of emphasis on the artist, rather than their art, seems to be a predilection of the times, dictated by the ego of that person. Notable exponents of this device utilize it to publicize themselves, with the aid of the powerful media machine; however, in corners throughout Britain artists are quietly but resolutely producing astounding art that bears their 'signature' without a direct reference to self. This polemic facet of art practice has a strong Western focus, whilst in contrast the Japanese, as discussed by Lesley Millar in *Textural Space,* view the relationship of the artistic process to the artist's self, not as a means of self-expression, 'but as a development or construction of the self' (Millar, 2001).

Sourced Material

Primary sourced material is usually in the form of drawings (accepted in its widest remit – line drawings, paintings, collage, prints and so on) and photographs. For many artists this research is rarely confined to the studio: it is often a more active participation that requires visual investigations supported by theory or facts. For instance, in order to have a deeper insight into waste management practices, I traverse over landfill sites and visit recycling centres, liaise with staff and environmental experts, attend conferences and read literature on the subject, to try and understand the 'bigger picture' surrounding the issues. The research feeds into my work, not just from a visual understanding, from the photographs I take and the drawings I make, but also from an environmental stance, to attempt to absorb the scale of the problem.

Other avenues for exploration include secondary sourced material, from galleries, museums, exhibitions, books, magazines, periodicals, newspapers and the internet. Moreover, the study of historical precedents, museum archives and contemporary work can all inform and inspire. The importance of drawing cannot be underestimated, as it is the most accessible way of focusing the mind on a concept or object and therefore nurtures the idea of 'learning to see with fresh eyes'. Executing a drawing in general terms concentrates the mind to analyse the item from new standpoints. This can lead to investigations of unusual angles, exploration of fresh interpretations – literal or abstract translations, and the very necessary record of study – colours, textures, spatial relationships, atmospheres and so on.

Louise Bourgeois described her relationship with painting in a film about the sculptor made by Camille Guichard in 1993; the transcript was later published in a book: '…a drawing leads to a painting, and a painting leads to sculpture, because sculpture is the only thing that liberates me. It's a tangible reality.' (Bernadac, 1996).

Caroline Murphy, drawing.
Photographer: Andrew Morris.

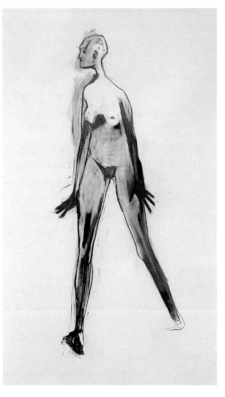

Gemma Smith, 'FOOTED WOMAN',
graphite drawing.

Anniken Amundsen,
'EXAMINATION MICROSCOPY',
black and white photograph.

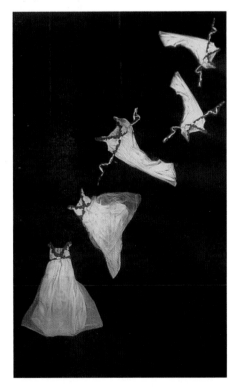

Lucy Brown, 'CAST–OFF', collage.

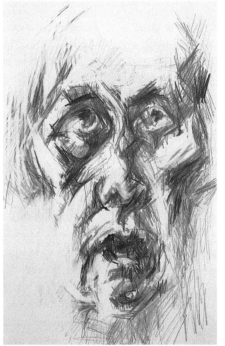

Rozanne Hawksley, pencil portrait.
Photographer: Brian Hawksley.

Fiona Gray, research photograph.

Shelly Goldsmith, heat touch-sensitive paper drawing.

Carole Andrews, sketches.

Joanna Chapman, drawing.

Jac Scott, two monoprints. Photographer: Andrew Morris.

Jac Scott, research photograph.

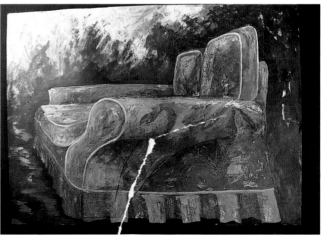

Jac Scott, acrylic painting for 'WASTED' research.
Photographer: Andrew Morris.

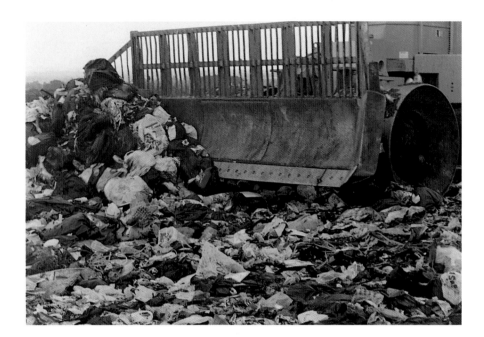

Jac Scott, research material at landfill site.

OPPOSITE: **Jac Scott, acrylic painting for research for 'OFFICE BLOCK' sculpture. Photographer: Andrew Morris.**

The Value of Drawing

The drawings of sculptors provide an intimate portrait of the artist's creative thinking, as they reveal '…the gap between the two-dimensional image and the three-dimensional imagination' (Curtis, 1997). My own approach to drawings always starts from the questioning of the value of a drawing – why do a drawing? What do I hope to learn from it? Which medium and technique would provide the most suitable outcome? Is it for private record or public attention? The latter consideration comes particularly into play for proposals of work and for commissioned pieces. As the drawing may be presented alongside a design, it therefore needs to reflect strongly the initial inspiration. Penelope Curtis discusses the sculptor's approach to drawing in *Breaking the Mould* (1997):

> Drawing is at once the clear light of consciousness and the dark record of the suppressed or the submerged. In this sense, it can be seen to cause emergence; to bring out the forms and give them shape on the page. Antony Gormley makes a point of saying how much he likes the word 'drawing' because of its relationship to 'drawing out'.

The siting of a drawing is also of relevance. Personally, I prefer to organize all my initial thoughts and sketches in a blank book, using it as a log to collate my artistic meanderings; this book forms a personal record of my work, and is rarely for public display. Rachel Whiteread has a deliberate policy of keeping her sketchbooks out of the public gaze and believes in 'keeping hold'

of her own work through this action. Logbooks are usually treasure troves of creativity and become intimate artistic companions, bulging with inspiration and innovation, not only filled with drawings, sketches and writings, but also photographs, clippings from magazines, samples of materials, textured surfaces, and any other thing that speaks to the artist and brings inspiration.

Kieta Jackson has a holistic approach to her research, electing to work simultaneously in a collection of logbooks which she has bound herself. The act of trapping and protecting her creative documentation echoes her inspiration of entrapment: fishing nets, traps and lobster pots. She fills one book with samples of woven copper and brass, and another with sketches and designs

Kieta Jackson, research sample book.

Helen Weston, 'DIVISION'. Materials: mixed-media drawing.

of lobster pots and fish traps, whilst a third book is filled with drawings of sea creatures. The handmade books are created from brown paper and leather thonging, the hues and textures resonating in her finished sculptures.

In contrast, Gill Wilson employs notebooks to record her ideas like diaries, tracing moments of thought as they occur, and developing drawings about linear and repetitive relationships. Her research is informed by other disciplines – for instance by painters, particularly Sol Le Witt and Agnes Martin, by architects such as Louis Barragan, by designers and writers – whilst Joanna Chapman regards her primary research as pieces of work that stand up in their own right, and not just as inspirational records of her walks. She uses them directly, often incorporating the sketch, photograph, found object, plant form or soil sample, in the final piece of work.

Maddi Nicholson's research originates in realms of words, phrases, thoughts and sketches that she compiles in her logbook. Her book acts as a constant source of reference, as she explains:

I am very influenced by advertising, popular culture, the TV, objects I find, people, and the peculiar and unusual things that they say and do. It all goes into the melting pot of the sketchbook. From here every idea begins. This is usually followed with photographs I take, as a visual resource, and evolve through small sketches into large wall-hung drawings, sometimes paintings, and appliquéd textile pieces. The content of the work is incredibly important to me, and what I'm attempting to say will dictate the final physicality of the piece.

Nicholson occasionally extends her research with the aid of a computer – manipulating photographs, playing with colour, drawing with a wacom drawing tablet – all performed with the aim of creating a satisfactory end result.

My own work tends to lean towards extremes in scale, from tiny intimate forms to giant sculptures, with the scale between of little interest; and thus it is with my drawings. There is a point at which

I find myself compelled to release myself from the confines of the log book and produce some large, wall-based paintings and monoprints. The act of doing this is not only liberating creatively, but progressing to working on a larger scale instinctively feels right.

The description of drawings in this book embraces the full spectrum of medium and technique that that can include. Many artists have transcended even these boundaries and manipulated a wider range of materials in their 'drawings'. Helen Weston lets her research drawings dance between the inspiration, her emotional response to the concept, and the materials, and she uses this research as a pointer towards the final sculpture. She explains her approach:

I always start through drawing; the drawings are always mixed-media, and more often than not grow off the page, giving me my first insight into details that the object might include. The drawings take an abstracted form; I never work in a figurative context. They are vehicles in which to explore the manipulation of colour and materials, which could range from papers, boards, leather, fabric, wire, pins and tacks. They look into the emotional content of marks, and the combination of proportions of emptiness and fullness, of boundaries around and between things, the containment of a colour or its escape. These are interests for me on a two-dimensional and a three-dimensional level. Text also plays a part, particularly at the drawing stage: it is a method in which to set the tone of the drawing, and eventually setting the tone and aim of the objects that are inspired by them. The objects pick up on certain techniques within the drawings that are then explored further in the making of the components for the sculpture.

Shelly Goldsmith utilizes medical waste paper, not only to achieve a complete marriage between research and end product, but also to exploit the new challenges that the unusual materials bring to her drawing. The drawings are made on electrocardiograph machine paper that is heat- and touch-sensitive. Goldsmith works into the paper to make meaningful marks on the surface.

Shelly Goldsmith, heat touch-sensitive paper research drawing.

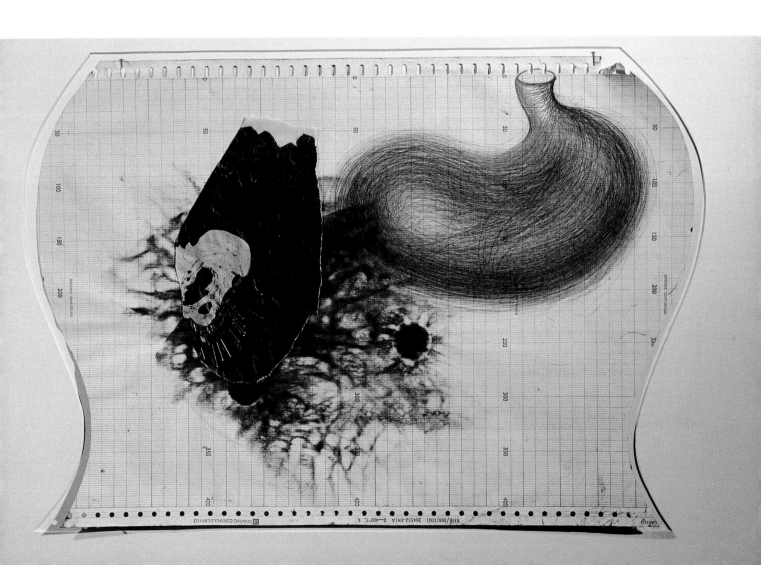

Sculptor's drawings are rarely conclusive, rather signposts on their creative journeys, and Curtis observes this (1997):

> In the more powerful drawing there is a kind of spatial elasticity that is exciting to observe. But even in other, ostensibly ordinary drawings, there is something about the moment at which the drawing is no longer enough, which does indeed take us close, not just to the sculptor, but more importantly, to sculpture.

The Design Development Stage

The design development stage of the design process is when the artist's research informs and inspires new and innovative designs, and the secret to success in this stage relies on the compilation of appropriate and informed research. I find logbooks are particularly useful as a reference and as a place to record and explore design ideas. Designs vary enormously from quick scribbles to painfully detailed designs, and it is only with due consideration to the proposed outcome that the right amount of information will be dictated. Generally speaking, it is at this stage that the creative juices should be flowing freely, and that the air is highly charged. Therefore very focused, yet quickly executed sketched designs result in many alternatives naturally arising in the development.

There is a point when the planar research demands to take on three dimensions, and it is at this stage that the employment of samples, mock-ups, maquettes and models enters the design process. This is a vitally important part of designing any artwork made in the round, as the elements of mass, volume, weight, balance, scale, form, angle, viewpoint and material begin to take on a more realistic outcome.

Anniken Amundsen has developed an innovative perspective to this stage of the creative journey, which reveals a harmonizing of subject and process. By choosing to investigate her three-dimensional samples through a macrolens that she places inside the forms, she simulates an invasion, alluding to her focus of uncontrolled growths and mutations in the body. The photographs are 'x-rayed' in the darkroom, and manipulated and distorted on the computer. Amundsen explains her approach:

> I thoroughly familiarize myself with the objects' shape, irregularity, personality and force. The photographic images are often repeatedly reworked and distorted more and more. I switch from a negative and positive result, from colour to black and white, and back again. A cross-developed photographic image can be used as a negative in the darkroom, and the print from that can be further reworked in Photoshop, then re-photographed – and so the process may go round in cycles…One purpose of these images is to serve as drawings for my work, but it is also a very open-minded process that spins off ideas and solutions for further development. It is an intermediate stage in my sculpture production that is filled with lots of energy, playfulness and spontaneous creativity. Some of the results serve purely as creative boosts and sketches, others end up as final pieces that I exhibit individually or as an installation together with the sculptural work. The photographic investigation together with the ever on-going thematic and visual research leads to the planning and making of the final pieces.

Consideration of financial, practical and logistical constraints should all be sorted out during the design development stage, and resolutions found to avoid unnecessary hassle and expense. Sculptors who work to a large scale, such as myself, Gemma Smith, Maddi Nicholson and Carole Andrews, all encounter logistical problems. I find it is not only the delivering and installation of a sculpture that raises difficulties, but also the day-to-day overcoming of moving the sculpture around the studio in order to work on it. Consequently, much of my work has to be designed and made in sections so that it can be more easily manoeuvred, transported and erected. All the sculptures for the 'Wasted. "Are you sitting

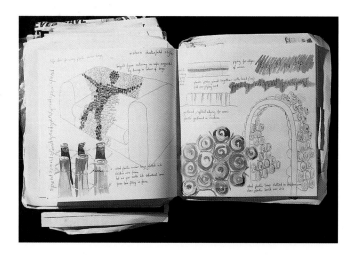

Jac Scott, pages in 'WASTED' logbook.
Photographer: Andrew Morris.

OPPOSITE: **Anniken Amundsen, 'BIOPSY',**
transparent computer print.

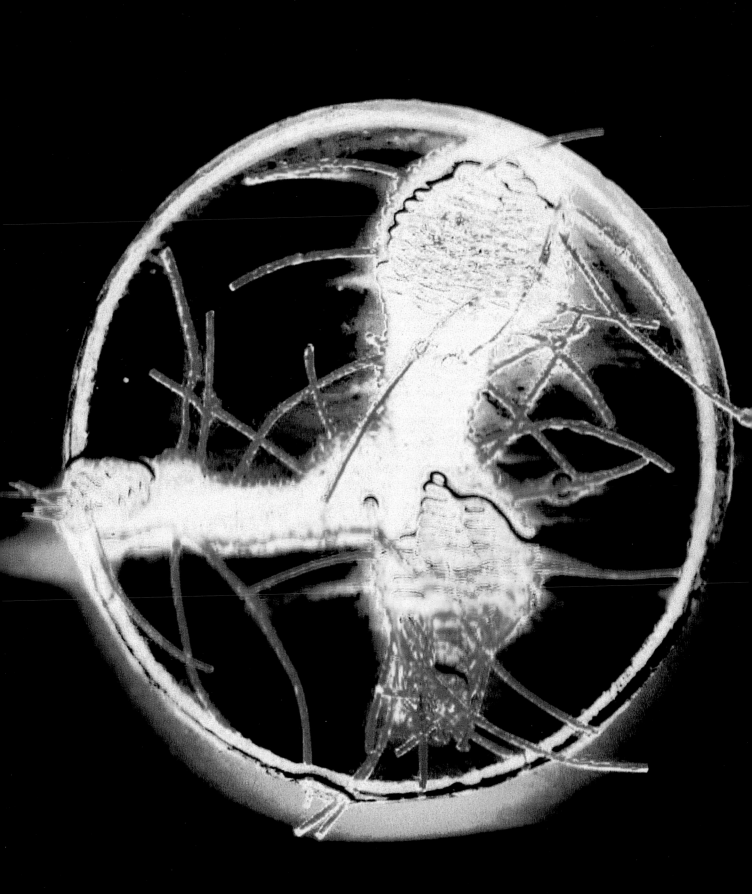

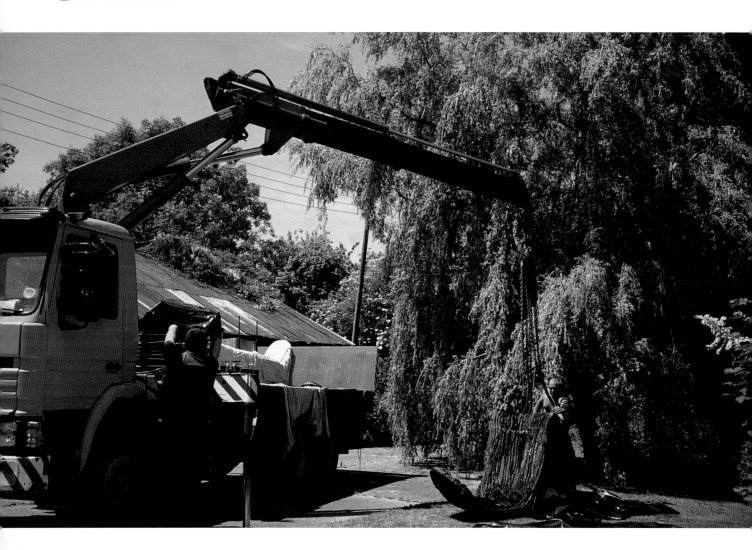

Carole Andrews, installing a sculpture.

comfortably?"' collection were made in several parts that were slotted and secured together on arrival at the gallery. For 'Office Block', the weight and fragility of the sculpture meant it had to be made in two sections that would 'invisibly' join once installed. This problem is endemic in the discipline of sculpture and due consideration to such elements of the practice is essential.

For public presentation or commissioner's consultation, the designs need to be evaluated, selected and displayed on design boards. These are usually neatly executed, and can appear dry and sanitized. It is the skill of the artist to try and retain the initial spark of the concept and capture that essence on the presentation boards. These displays will have different information included on them, depending on the remit, but generally show the choice of design(s), material, scale, construction and location (if relevant). The boards may be complemented by models of proposed sculptures and research drawings.

The Final Making of the Sculpture

There are two more landmark stages on the creative journey: the final making of the sculpture, when the artist consummates substance to their journey; and the evaluation process. The former should be straightforward, if the previous work has been thoroughly executed, although there are few artists who do not indulge in some further hands-on development of the design, with the materials and suchlike, once the making is under way. This freedom is often referred to as 'artistic license', and should never be underestimated for its nurturing of the creative spirit and respect regarding the notion that an artist will always want to 'improve' on his design when in touch with the material.

Wanda Zyborska and Gemma Smith both visualize their practices from an external and internal viewpoint, employing modern technology to record their external experiences photographically. For Zyborska the process alludes to performance art, so a video

camera follows her at each stage, including the installation of the finished sculptures, whether that be in a gallery setting or outside in the environment. Gemma Smith's process employs a camera to record the drawing and making stages of her sculptures, viewing it as a transitory performance which is integral to the work as a whole. The value of this 'performance' steps beyond simple documentation, and so it is often shown alongside the sculptures. Smith elucidates on the subject:

> Over this period of making I was becoming more aware of transitory performance in my practice. This refers to the development of an internal awareness of my own movement while drawing or making, and to the mediated 'private performances' which I present as photographic document. The interplay between time and movement in ordering my space, materials, processes and ideas informed a closer relationship between what had been disparate elements…I choreograph instructions for performance, which transform the sense of a studio activity into the language of transgressive media. This cycle of sculpture into movement into instruction for 'watched' movement is completed when the original sculpture is finished as a self-aware object.

Evaluating the Work

The final stage, that of evaluating the work, is sometimes overlooked, but this is a shortcoming, and will only lead to avoidable disappointments in the future. The artist needs to recognize the value of evaluating his own work, to analyse its strengths and weaknesses, and consider how the weak points might be overcome, in order to move forward in a positive direction from a more informed standpoint.

Shelly Goldsmith follows the traditional path of the design process in her practice but happily allows a blurring of the boundaries during the making and evaluation stages. In *Art Textiles of the World – Great Britain 2* (Harris, 1999), she writes:

> Unlike the traditional approach, where designs or 'cartoons' are translated into tapestry by a team of weavers, my practice is a solitary undertaking. Rarely do I choose a drawing to transcribe literally, since such an approach would leave me little opportunity for creative development in the making of the piece. I just know that I would get bored! The process of weaving is for me a decision-making experience where issues are explored. This process of discovery through manipulating materials consolidates my ideas and

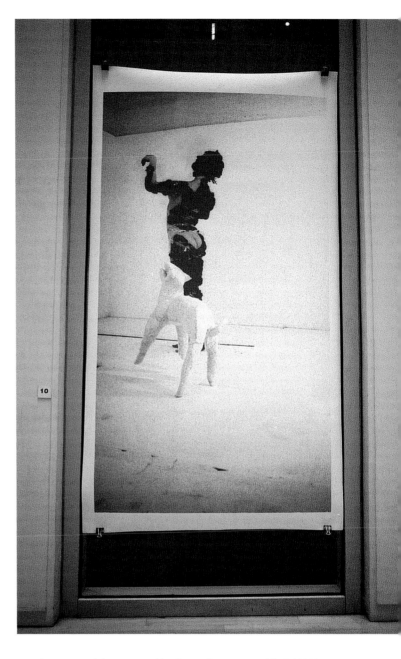

Gemma Smith, wrapped body performance with 'LAMB' sculpture. 'WITNESSED' exhibition at Atrium Gallery, London, 2002. Ink-jet print from black and white photograph.

> allows me to reject inappropriate or unrealistic approaches. I learn about the essence of the idea, how to translate it, and the potential of the materials. Each piece is like a sketch with a series of complex decisions to be made along the way.

Lucy Brown utilizes drawing at each stage of the process, viewing the practice to clarify ideas and document the various stages.

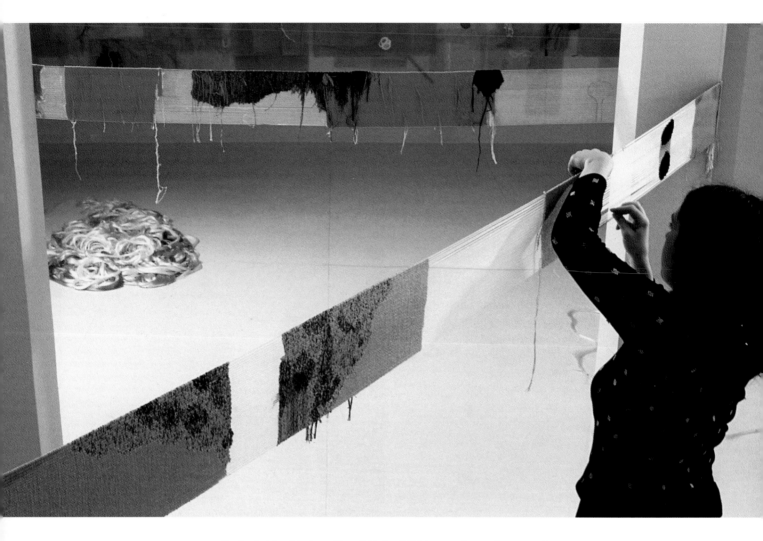

**Shelly Goldsmith, installing 'RIPE' exhibition at the Crafts Council, 2000.
Photographer: Colin Campbell.**

She develops black and white collages from photocopies of the garments, which she aptly calls 'Cast-Offs', and she creates other drawings once the sculptures are complete. These later planar developments act as indicators for installation and assist Brown in evaluating her work.

Working Directly with Materials

As illustrated in the examples above, the creative journey is a very twisting path with many diversions and road blocks that both challenge and frustrate the artist. It is for each individual to discover and formulate their preferred way of working, and the so-called 'design process' is only one formula that suits some practitioners. There is a whole band of artists who work directly with materials, preferring to do only a little preparatory research and design work: instead they are inspired by the materials themselves. Simone Cobbold is an interesting example of such an artist, who feels a strong affinity with stained and marked objects and materials. She is fascinated by the evidence of human use on these materials and the history they contain. Cobbold's story discloses her journey of discovery to develop a personal aesthetic language, and it forms a fitting way to close this chapter. She writes:

> During the first year of my degree, I mainly concentrated
> on printing and drawing from the figure, but I was not
> happy with my work. It took me a while to realize that
> just printing the fabric was not enough, I could not
> express myself in two dimensions. During the following
> summer I began to pad my prints, to make areas of the

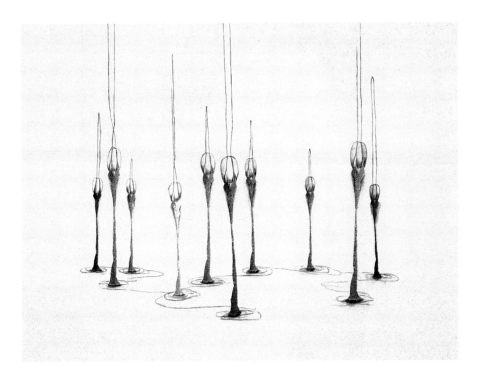

Lucy Brown, 'MASS SQUEEZE'.
Materials: collage.
Photographer: Bob Curtis.

body bulge away from the surface. I immediately began to get excited, and over the next few months my prints became padded three-dimensional slabs and forms, gradually becoming larger.

It was at this time that I again began to collect and work with domestic materials. My mother had always shopped in second-hand and charity shops, and I finally realized that it was the type of fabric sold in this type of shop that I was really interested in using.

It was during a shopping trip for fabrics that I came across an armchair that I later called Harry. The chair was out at the back of a second-hand shop and was obviously destined for the tip. It was torn and stained, with indentations where somebody had sat in it over many years, and this object really spoke to me. I imagined a lonely old man sitting in this chair and basically waiting to die. This chair told a story of somebody's life, it made me realize what it was that I found interesting in the materials and objects I was drawn to working with: it was the evidence of human use and contact that excited me – the stains and the marks tell the story of each piece's life history, they have seen beyond the lacy net curtains to the realities of domestic and family life.

Over the last few years I have produced a whole family of forms using second-hand furniture and fabrics, the character of each piece coming directly from the found object itself or from stories I have heard, or from people I have known. I still have Harry, and I am still not sure what it is I want to do with him. Over the years he has been stripped down, re-upholstered in parts, and then stripped down again. I do feel that I need to work with him – but there is also a part of me that wishes I had left him as I found him, as the story he told was far more powerful than anything I could reproduce.

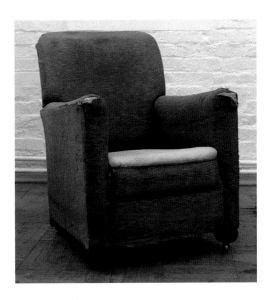

Simone Cobbold, 'HARRY'.
Research artefact.

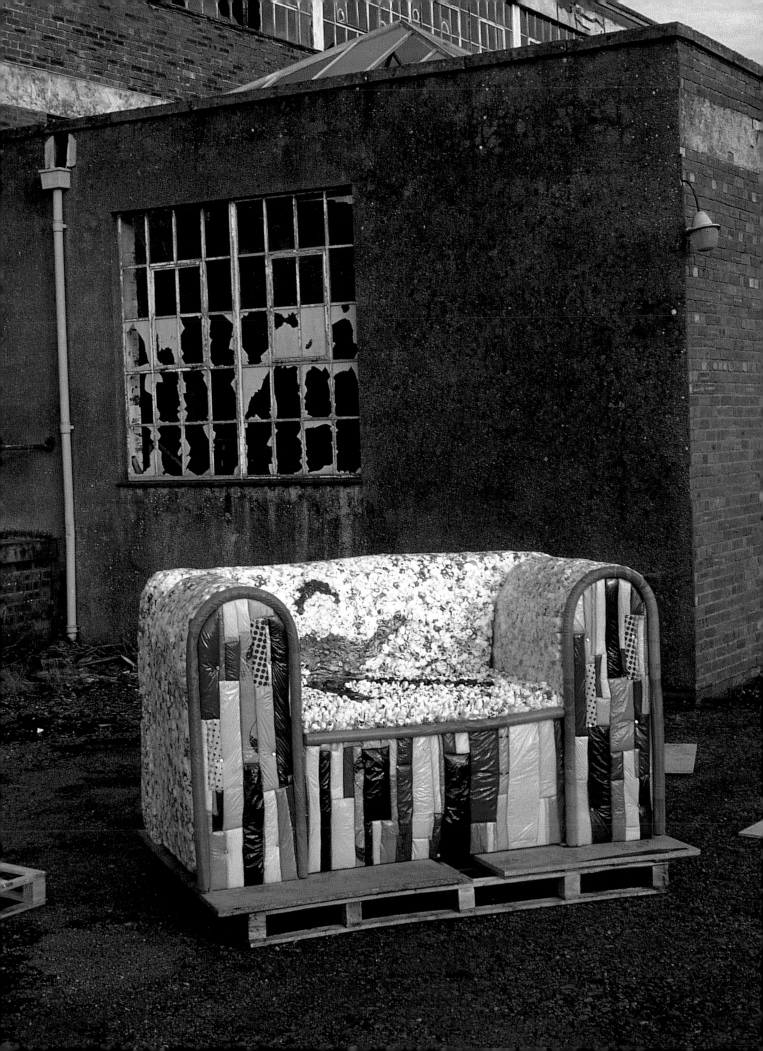

PLASTIC

It is important first of all to clarify what is meant by 'plastic'. In the arts, the term 'plastic' refers to modelling (ceramics or sculpture) or representation of the solid form. In this chapter, plastic will be used for its other meaning, namely as a collective term for synthetic, resinous substances.

Plastics Revolutionize the World of Sculpture

A hundred and fifty years ago plastics did not exist. In the twenty-first century, plastics form an intrinsic part of our lives, no longer a luxury or revered new material, but rather an easily recognized and fully integrated substance in our lives. The first plastic was invented in 1862 by Alexander Parkes, yet it was not until 1910 that a completely synthetic material, that we regard as plastic, was commercially produced. The Belgian-born American chemist Leo Baekeland, created a dark, thermosetting resin that became known as Bakelite. The creative chemistry – of combining hydrogen, nitrogen, chlorine and sulphur – produced a product that revolutionized both industry and the home environment. However, the art world was slow to respond to using this new material in their work, and it was not until the 1930s that plastics were inaugurated into the treasure chest of materials acceptable for creative expression in sculpture. This embracing of such a new and synthetic material revolutionized the world of sculpture. Its first greatest exponents include Naum Gabo and Laszlo Moholy-Nagy. Gabo built constructions from acrylic plastics and nylon cord, achieving an innovative and

Jac Scott, 'ARE YOU SITTING COMFORTABLY?' 2001; 'WASTED' Collection photographed at recycling factory. Materials: 10,000 plastic carrier bags, metal and timber armature. Dimensions: 226 × 128 × 122cm. Photographer: Andrew Morris.

ground-breaking approach to the use of new 'artificial' materials. In 1937 he wrote:

> Materials in sculpture play one of the fundamental roles. The genesis of a sculpture is determined by its material…There is no limit to the variety of materials suitable for sculpture…Carved, cast, moulded or constructed, a sculpture does not cease to be a sculpture as long as the aesthetical qualities remain in accord with the substantial properties of the material.

Moholy-Nagy worked with acrylic sheets that he heated and manipulated into multidimensional shapes. He is remembered particularly for his approach to the intertwining of science with art, and the exploration of sculpture that 'resisted' gravity. Both Moholy-Nagy and Gabo developed early examples of kinetic art, and the work of both sculptors examined and employed 'new' materials, particularly lightweight plastics.

In the 1960s Claes Oldenburg distinguished himself by challenging the viewer with a collection of witty sculptures made from textiles and, later, soft vinyls. His mission was to glorify the minutiae of life by consciously subverting the scale, material and character of the commonplace object. To help him achieve his 'innocent vision' he explored the soft/hard dichotomy with oversized sculptures of a bizarre range of items: sandwiches, typewriters, vacuum cleaners, toilets, and later, in the 1990s, musical instruments. Objects were often mirrored in soft form by a canvas skin stiffened with resin. Vinyls were selected for their smooth, light, reflective qualities that echoed the metal of the object's origins.

Contemporary sculptors who choose plastic as an expressive medium include the acclaimed Tony Cragg. Cragg's interest lies in the state of the environment, and the plastics he uses are imbued with past histories, being plastic detritus from our consumer society. His assemblages fixate the onlooker by the mesmerizing play with colour, and the manipulation of the individual objects into a cohesive, yet segmented, whole. From a distance the effect is decorative, but closer inspection creates

a tension with the spectator as realization of the object's true identity becomes apparent.

There is a confusion that surrounds plastic, and therefore this creates a dilemma for the artist. Plastic is seen as a substance that pollutes the environment because it does not biodegrade, and yet in sculpture it is viewed as an impermanent material as it changes so easily. All materials change to some degree when exposed to the internal and external elements. With plastic the internal chemical structure and composition is fixed in production, and it is our management of the external environment that can influence change. Plastic is often considered an iconic material of our mass-consumerist society – its label can assist and deter its use in art. Sculptors in this book have embraced the use of plastic from all spectrums, recognizing its limitations and connotations, and creating work that reveals the true potential of the material.

Technical Information

Plastics are a vast subject, and for those seeking in-depth knowledge, specialized publications should be researched. The primary aim in this chapter is to provide a background to their use and application, as appropriate to the overall aim of the book.

Properties

The use of plastic in art is laden with connotations referencing its proliferation in our society. Plastic's mass-produced image of consumer items for the household brings a wealth of inspiration and dialogue for artists: past histories of the items provide a rich embryo with which to embark on a creative journey of transformation. Consideration of the properties of plastic, in its virgin state, reveals its appeal as a versatile, expressive material.

Most plastics are extremely light in weight, and therefore can make ideal structures when weight considerations are essential. From a purely practical point of view, this also means that the logistics both inside the studio and for transportation become much easier. Plastics are strong, durable and dimensionally stable. Another highly valuable property of plastic is its ability to transport light. Some plastics, such as casting resins, acrylic sheets and monomers, are transparent, and this embraces a whole new ethos towards sculptural work, as light journeys through the tangible form. The control of the quality of light in the presentation of all sculpture is vital in practice, and subjective in the success of the outcome. This added dimension was exploited to new horizons in the 1990s by the use of fibre optics: conceptually and visually engaging, fibre optics were woven, interlaced and threaded. For example, Sonja Flavin, an American artist, combines fibre optics

with sheet plastics to produce illuminating structures, and this play with light and translucency delivers a new tension between the audience and the work.

Sculptures made from plastics can appear to lack depth and feeling, in direct opposition to those made from natural materials, where a warmth and a tactile quality is omnipresent. This condition, coupled with plastic's tendency to lose its radiant charm over time, presents a dilemma for the sculptor, as plastics do not age in the same attractive way of other materials such as stone, wood and metal. As previously mentioned, revered works of art by Gabo and others have become dull and faded over time, whilst acrylic paintings completed half a century ago lose their lustre and appear dark. Realizing these inherent conditions of plastics, and adjusting accordingly, is vital if sensitive and valuable work is to result. Longevity and subject matter need to be addressed accordingly. The use of plastic reflects our consumerist's taste for a continual renewal of possessions, regardless of condition, to fashion our need to show wealth through material manifestations. Therefore, the concept behind that of art made from plastics is imbued with this referencing regardless of intent. It is not the remit of this book to suggest that all art should be made to last, nor that while it lasts, it should age gracefully, but rather to say that the material selected for the work should always be chosen from both an intellectual and a practical standpoint.

The group of synthetic substances collectively known as plastics are too numerous to discuss; however, in simplified terms, most plastics are derived from petroleum, and are mostly polymers made up of long chains of identical molecules. The focus will be on two basic types of plastic: thermoplastic, and thermosets, as these are the most relevant to sculptors.

THERMOPLASTIC RESINS

These are plastics that soften when exposed to heat and then harden again when cold, no matter how many times the process is repeated. Acrylics, cellulosics, nylon, polyethylene (wrappings), polystyrene (used in numerous forms, including packaging), polyfluorocarbons, polyvinyl chloride (PVC, wide range of uses: shoes, bags, drainpipes, floor tiles, audio discs), acetal resin, polypropylene and polycarbonates are thermoplastic.

THERMOSET PLASTICS

These are formed into their final shape through heat and pressure, but remain rigid once set and do not soften when warmed. Epoxy resins (often used in paints, adhesives and varnishes), polyesters (found in textiles and in fibreglass reinforcement), polyurethane (paints, varnishes and foam), phenolics, amino plastics, alkyds, allylics, caseins and silicones (commonly used in insulation materials, laminates, cosmetics and synthetic rubbers and textiles) are all thermoset plastics.

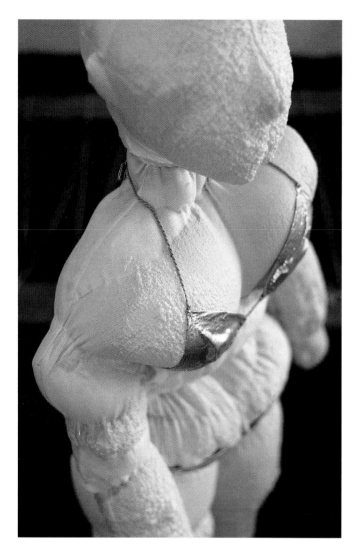

Nicola Morriss, 'THE THREE GRACES', 2001; work in progress. Materials: insulation foam, muslin, gold bikini.

The Use of Plastics in Sculpture

Plastics are manufactured in various forms: powders, liquids, emulsions, pastes, pellets, foams, sheets, rods, tubes and solid volumes. The processes employed include moulding, casting, extruding, laminating and fabricating. Plastics can be used in sculpture in a variety of ways:

▥ POLYCHROMING: The most popular way of using plastics is by painting work with plastic-based paints.

▥ WEAVING: Linear plastic elements woven together.

▥ CASTING: Liquid resins into moulds or forms.

▥ CARVING: Into blocks, cellular plastics or laminated forms.

▥ FORMING: By vacuum, cutting, heat bending, bonding or machining.

▥ LAMINATING: Strata formed by sheets sandwiched together, or used to form a layer with other materials.

▥ IMPREGNATING: Polyester resin can be used to saturate materials to create solid forms with better sealing properties, and therefore protect porous surfaces.

▥ RECYCLING: Redundant plastic matter can be transformed through process to another form, or through the change of role through creative manipulation of its placing in a piece of work.

Nicola Morriss has developed a novel approach to using polyurethane foam. An industrial residency at a factory producing the foam, normally used for insulation, created the opportunity for experimentation. The chemicals polyol and diphenyl-methane di-isocyanate (MDI), when combined, produced a rapidly expanding

HEALTH AND SAFETY

Some health and safety points to consider when using rapid expansion insulation foam:

▥ Chemicals are flammable, therefore it is necessary to take sensible precautions – such as no smoking in the vicinity, and the avoidance of naked flames. Store chemicals in cool conditions.

▥ Some fumes or odour are given off, so it is advisable to use the foam in a well-ventilated area.

▥ The foam adheres to the skin, therefore wear protective clothing, and use rubber gloves or an industrial barrier cream on the hands. Adhesion of the foam to fingernails is a particular problem. Morriss found that using several layers of nail varnish formed a good protective barrier. White spirit, used sparingly, will act as a solvent.

▥ An irritant dust is created when the foam is cut with an electric saw. Take adequate precautions during prolonged activity by wearing a dust mask and protective clothing. Perform tasks in well-ventilated areas, or with the assistance of dust extraction.

foam that took only ten seconds to increase in volume thirty-fold. The chemicals were weighed in a container and then quickly mixed with a mixer head on an electric drill. This liquid was injected into muslin skins that were modelled on the human figure. Pressure was applied to ensure the body part was fully filled as the liquid transformed to a stiff foam. The process was rather imprecise, but Morriss exploited the rapid 'growth' qualities of the product and the outcome was figures with a sense of vitality and movement. The foam was only partly trapped by the muslin, bleeding randomly to suggest maligned epidermal ailments. The sculptures were installed outside where the foam reacted with ultraviolet light altering to a rich tan colour. For Morriss, this tanning referenced our own fashion for sun worshipping and the connections with skin cancer. The figures were portrayed as beach lovers with tattoos and skimpy clothing.

Methods of Joining Plastics

■ SOLVENT BONDING: Used to soften and fuse thermoplastic surfaces together.

■ ADHESIVE BONDING: Specialist bonding agents that join plastics without damage.

■ THERMAL BONDING: A welded joint formed by the application of heat, which softens and fuses the thermoplastic.

■ MECHANICAL PARTS: Linkage achieved through the use of screws, nuts and bolts, rivets, clips, cable ties, hinges and so on.

■ INTERLOCKING: Techniques employed to join, construct and weave.

Sarah Crawford, 'HAIRY STRING BAG' (detail), 2001. Materials: punched and pleated PVC sheet, smocking secured with dyed nylon washers and dyed nylon cable ties, and PVC tubing for the handle. Photographer: Richard Stroud.

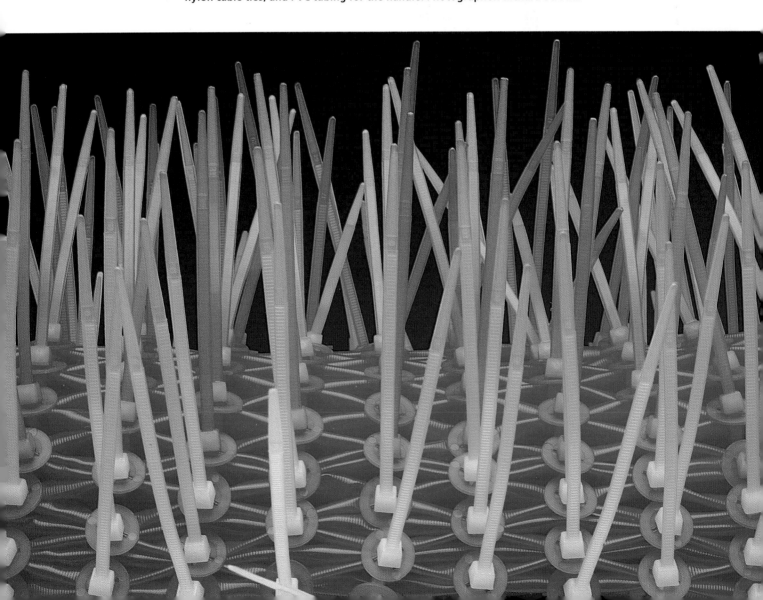

Thermal Bonding Techniques

Plastics and textiles are happy and complementary partners when some fundamental points are considered. These include the relationship of their individual properties, and how perceived problems can be overcome and sometimes exploited to an advantage. Both materials are diverse in nature: texture, drape and finish, and therefore depending on the selection the challenges are numerous. Techniques traditionally associated with textiles can be manipulated to be suitable for working with plastics.

WELDING WITH AN IRON

An iron is a useful tool for performing welding and laminating processes with plastics and textiles: on a low setting, and with paper between plate and plastic to avoid sticking, the heat welds the plastic sheeting to the adjoining plastic surface. Care should be taken with the selection of plastics suitable for this operation, as different chemical compositions react differently. Variations in the temperature of the iron may be required to effectively join the materials. Always start on a low setting, and gradually increase the temperature to avoid mistakes. Avoid prolonged contact with the iron and the plastics, as burning will result. Experimentation is the secret, with due care taken to protect the iron with a layer of clean paper.

A subtle print effect can be achieved by selecting printed paper surfaces and laying these face down onto the plastic. Keep an even pressure with the iron over the printed area, and a facsimile in reverse should result.

Interesting patterns and textures can be created by weaving plastic strips together, or by replacing the warp or weft with a textile or yarn. The addition of heat from the iron will alter the form of the plastic. The welding may cause some plastics to shrink, which will produce an unusual surface. Thin plastic sheeting or plastic carrier bags cut into strips are ideal for this weaving technique.

Always work in a room with adequate ventilation, as a mild, unpleasant odour is produced during this process. Follow normal health and safety guidelines for using an iron whilst performing this technique.

Multicoloured patchwork plastic sheets can be created by welding plastic scraps together. Sewing these onto a heavier textile with wadding between the two layers will create a padded patchwork quilt.

When stitching plastics using the sewing machine, always use the specially designed foot for plastics: it has a coating on the metal foot to avoid sticking. It is also advisable to use synthetic threads.

USING A HOT AIR GUN

This is an indispensable tool for anyone working with plastics. It is traditionally used by the joinery fraternity to strip old paint or lacquer from wood or metal; it can also be found in a ceramist's

HEALTH AND SAFETY

The following health and safety points should be considered when using the hot air gun:

- Noxious fumes can be given off during the welding activity, but will vary in strength depending on the plastic being used. It is advisable always to work in a well-ventilated environment, and to wear a face mask. Overheating of polythene can lead to the creation of carbon monoxide. Specialist advice should be sought if concerned, from the Plastics and Rubber Advisory Service (for contact details, see page 153).

- Do not let children handle the gun; all onlookers should be kept well away from the work area.

- To guard against electric shock, always keep the tool clear of the cable while working, and remove all other live services and equipment.

- Do not use the gun in damp or wet environments.

- Flammable liquids and gases must be stored away from the work area.

- The wearing of safety goggles or glasses and protective gloves is advisable.

- Tie back long hair.

- Store the tool in a dry place away from children.

- Damaged cables should be replaced immediately.

- The plastic will become intensely hot: to avoid burning of the skin the plastic should not be handled until it has cooled down.

- Disconnect the tool when not in use. Do not lay the hot nozzle on a polished or plastic surface, as the heat from the operation will remain in the nozzle for some time and could spoil the surface.

- Check that the vent at the rear of the tool is kept clear at all times to avoid overheating.

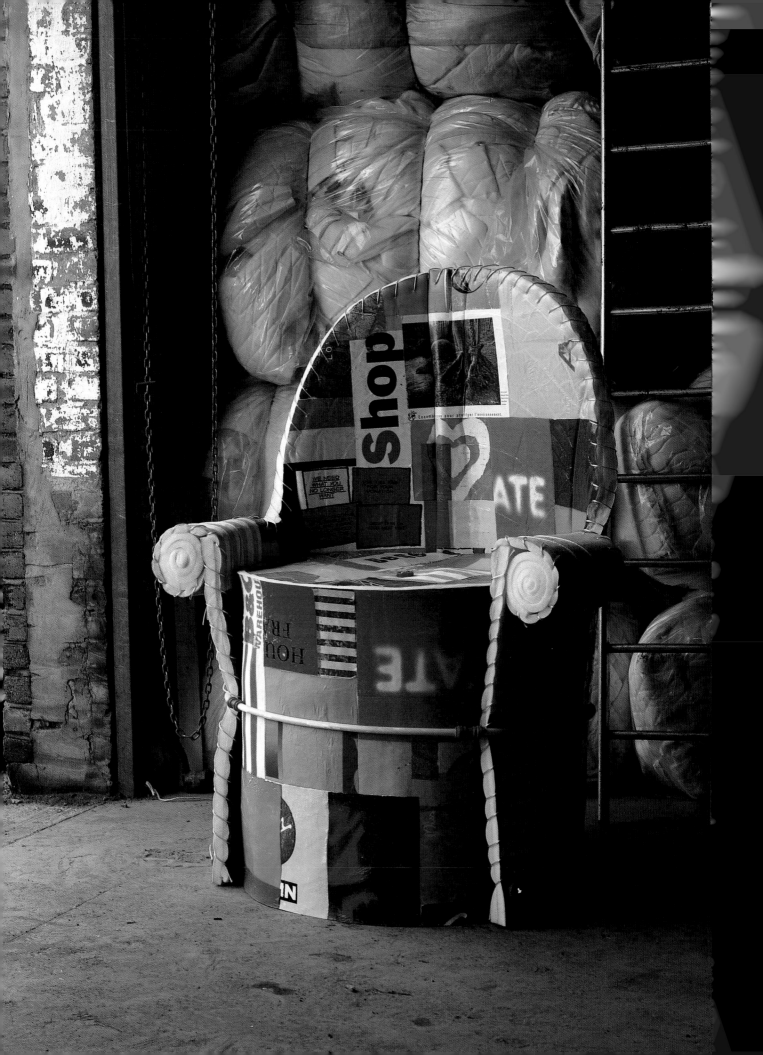

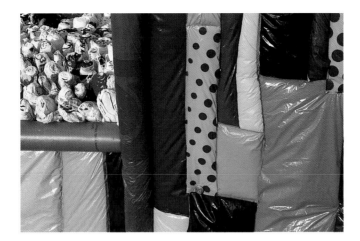

LEFT: **Jac Scott**, 'SHOP TILL YOU DROP', **2001.** 'WASTED' Collection photographed at recycling factory. Materials: plastic scraps welded onto foam. Photographer: Andrew Morris.

Jac Scott, 'ARE YOU SITTING COMFORTABLY?', **2001. Materials: detail showing patchwork of plastic scraps sewn on to wadding. Photographer: Andrew Morris.**

toolbox as a method of accelerating drying times. The gun is easy to operate, but due care must be taken, as the heat from it can be highly dangerous. Gun temperatures ranging from 250–450°C are highly useful for melting, fusing and welding plastics. Practice is the key, as the distance between the tool and the material is crucial in determining the speed of the operation and its success or failure: thus too close, and the plastic 'boils' and burns, creating unsightly bubbles and browning; too distant, and the action is unnoticeable. Nozzles come as attachments, and control the concentration and direction of the air flow.

The sculpture 'Are you sitting comfortably?' was created by utilizing variations of thermal bonding techniques. Plastic bags were coiled and inserted into a timber and chicken-wire armature, and a hot air gun was used to melt and weld individual components together. An iron provided heat to weld clear plastic sheeting over the coils to form a smooth, protective surface over the structure.

The front panels were covered with welded plastic strips, forming a multicoloured sheet, which was quilted on the sewing machine, with wadding and a backing fabric.

**Jac Scott, 'ARE YOU SITTING COMFORTABLY?' (detail), 2001.
Materials: coiled carrier bags in the seat of the
sculpture, melted with a hot air gun. Photographer: Andrew Morris.**

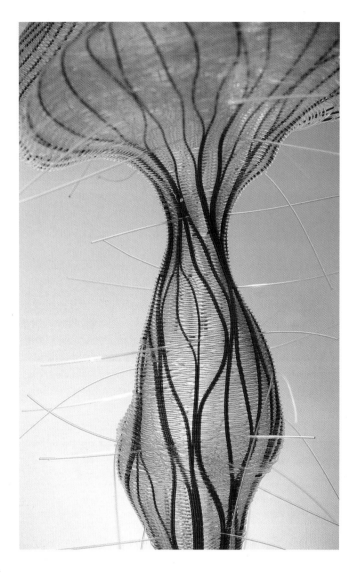

Anniken Amundsen, '1-01 PARASITE' (detail), 2001. Materials: woven fishing line. Photographer: Jan Ahlander.

Shelly Goldsmith, 'MONSOON CAPITAL', 1999. Materials: nylon monofilament, cotton, silk, heat transfer funnel.

Weaving with Plastic

Plastics for weaving need to be either linear in form, such as tubing, or available in sheet form that can be cut into lengths. A wide choice of potentially usable material can be purchased from the most unlikely outlets, such as plumbers' merchants, ironmongers, or do-it-yourself shops. Large plastic bags can be easily cut 'on the round' to provide long strips that are ideal for weaving. Once woven, these can be further treated with other processes, for instance welding, which will create unique, hard twists in the weave. Plastic tubing can be readily cut with a sharp craft knife and employed in a myriad of applications. Cutting slits or drilling holes in the tubing can open up further possibilities for the insertion of other materials or additional tubing. Plastic tubing can form an armature or the visible main framework for the sculpture itself, depending on the desired outcome. The nature of plastic provides a slippery surface with which to weave, and so it can be more difficult to work with than natural materials. However, the effect achieved is unique and well worth the effort. Traditional basketry techniques for building form can be applied to linear plastics. It may be necessary to employ additional holding apparatus while construction is in progress – masking tape or pegs can be very useful.

Experimentation is the key to discovering innovative applications for plastics and, as long as good health and safety practices are followed, a wealth of new material can result.

Anniken Amundsen creates her sculptures by manipulating traditional basket-weaving techniques: for instance, fishing line and steel wire produce a malleable combination of materials. Shelly Goldsmith, on the other hand, subverts traditional tapestry techniques by drawing attention to the warp threads: in 'Monsoon Capital', she used extended lengths of nylon monofilament as a warp to form a three-dimensional tapestry, the use of the semi-transparent nylon forming a slippery contrast to the cotton weft. The rationale for the nylon was its transformation of the piece to resonate the relationships to subject matter which intrigue Goldsmith: the flow of water from global and bodily perspectives. These warp threads extend beyond the tapestry part of the sculpture, flowing out onto the floor and then through a heat transfer, x-ray funnel.

Plastic-Based Sculpture for the Outside Environment

Traditionally, the exterior environment has not had an influx of permanent, textile-based work due to the rapid deterioration of the material. Temporary work – banners and some felt sculptures – have had transient homes, but the weathering process

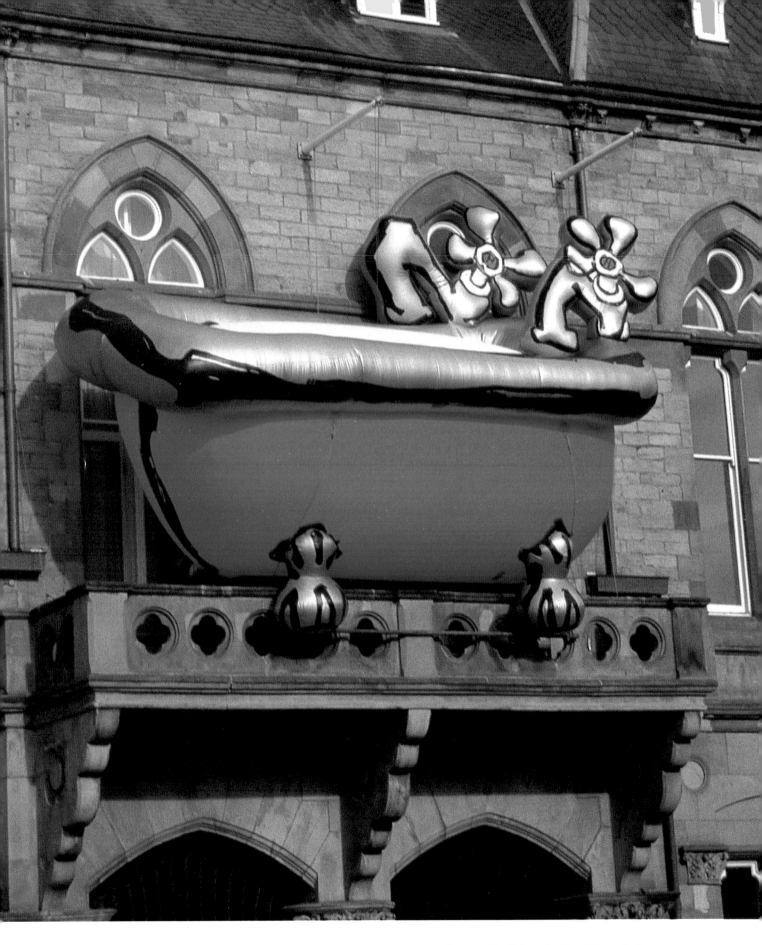

Maddi Nicholson, 'SHALL I DRAW YOU A BATH, MY DEAR?', 1996. Installed outside Bishop Auckland Town Hall.
Materials: inflated waterproof fabric and PVC inks. Dimensions: 5 × 6 × 3m.

quickly takes its toll on the work. Sheet plastic is widely used, and polyester resins provide another dimension to the concept of exhibiting mixed-media sculpture outside. Polyester resins are useful for strengthening materials, particularly when used in a laminating technique with glass fibre. The resin is also suitable for making them weather- and water-resistant.

The use of plastic outside, such as executed by Maddi Nicholson, presents a new dynamic for the mixed-media artist. Her approach utilizes techniques employed by the industrial makers of the children's favourite building: the plastic 'bouncy castle'.

Maddi Nicholson works with plastics on a grand scale, particularly enjoying the lightweight nature of the material to form inflatable PVC sculptures. She collaborates with industry to devise and execute new technologies that give her work a unique vitality and aesthetic. The large-scale exterior pieces are created from heavy-gauge, waterproof PVC which has a fibreglass inner layer for added strength. This inner layer makes the material impervious to light, which is useful when the structures are constructed to invite internal exploration on foot. Various weights of plastic, with varying levels of waterproofing, are selected, depending on the work. Nicholson's images are inkjet-printed onto the PVC by a printing company. The plastic is further embellished by hand-painting with screen inks, embroidery, appliqué, or the addition of self-adhesive, vinyl 'decals'.

Pattern cutting is an important part of the creative process: the newly decorated plastic sheet is cut, and either the seams are welded, using an industrial high frequency welding machine, or sewn with a double-felled seam for strength and then sealed with a latex adhesive or iron-on vinyl tape.

Some sculptures are inflated, while others are stuffed. Inflation valves are welded to the sculpture to allow for inflation, if appropriate. A steel armature inside some of the pieces is necessary to support other hard elements such as wheels, timers, movements and lights. Inflation methods vary widely according to the size of the work, from simple blowing from the mouth of the artist, to blasting air from industrial machines.

Polyester Resin

Polyester resin is a liquid made from unsaturated alkyds with a reactive monomer (styrene). It has the appearance of syrup and a matching viscosity, which changes to a solid with the addition of a catalyst or liquid hardener (organic peroxide). The polymerization, or curing process, between the resin and the hardener, can take from a few moments to a few days, depending on a number of factors. These influencing factors include the amount of catalyst, the quantity of accelerator, the type of application and the ambient temperature.

An accelerator is often added to speed the process of hardening: cobalt napthenate mixed with a carrier of white spirit. Control of the hardening process can be achieved quite accurately with the amount of accelerator used. Always thoroughly mix the accelerator with the resin, then add the hardener. Polyester resins usually come with an accelerator already added – always read the manufacturer's directions before embarking on a task. Accurate measuring of the chemicals is vital for a successful result.

When selecting which polyester resin to use, consider carefully not only its application, but also its intended final destination, proposed site, and the likely demands that will be made upon it by the elements and the public. Fire-retardant and chemical-resistant formulas are available.

An important point to note when working with polyester resins is their short shelf life: always read the instructions to avoid unnecessary wastage of materials.

Working with Polyester Resin

Polyester resin is a thermoset plastic that retains its final shape after completion of the curing process. It remains rigid and will not soften when warmed, so careful handling and preparation is vital to achieve a satisfactory outcome. The curing process commences when the chemical reaction between the resin and the catalyst (liquid hardener) produces heat and begins to polymerize. The change from liquid, to jelly, to a soft, rubbery substance and then a hard material is rapid. The point where the substance is irretrievable is at the jelly stage, and the time the resin takes to change to jelly is referred to as the *gel* time. The exothermic action is accelerated when the substance is in bulk form, as in a mixing pot, rather than when it is applied as a laminate, and therefore the working life of a mix is the time it is in the pot – this is often referred to as the *pot life* of the resin. The *pot life* varies considerably, depending on its application and the use of fillers, accelerators and so on.

Providing the right working conditions is essential when using polyester resin. These plastics do not like the cold, and exposure to cold conditions will result in a permanent undercure, or stickiness. The ideal temperature is 20°C (67°F): any lower, and the curing time increases, whereas higher temperatures result in a reduced curing time. Increasing the amount of accelerator may counterbalance the reaction to lower temperatures, but do not work in temperatures below 10°C (50°F). A very thin layer of resin may be unable to build up enough exothermic heat to properly cure, and in this type of case, additional heat may be required to assist the process.

Avoid working in draughty places and damp atmospheres, as this, too, could result in an unsuccessful polymerization.

Mixing containers for resin should be made from a flexible material such as polythene, as containers made from hard

HEALTH AND SAFETY CONSIDERATIONS WHEN WORKING WITH POLYESTER RESIN

Polyester resin has vast potential for the sculptor who employs textiles or textile techniques in their work, but it is a highly dangerous substance, and due care and attention to safe working practices is essential. The following list covers some health and safety considerations which should always be used in conjunction with the manufacturer's guidelines and instructions.

▦ Always work in a well-ventilated area. A toxic styrene vapour is given off by polyester resin, and this vapour can cause nausea and giddiness at low concentrations. It is heavier than air, so a useful tip is to leave a door slightly ajar: this often provides sufficient additional ventilation to avoid the problem. However, wearing a specially designed facemask or a respirator may be advisable.

▦ Wear old clothes, or utilize disposable, protective outfits.

▦ The wearing of protective gloves is advisable.

▦ The polyester resin will act as a solvent on the skin and cause skin irritations and complaints, so apply a specialist barrier cream to the skin before starting a task. Use a cleansing cream to clean the skin afterwards. Never use hot water to remove cured dust from the skin, but always use cold or lukewarm water; this will stop particles lodging in the pores of the skin, which could lead to irritation.

▦ The catalyst and accelerator must not come in contact with the skin, or burning will occur.

▦ Goggles may be necessary for certain operations, especially if splashing may occur.

▦ Wear a filter mask when dry sanding, cutting or filing cured resin. Resins are chemically active for up to thirty days after gelation.

▦ Always keep resin, catalyst and accelerator well away from naked flames and all other heat sources. If the catalyst burns it creates an oxygen-high vapour that ignites.

▦ Do not smoke while using resins.

▦ If a catalysed resin in bulk form starts cracking, smoking or becomes excessively hot then douse immediately in cold water.

▦ Never leave catalysed resin in bulk form unattended as the exothermic reaction could ignite it.

▦ It is advisable to cover the working area with polythene.

▦ Clean up spillages immediately – do not leave to harden.

▦ Clean equipment in hot water and detergent before the resin cures. A strong, powder detergent, used neat with a little water, should be effective. If a solvent is preferred, or is necessary for thorough cleaning, then wash out the equipment afterwards with hot water and a detergent to avoid any residue.

▦ Store substances in a cool, dark place.

▦ Do not store liquid accelerator near liquid hardener.

▦ Large quantities of flammable materials should be stored in special containers/storage areas – seek specialist advice.

▦ Waste catalysed resin should be spread out thinly on a polythene sheet so that the exothermic heat dissipates rapidly.

▦ A daily disposal of the waste is recommended, with adherence to safe working practices.

materials make it more difficult to remove the old resin. Using old or cheap brushes is fine for applying the coats of resin, but avoid the stiff, bristle type.

Laminating

An ideal way of strengthening sculptures is to laminate glass fibre and resin to a surface. Maddi Nicholson's giant plastic structures are reinforced inside with a glass-fibre layer. Carole Andrews also often uses glass fibre to strengthen the underside of her sculptures made from roofing felt.

Glass fibre is available in various forms; the two types most suitable for use by sculptors are a woven glass fabric and a chopped strand mat. The first has the greatest mechanical strength but is usually more expensive, whereas the chopped mats are easier to manipulate and cheaper to buy. The chopped mats are impregnated with catalysed resin, which dissolves when liquid resin is applied to it. The cloths come in various weights, so selection should be based on its application. Both types of cloth provide a rigid reinforcement to a sculpture's surface.

Coat the material with resin, then wait for the curing to finish before adding layers of glass fibre. It is sometimes advisable to add a final layer of resin. This technique of building up layers is known as 'laminating'.

Impregnating

Porous materials such as textiles can be impregnated with polyester to create rigid forms from flexible origins. This also transforms the textile into a structure that is weatherproof, freeing the artist to design and create outdoor textile sculptures with an extended life.

There are two simple methods of impregnating cloth: in method one the catalysed polyester resin is placed in a container,

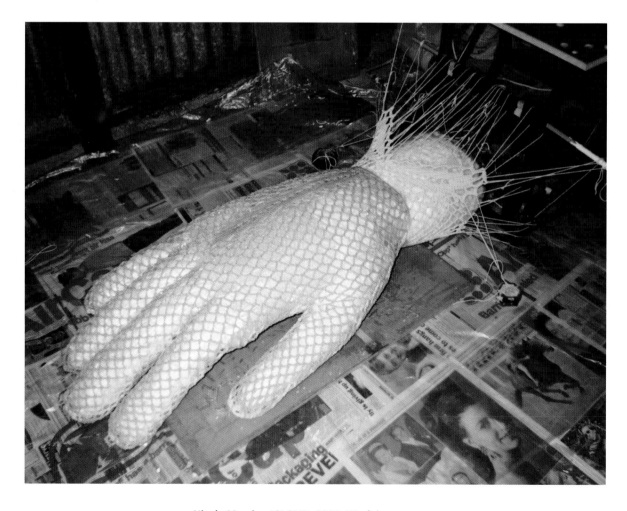

Nicola Morriss, 'GLOVE', 2002. Work in progress.
Materials: crocheted cotton impregnated with polyester resin.

and the cloth is immersed in it until saturation occurs. The saturated cloth should then be draped over an armature, or a temporary support, to achieve a specific shape, or it may just be manipulated into the desired form and allowed to harden.

In method two, the textile is arranged first and then painted with the catalysed polyester resin. Several coats may be needed to achieve the desired result.

Canvas, burlap, leather, card, wood, sponge, paper and other porous materials are suited to this technique. Textured surfaces can also be created by sprinkling particles of loose materials, such as sand, onto the hardening resin.

Special pigments, in opaque and translucent qualities, are available to colour the resin if desired.

For 'Glove', Nicola Morriss crocheted thick, dishcloth cotton on a large size hook to achieve a giant-sized glove. To make the sculpture rigid and weatherproof, she impregnated the yarn with polyester resin. Several coats of resin were required to build up sufficient strength in the material. The crocheted glove was stretched over a collapsible polythene form to maintain the shape of the glove whilst the resin was applied. The stuffing was removed, and the polythene casing taken away after the resin had set.

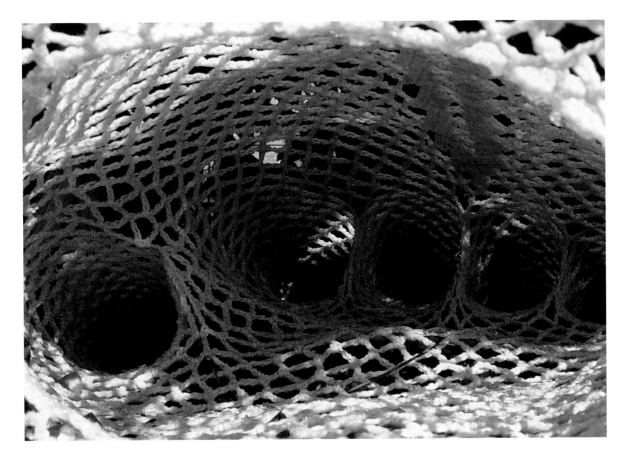

Nicola Morriss, 'GLOVE' (detail), 2002.

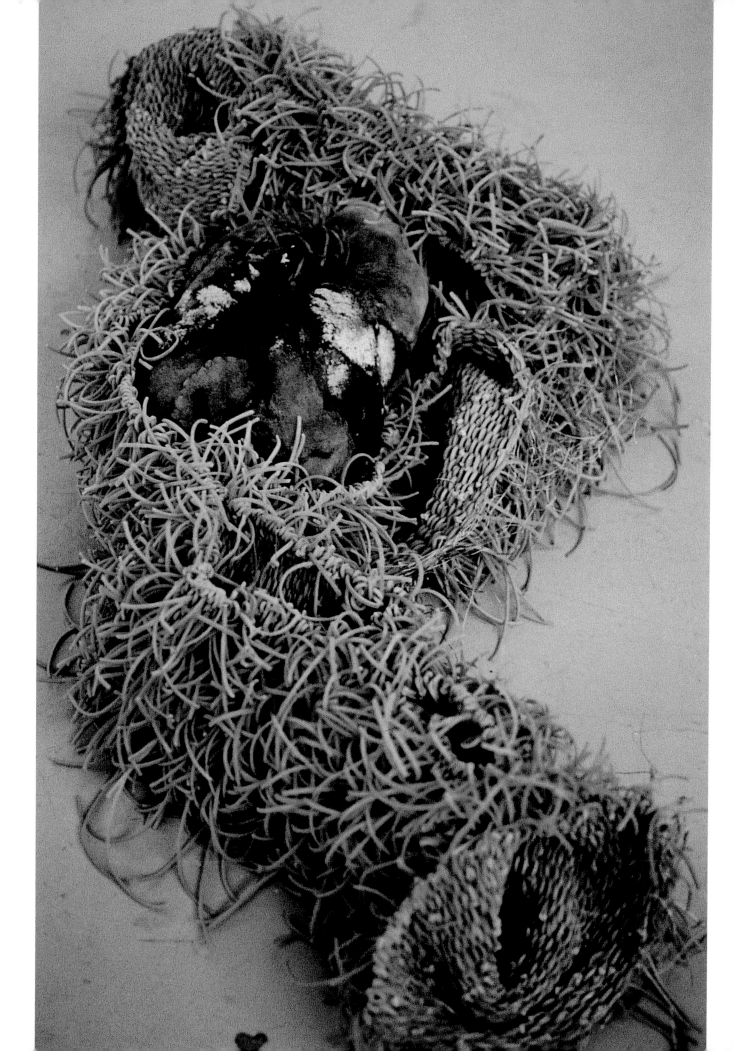

RUBBER

Rubber exudes notoriety: it presents an incredible paradox of revulsion and sensual pleasure. Haptic knowledge creates a tension between the material and the individual: reactions are usually clear and strident. Rubber's employers in the past have embraced a wide and confused cornucopia of uses: from tyres, to objects of perversity. This lacing of conceptual binding with the material creates a formidable power for the artist to exploit. However, few great art works are made of rubber, to be hallowed in the cathedrals of art collections, due to the inherent and problematic nature of early decay. Rubber's lack of longevity is an important issue that will be further discussed later in this chapter. For the artist, rubber possesses some unique qualities that can excite and challenge the practitioner. Its viscosity can be manipulated to produce a multitude of surfaces and forms. Traditionally used for mould making, it can easily be adapted to more adventurous applications.

Many sculptors have dabbled with the peculiarities of rubber over the years, including Louise Bourgeois and Bruce Nauman, but few have responded as Eva Hesse. Eva Hesse was a German-born American artist whose primary focus during the 1960s was a personal contribution to the Minimalist movement. Working on the periphery of the Minimalists' ethos, she embraced craft disciplines to create sculptures that exploited gravity, stress and deterioration. Her use of latex rubber with cloth allowed her to develop epidermal work with sensual qualities. Hesse's inquisitive nature regarding the potential of materials also led her to work with tubes, cords, surgical hoses, steel tubing, wires and textiles. She wrote in 1964: 'I want to be surprised, to find something new. I don't want to know the answer before, but I want an answer that can surprise' (Cooper, 1992).

The fragile nature of her work was a deliberate choice to nurture the concept of mortality, decay, contingency and flux. Her poor health and early death, at the age of thirty-four, can be viewed as profound indicators of why her preoccupations were with the transient nature of human life.

**Anniken Amundsen, 'FUNGATED SORE II', 1999.
Materials: rubber bands and metal wire. Dimensions: 150 × 30cm.**

Technical Information

Natural rubber was discovered about 400 years ago by Spanish explorers in South America. The natives were observed playing games with an elastic ball made from a liquid tapped from certain trees: the *Hevea brasiliensis* tree. There was a rubber shortage during World War II, and this led to the development of synthetic substitutes. The best known is neoprene, developed in 1931 by the DuPont Company.

Properties

Natural and synthetic rubber share similar properties; the main difference is that the natural product is softer and stickier. Latex refers to natural rubber when it is in a liquid state; however, it can be purchased in a formula that is ready for use (*see* Suppliers, page 153). Natural rubber is ideal for a wide range of applications. The latex consists of a mixture of rubber particles suspended in water, with antioxidants added to prolong its life. Latex has a heavy viscosity, which makes it easy to work with by pouring, dabbing or brushing. The rubber will cure at room temperature, and will benefit from some air movement to assist water evaporation. The curing process can be quickened through an increase in heat or through the use of accelerators. These can be purchased at any good art suppliers. If a delay in the drying time is required, then retarders are also available. Natural latex is a creamy colour, drying to a mucky mid-brown. Coloured rubber can be made easily by mixing in any water-based dye or paint to the latex. Stronger colours will last longer. Fillers can be added to alter the texture of the rubber. Note that air bubbles can be a problem, and should be popped by blowing or piercing.

When the rubber is fully cured it is a flexible material that is lightweight and waterproof. However, rubber should not be left outside, as the elements will quickly cause deterioration. Other properties include superior tear resistance, and an excellent ability to pick up fine detail from other objects and surfaces.

Working with Latex Rubber

Latex is a versatile substance with a wide range of applications. It can be used to create a textured material by picking up detail from a multitude of surfaces and objects, including clay, wood, metal, ceramics, bricks and plastics.

The condition of the object is important to the success of the outcome, therefore always clean the object or surface thoroughly, as any residue deposits will be absorbed into the rubber. Apply by dabbing, brushing or pouring a thin layer onto the surface/object: about 1–2mm is a good thickness. Allow to cure thoroughly between layers. The number of layers depends entirely on the desired end result: obviously the more that are applied, the thicker the rubber, and the stronger the material. Remove by peeling back the rubber or removing the form. A negative imprint of the surface/object will be created from the positive item.

Between layers always wash the applicator, or brush with soapy water. Using a wet brush with the latex makes removal of the latex easier after use. Nylon brushes are the easiest to clean. Dusting rubber with talcum powder will help remove any tackiness that can occur.

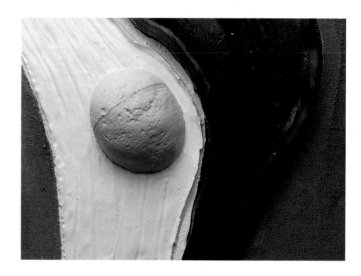

Jac Scott, 'SPIRIT OF THE FLOW – STONE DANCE' (detail), 2000. Composite wall relief (rubber formed in clay moulds). Materials: rubber, canvas, maximum density fibreboard (MDF) frame. Photographer: Andrew Morris.

Latex and Clay

Clay is an ideal mould-making material that is easy to manipulate to create intricate forms or detailed surfaces. Shape, form or texture the clay as desired, and allow it to become leather hard before applying the latex. If the clay is too moist or soft, the curing process will be delayed and may result in a weak rubber. It is advisable to build up thin layers of rubber gradually, rather than pouring on a thick pool: if the latex is too thick, an outer skin may form, with the result that the centre cannot cure properly. You can avoid this by applying thin layers. Also, make sure that each layer has fully cured before adding another, or coagulation may occur. Place the mould by a radiator, or use a fan or hairdryer to speed up the curing process. The rubber should come away easily from the clay mould. The mould will often crack and break during removal of the rubber, so if a duplicate is required be extra careful at this stage.

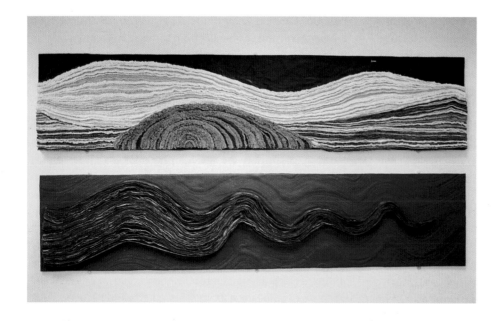

LEFT: Jac Scott, 'FROZEN RHYTHMS', 2002. Wall relief in two panels. Materials: rubber, textile waste on MDF frame. Photographer: Andrew Morris.

RIGHT: Jac Scott, 'SPIRIT OF THE FLOW – WRAPPED AIR', 2001. Materials: damask selvedges and rubber. Photographer: Andrew Morris.

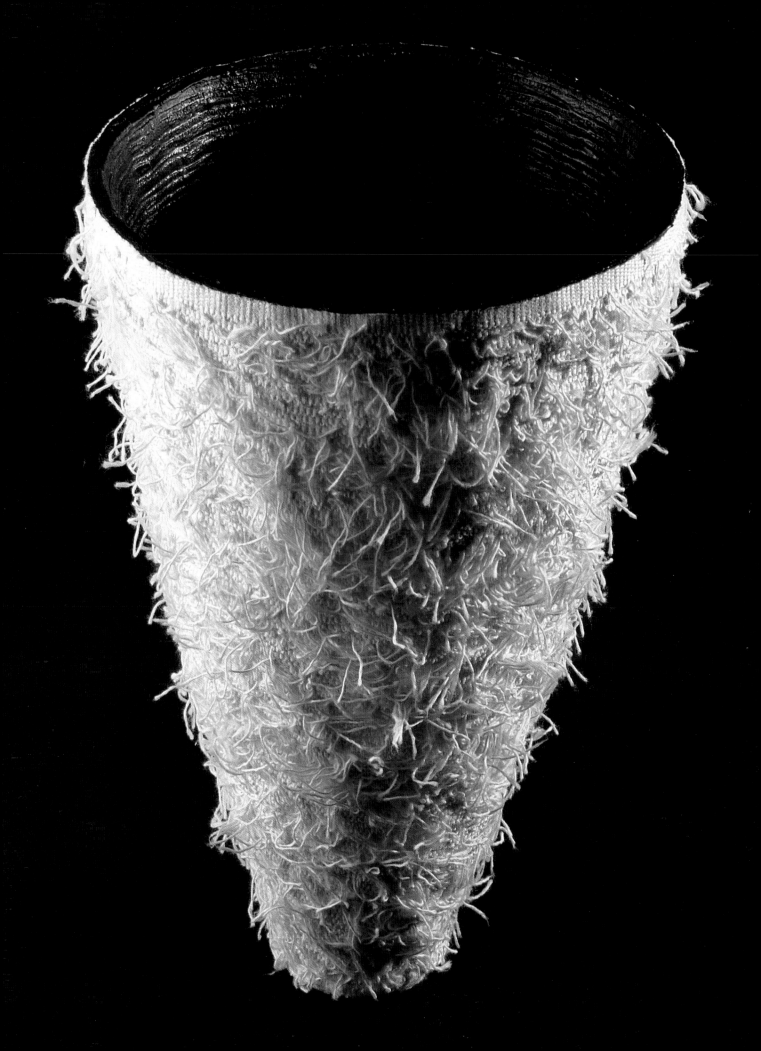

Cutting Rubber

Rubber in sheet form can be cut with a sharp craft knife, or thicker pieces with a bandsaw fitted with a coarse tooth blade. Chunks of rubber can be cut under tension with a knife lubricated with water and glycerine or soap. Holes can be drilled into rubber with an ordinary twist drill rotated at high speed; it is helpful to chill the rubber before this operation. A belt or disc sander can be used for shaping and finishing. Always keep the rubber part moving to avoid burning the surface, and do a final buffing on a cloth-buffing wheel with some rouge as an agent. The rubber will need washing afterwards in soap and water to remove the buffing compound.

Methods of Joining Rubber

Adhesives

Selection of the correct adhesive for joining rubber to another material is imperative. Some contact adhesives have been developed for this purpose, but require careful handling. Always refer to the instructions provided by the manufacturers.

Latex can be used as a self-adhesive for joining two pieces of rubber together, and as a substance for joining textiles.

'Wrapped Air' is a sculpture from a collection of work entitled 'Spirit of the Flow'. Latex was used in both the construction and the decoration of the piece. Inspiration for the collection came from abstracting the movements from studies of air and water currents. The energy released by these natural forces was captured in the movement within the work. Textile selvedges, from factory waste, echo the spiralling air currents of tornados. The selvedges have highly textured edges which, when placed in close proximity to each other, metamorphose into a completely new surface. Latex holds each spiral in place. Several 'skins' of latex are then applied to the non-textured surface. When cured, this acts as both an aesthetic contrast to the textiles, and a necessary constructional element to the sculpture.

'Frozen Rhythms' was inspired by the surrounding landscape of the library where this commission was installed. It was made by placing textile strips, on edge, into coloured latex. When the latex cured, it held the textile firmly in place and thus created a wall relief.

Mechanical Linkage

Many artists join sheet rubber with devices that form an element vital not only to the construction of the sculpture, but also to its decorative qualities. Two sculptors who choose rubber as their

base material with decorative and constructional mechanical links are Sarah Crawford and Wanda Zyborska.

Quirky imagery and vivid colours are hallmarks of Sarah Crawford's work. Her exuberance at manipulating traditional textile techniques in less conventional materials makes tactile sheet rubber an obvious choice. Her haptic sensibilities are integral to her practice, while the exploration of pattern is fundamental to her approach. Folding, pleating and smocking are employed to great effect with manufactured sheet rubber. Its vibrant colours and softness make it easy to pleat. Working from the centre outwards, she builds up the form, never disguising constructional elements

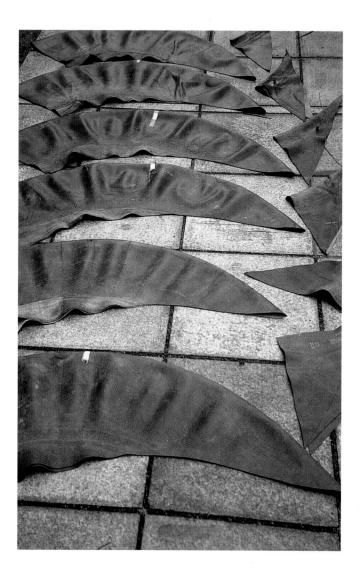

Wanda Zyborska, pattern-cutting from rubber inner tubes from tractor tyres.

RIGHT: **Wanda Zyborska, 'EGG' (performance 3 in woodland), 2001. Materials: rubber, wing nuts and galvanized rod. Dimensions: diameter approximately 1m. Photographer: Stephen Filipski.**

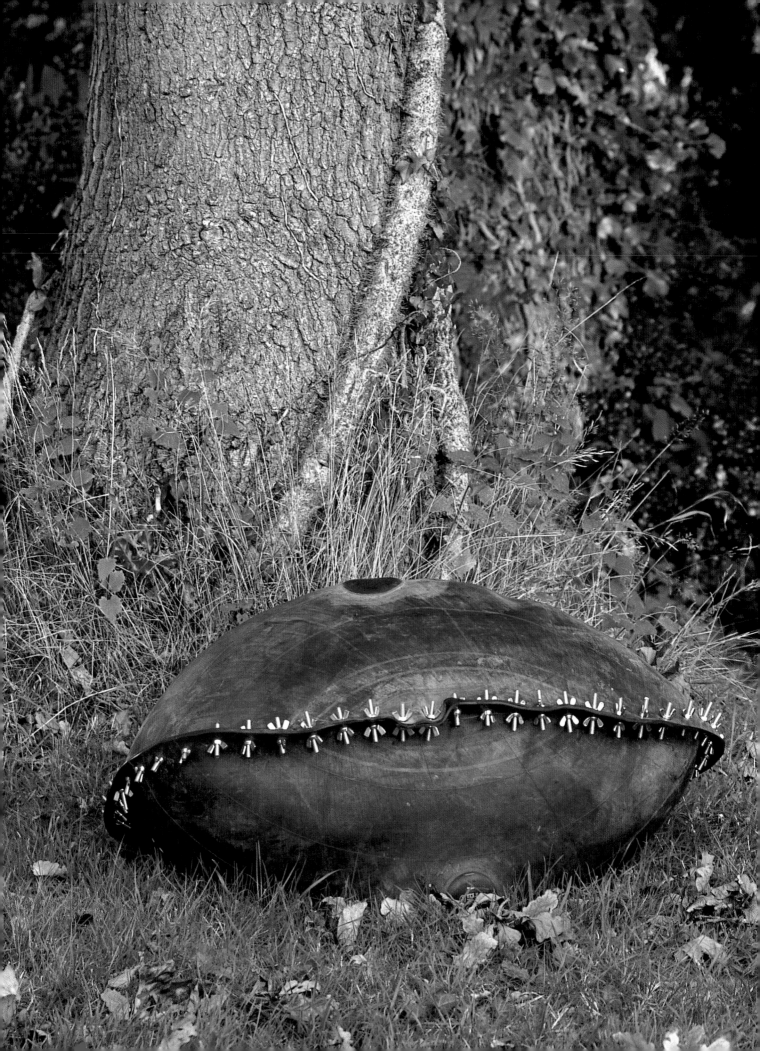

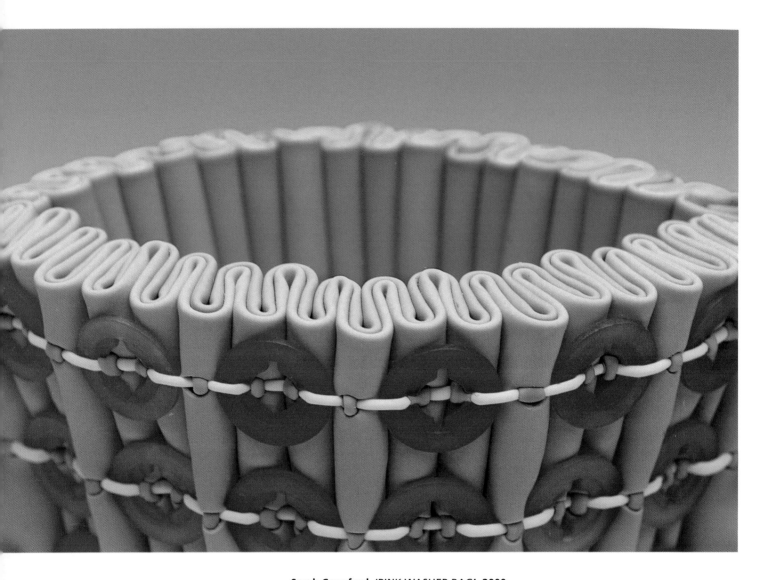

Sarah Crawford, 'PINK WASHER BAG', 2000.
Materials: detail shows punched and pleated rubber sheet
with elastic fishing line, dyed nylon washers, and PVC cord. Photographer: Richard Stroud.

and joins, but instead exploiting their decorative qualities. Wanda Zyborska's powerful rubber sculptures confront boundaries between genders. Her choice of recycling rubber tractor inner tubes, complete with patches, complemented with further masculine accessories, such as nuts and bolts, are used in the traditionally feminine pastime of 'stitching' the parts together.

Deterioration

Natural rubber is an impermanent material: a life of up to ten years can be expected, but only if the correct conditions are maintained. For instance, the rubber should be kept in cool, dark conditions, avoiding natural sunlight and direct heat. Ultraviolet light quickly causes the material to break down, making it brown and brittle. All solvents should be avoided, and only basic soap and water should be used to clean it. Avoid contact with oil, grease and other petroleum products, as these are very destructive. The presence of copper or manganese will also shorten its life, as will extended periods of dampness, or temperatures above 82°C (180°F).

HEALTH AND SAFETY

Latex is not a pleasant substance to work with, and due consideration to health and safety is essential. Follow the points below for safe practice.

- Good ventilation is essential, especially when opening containers of latex, because the odour is ammoniacal, it can cause eye sensitivity and headaches. Avoid inhaling vapours for long periods. Extraction fans are desirable.

- Replace the lid of the containers as soon as possible, as latex starts to cure on contact with the air. Keep containers closed tightly when not in use.

- If a skin forms inside the container remove it before use.

- Storage: protect containers and cured rubber from frost and direct sunlight.

- Latex represents a low fire hazard as it is a water-based product. All extinguishing media are suitable in the event of combustion. However, sensible precautions are necessary, so do not smoke or strike matches near open containers.

- Hand protection is advisable for prolonged contact with latex. Otherwise, wash it off the skin promptly with soapy water, as it can cause irritation.

- Eye protection is recommended. If latex does contact the eye, wash it out with plenty of water for at least fifteen minutes, and seek medical attention.

- Ingestion of latex may cause nausea: give plenty of water to drink, and seek medical attention.

- Wear old clothes, as latex is extremely difficult to remove when in contact with textiles.

- Prevent latex entering watercourses and drains. Absorb spillages with sand.

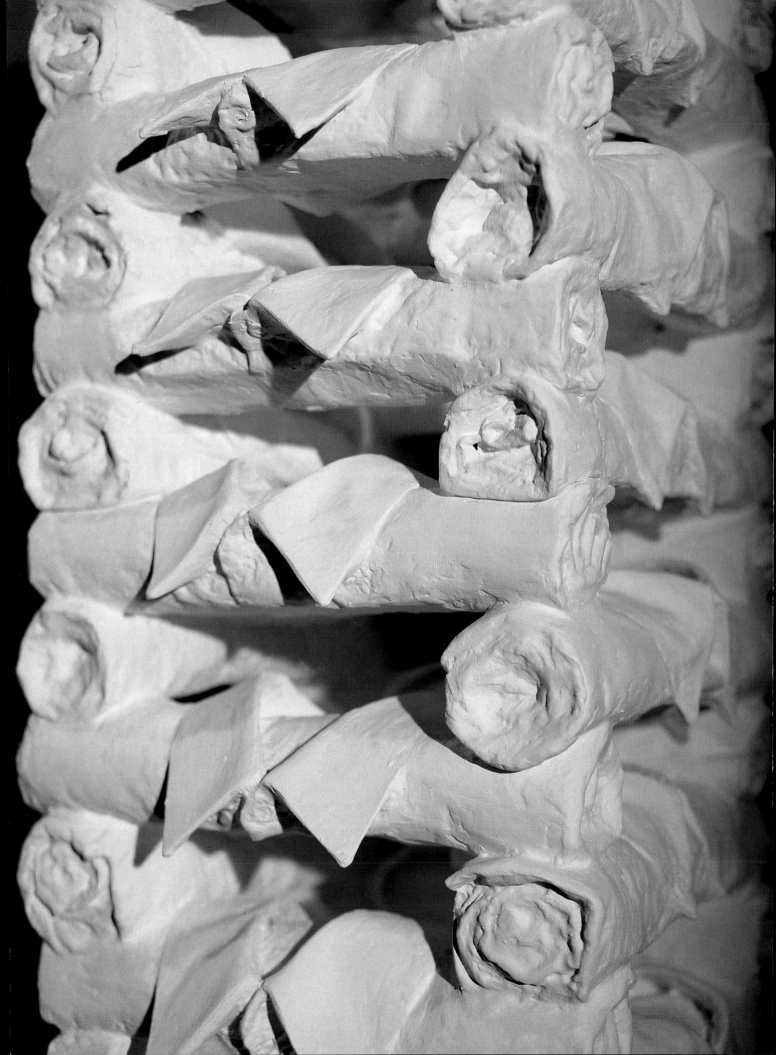

PLASTER

Plaster is an amazing material that is invaluable to the sculptor. Historically it is viewed as an intermediary substance that is suitable for mould-making for other materials to be cast. However, in this chapter we challenge this assumption, to provoke awareness of its application as a first material when used in combination with others. This mixed-media approach fully embraces the fragile nature of plaster, and utilizes other matter to engage the plaster in a more positive role. It is not a material that is suitable for outside installation, and generally it needs reinforcement in some manner to provide adequate integrity. The immediacy of the substance makes it a dynamic material to work with, which can create an energy around and within the work that is attractive to sculptors. This chapter focuses on the general nature and working processes with plaster, with an emphasis on applications linked with textiles. This marriage of materials celebrates the soft/hard dichotomy that entrances many practitioners.

Plaster is an ancient material that can be traced back to early civilizations, but because of the soft nature of the material, which deteriorates in damp conditions, examples have not survived. Early Mediterranean cultures show evidence of understanding techniques using gypsum, but actual samples have long since perished. The first records of mould-making date from an Italian potter's manual of 1554. Architecturally, decorative plasterwork became the fashion in the eighteenth century. In statuary, indoor sculptures with religious significance have been made for hundreds of years. Often richly painted and inevitably chipped over time, the statues represent theological icons.

Claes Oldenburg worked in the 1960s on sculptures that exploited scale and material inspired by commonplace objects. He created gigantic parodies with a mixed-media palette: plaster, textiles and plastics. His works may be considered as monuments to everyday life. They opened up new ways for questioning the banal, and also the employment of new materials. He describes his approach in a debate about materials on a New York radio show in 1964, moderated by Bruce Blaser, with Roy Lichtenstein and Andy Warhol. Oldenburg's attitude is captured in this statement, made during the broadcast and later printed in *Artforum*:

> In fact, that is one way to view the history of art, in terms of material. For example, because my material is different from paint and canvas, or marble and bronze, it demands different images and it produces different results. To make my paint more concrete, to make it come out, I use plaster under it. When that doesn't satisfy me, I translate the plaster into vinyl, which enables me to push it around. The fact that I wanted to see something flying in the wind made me make a piece of clothing, or the fact I wanted to make something flow made me make an ice cream cone.
> (*Artforum*, 1966)

A notable contemporary sculptor, Rachel Whiteread, casts with plaster, concrete, resin and rubber the negative spaces between familiar objects. Fiona Bradley, in her introduction for Whiteread's catalogue *Shedding Life*, encapsulates her work in words:

> Rachel Whiteread's sculptures solidify space. Casting directly from known, familiar objects, the artist makes manifest the spaces in, under, on or between things. Her casts, in plaster, rubber and resin, have a strong material presence: they hold and occupy space, speaking to the viewer and to each other of the domestic landmarks of human experience.
> (Bradley, 1996)

Sculptures by Mary Cozens-Walker, Belma Lugic, Gemma Smith and myself all employ plaster as a first material mixed with other matter, for our finished pieces. Understanding plaster's foibles, and working with these, is the key to its success as a sculptural material.

Jac Scott, 'OFFICE BLOCK' (detail), 2002.
Materials: plaster, recycled office workers' shirts, plaster sealant, paint.
Dimensions: 166 × 38 × 36cm.
Photographer: Rachel Elliot.

Technical Information

Properties

Plaster has distinct peculiarities that both limit and challenge the creative mind; however, this plurality of office can be nullified once the nature of plaster is fully comprehended. Its advantage is its ability to provide a smooth surface without lumps, grains or knots, thereby offering greater freedom for creative expression. There are several formulas of plaster manufactured, the most common being builder's plaster, which is used for applying to walls in buildings. This type is of little use to the sculptor, whereas fine casting plaster, employed by the building trade and antique restorers for making architectural mouldings and cornices, is an essential material. Dental plaster, as the name implies, is traditionally used by dental technicians: it is a finer powder, and creates an outcome that is denser, and with a stronger finish; but it is more expensive. Plaster of Paris is often regarded as a workhorse in sculpture, equal to clay, as its traditional role is of an intermediary material, due to its fragile nature, in preference to more robust matter.

Plaster is made from the common mineral gypsum, a crystalline solid composed of hydrated calcium sulphate, which occurs widely and naturally. When heated and ground, this white mineral becomes a fine powder; and when this powder is mixed with water, it recrystallizes to make a solid, and thus returns to a mass similar to that of its original state.

Sculpture made solely from plaster is unsuitable for exterior installation. The material is porous and fragile, and therefore likely to deteriorate rapidly in the outside environment. This is illustrated by the gift of some plaster sculptures by the revered sculptor Henry Moore to the Ontario Museum of Fine Art in Canada. The work included some master casts that were treated with coatings of white shellac to resemble ivory or bone – but they only lasted a couple of years outside. The brittle nature of dry plaster can be improved by the addition of a reinforcement material such as jute, scrim, burlap, hemp or gauze. This concept of transforming the plaster through the employment of textile inspired the process of fabric manipulation, discussed later in this chapter.

Mary Cozens-Walker, 'DINNER DANCE', 2001. Materials: plaster and papier-mâché head and torso, painted with acrylic paints with embroidered, heavy brocade skirt, jewels on wooden stand. Dimensions: 130 × 41 × 41cm. Photographer: Reeve Photography.

Working with Plaster

Basic Mixing Directions

Mixing plaster is a basic skill that can be quickly acquired through practice. It is a useful skill for the sculptor in many ways, not only for its traditional role in mould-making, but also in relief work and sculpture in the final piece. The most important consideration is the immediacy of the process, and therefore adequate preparation should be made.

Plaster is made by judgement, rather than by weighed ingredients, but for a general guideline the normal proportions of water and plaster are roughly equal parts. Pour clean water into a container, allowing enough capacity for the plaster to expand the volume – avoid filling containers with water to the rim. Sprinkle the plaster carefully onto the water to avoid lumps: do not throw large quantities of plaster in at once, or the mix will be lumpy. Continue sprinkling until the powder rises from the

base of the container, just breaking the surface of the water and appearing as small islands. At this point the mix can either be left for a minute or two, or be stirred efficiently to an even, opaque, creamy consistency: this stirring encourages the plaster to set more quickly.

The process of mixing plaster, by its very nature, incorporates air into the mix, and it is vital to remove this air before setting. Tap the sides of the container to dislodge any air bubbles.

Use the plaster as desired, remembering that the setting time, when the plaster 'goes off', is about five to ten minutes, depending on atmospheric conditions, the temperature of the water, and the amount of plaster used. Tap the sides of the mould to dislodge any air pockets before the plaster 'goes off'. During the final stages of setting the material gives off heat: this is an exothermic chemical reaction. Once set, the plaster will return to a cold state, and will continue to dry and harden. Air-dry the plaster in a well-ventilated space. The time required for drying will be dictated by the size of the piece and the atmospheric conditions of the room. The pink pallor of the wet plaster will gradually fade to a soft white when thoroughly dry; this colour change can be read as a true indication of the state of the plaster.

A brief delay in the setting time can be achieved by using iced water in the container. Citric acid (5 per cent solution) or decorator's size (wallpaper glue: 5–10 per cent solution) will also slow the setting time, but this should only be used carefully: experimentation is necessary, and by the experienced, as the consistency of the plaster is altered and can easily be unworkable if miscalculated.

Accelerating the setting time is possible by using hot water, or by adding some sodium chloride (common salt) or Portland Cement to the mix.

Mary Cozens-Walker developed the 'Dinner Dance' sculpture from a papier-mâché base covered with plaster that was modelled to the form and painted with acrylics. The heavy brocade skirt was embellished with machine embroidery and joined to the torso. The inspiration for the sculpture was her own mother's glamorous appearances at such formal social occasions as dinner dances in the 1950s.

Cleaning Up

Cleaning up after plaster operations is a tedious but very necessary process. It is imperative that any plaster residue is scrupulously cleaned off equipment and tools, as anything left remaining will make the next mix 'go off' more quickly. A green scourer is a useful cleaning device, and copious amounts of clean water and scrubbing will get most tools clean. The secret to getting mixing containers clean easily is to wait until the waste plaster has set firm, is cold to the touch, but is not hard. The plaster should fall out of the bottom of the container when tapped hard; sometimes it is necessary to hit the base with a hammer to dis-

HEALTH AND SAFETY

Because working with plaster is a messy operation, some important health and safety points need to be considered.

▓ Wear old or protective clothing.

▓ Wear a dust mask for measuring and mixing plaster to reduce the amount of dust inhaled, as deposits can irritate the respiratory system.

▓ Eye protection is strongly advised when carving or cutting the plaster. It may also be appropriate for working on suspended sculptures.

▓ Always work in a well ventilated area.

▓ Avoid prolonged contact with the skin, as it may cause irritation – wear rubber gloves when handling wet plaster. Wash dry plaster off with water in a bucket.

▓ Avoid ingestion of plaster, and always wash hands before touching food.

▓ Follow sensible practice with water.

lodge it. Never pour plaster remains down a sink or drain as it will rapidly solidify and block the outflow, and repair to the damaged pipe is drastic, as the blocked section has to be cut out. Waste plaster cannot be recycled, so always put it in a refuse bin.

Working with plaster is a very messy business, and it is therefore advisable to protect floors and tables with plastic sheeting. The plastic can be easily cleaned, as the plaster will just fall off once it is set. Plaster has a short working life, so once a bag is opened it will soon deteriorate – depending on atmospheric conditions, one to three months' lifespan can be expected.

Belma Lugic has an innovative way of applying plaster to boards in a manner similar to paint. Using acetate stencils and brushes, she gradually builds up layers of plaster in textile patterns further embellished with stitches of wool.

Finishing Plaster

When plaster is thoroughly dried out it can be further treated by working on the surface of the form with a variety of specially designed tools, such as chisels, gouges and scrapers. Traditionally plaster is carved and tooled. A smoother surface can be

Belma Lugic, 'MIGRATION', 2001. Work in progress. Materials: plaster, plasterboard, wool.

achieved by rubbing the plaster with graduated coarseness of sandpaper. Plaster repairs can be made by pre-wetting the area and then applying a firm mix of new plaster; note that this repair plaster will set very quickly when it comes in contact with the old plaster.

Set plaster is an absorbent material that will thirstily drink up paint if this is applied directly. It is therefore advisable to apply a sealant: a mix of PVA adhesive and water, or a proprietary-brand sealant specially made for the purpose, will bring satisfactory results. If paint is applied directly to the plaster then the paint absorption rate is higher. Aerosol paints spray a fine mist over the plaster – this can be a fast solution to intricate details

and difficult corners, but will require multiple coats to ensure an even distribution of paint over the surface. Applying paint by brush is tedious but tends to be cheaper than using aerosols, and offers more control. Most paints are suitable, with emulsion and acrylic producing good results.

RIGHT: Jac Scott, 'ECHO OF THE LOST SOULS', 2001.
Materials; plaster, cotton cloth, acrylic paint.
Dimensions: 153 × 145 × 95cm.
Photographer: Andrew Morris.

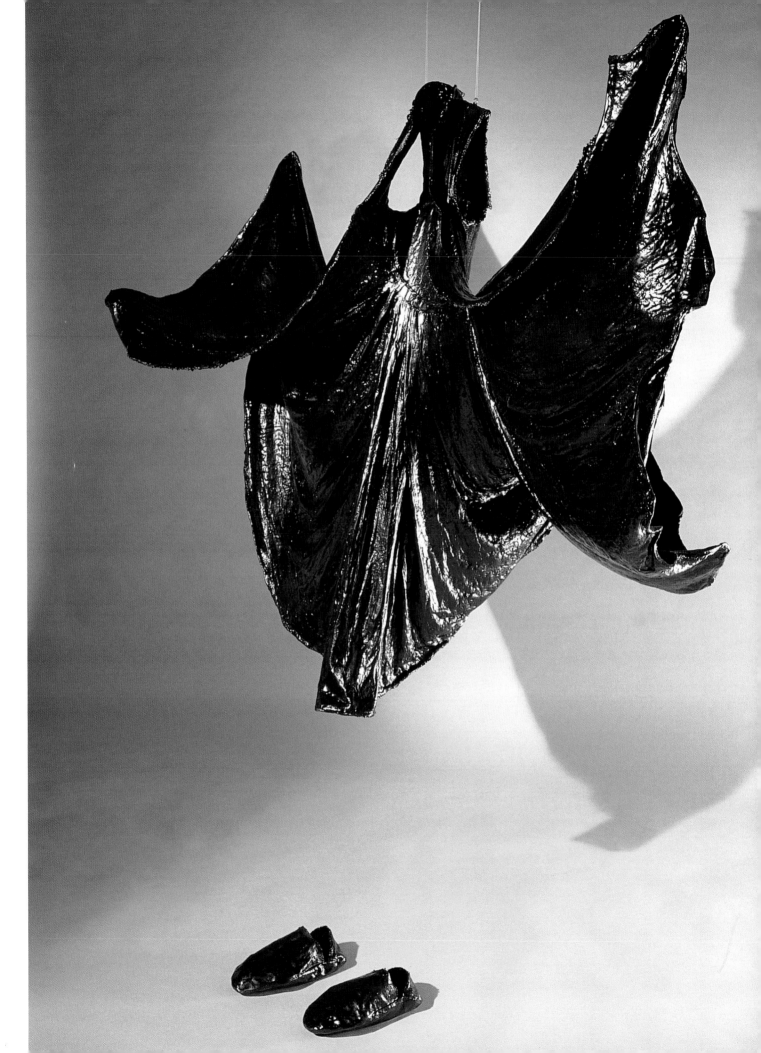

The sculpture 'Echo of Lost Souls' was made from cotton soaked in plaster, then polychromed with spray and pot paints. It was developed in response to the Edith Durham Collection at the Bankfield Museum in Halifax. A pattern from a traditional Albanian garment, a *giubba*, and a pair of shoes was transposed to cloth and transformed through petrification in plaster to form a suspended sculpture. The cut of the *giubba* formed a funereal black garment devoid of decoration and without the distraction of embellishment, to focus attention on the concept: the atrocity of genocide, which the sculpture commemorated. The absence of a bodily form intensified the emotions in this memorial. (*See* 'Fabric manipulation', below, for more information about this process.)

Plaster can be coloured before mixing by the addition of powder paint to the dry plaster powder. This additive can affect the setting time.

Special effects can be achieved on the plaster surface by using a drybrush technique, or by applying paint and then wiping it off with a cloth. This technique will emphasize the texture of the plaster, picking out the indentations and crevices. The result is a layered paint effect that creates depth in the surface. Polychroming plaster also adds a protective barrier to the sculpture. Protection can also be achieved through applying a latex coating to the plaster, which dries to form a rubber skin, changing the tactile qualities of the material to that of one with epidermal characteristics.

Fabric Manipulation

The fragile, porous nature of plaster, and its need to be reinforced through the employment of a textile content, inspired the development of a process that exploited this concept to the full. The additional play with texture and the manipulation of the soft/hard dichotomy that the process presented, was another attraction. The addition of the high fabric content not only strengthens the form, but also allows a flexibility that permits the design and creation of more flowing forms. The method is not without its problems, and it would be untrue to say that the resultant sculpture is not fragile – it is still prone to damage if abused. However, by following the correct procedure, dynamic forms can result, with an immediacy that excites the maker. But adequate preparation is essential for a successful outcome.

Mix the plaster in the normal way, submerging the textile into the mix, and carefully ensuring the plaster is uniformly saturated throughout the cloth. The new textile will be transformed from a lightweight, flexible cloth to a wet, heavy, sticky material that should be placed into the desired position quickly. Adequate preparation is essential, so experimenting with how the cloth is to be positioned will save valuable time, and is more likely to lead to a successful outcome. The employment of armatures and stands can be useful, but these require construction before saturation takes place. Plastic constructions can be ideal for acting as temporary props, the plastic easily peeling away from the plaster after it 'goes off'. Most textiles will respond to this process, but generally synthetics, by their nature, absorb less plaster and therefore the plaster may just sit on the surface of the cloth and break off when set. Cottons and loose-weave fabrics can produce exciting results.

Sanding and scraping the surface of the plaster before sealing it should always be undertaken carefully as the textile can easily be damaged if roughly treated. Avoid using rasps, as these might tear away at the surface.

RIGHT: **Jac Scott, 'PIROUETTE', 2002.**
Materials: plaster, recycled cotton cardigan.
Photographer: Andrew Morris.

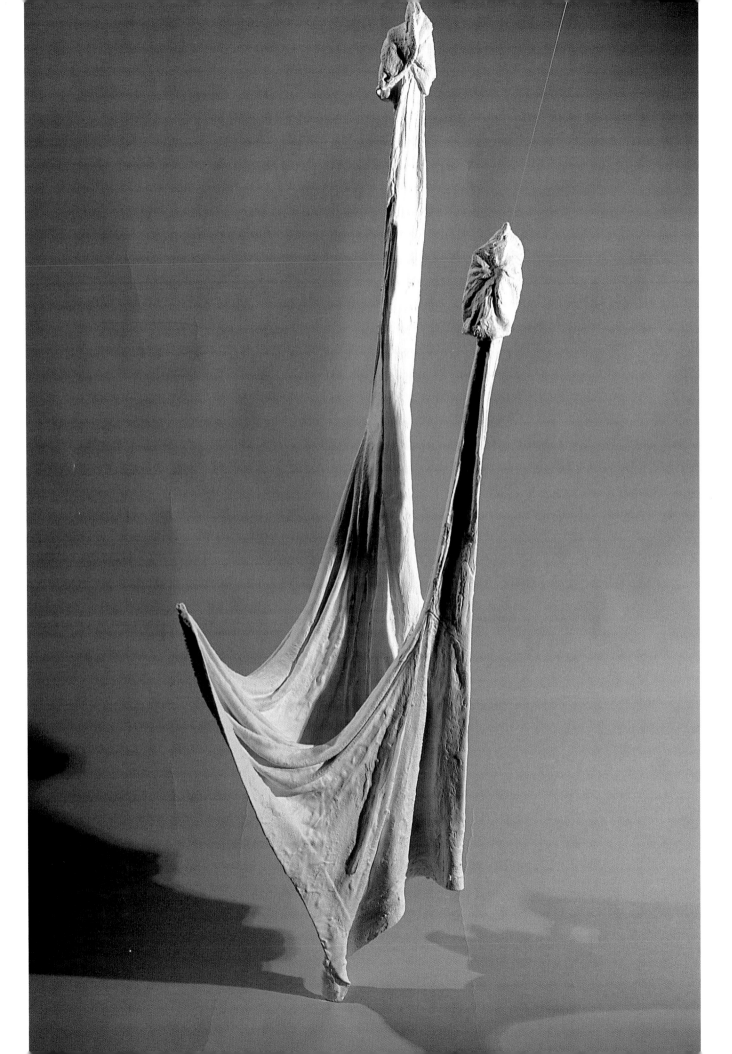

CHAPTER 6

METAL

In the last century, metal became a primary sculptural material with the particular growth of welded steel, due to the development of the oxyacetylene process. Both Pablo Picasso and Julio Gonzalez contributed to the advancement of the use of the process. Today, the striking work of contemporary exponents, Antony Caro and Antony Gormley, fully expound the process's virtues.

The engagement with metal widened considerably in the 1940s with Alexander Calder creating elegant structures using metal rods – 'Red Polygons' made in 1949 is a classic example. Calder considered these works to be spatial diagrams. Fausto Melotti delighted in building constructions of wire that encapsulated a poise and humour of abstracted characters he was portraying; 'Tightrope Walkers' from 1968 is a perfect example of Melotti's work with wire. During the years of the Bauhaus School in Germany there was an ethos of embracing a wide range of materials including glass, plastic, textile and metal in sculpture and architecture. This opening up to other material possibilities gradually led to a wider change during the 1960s, in the acceptance of all materials in sculpture.

The appropriation of mixed media into the treasure trove of accepted sculptural materials has evolved gradually; indeed, the combination of metal and textile in successful marriages has followed a winding path. The journey of such cohabitants has not been straightforward, as the background to one very famous sculpture illustrates: Edgar Degas' 'Little Dancer Aged Fourteen' was modelled in polychromed wax in 1881. The clothes the dancer wore were real, and so was her hair. Degas painted the clothes with thick oil paint. The sculpture was originally displayed in a glass case at the Sixth Impressionist Exhibition in 1881. The point about display is pertinent, as many 'soft sculptures' have deteriorated over time – and this particular example was no exception. It was decided to preserve the sculpture by casting it in bronze in 1922, poignantly after Degas' death, the textile content of the sculpture being replicated and added afterwards. What Degas had intended for the work is unclear, as his bequest included the piece. Interestingly, Degas held a lowly estimation of his own sculpture, and refused to have them cast in bronze in his lifetime. His decision to exhibit a wax and textile sculpture would have been considered challenging for the time. Tom Flynn in his commentary on the 'Little Dancer Aged Fourteen' sculpture writes:

> Degas' introduction of diverse materials marked a seminal moment in the development of modern sculpture, its introduction of organic components denying easy classification and thereby troubling the critics. The defying of the 'proper' boundaries between substances went on to inform much contemporary art.
> (Heuman, 1999)

If you trawl through the history of metal sculpture you would occasionally be able to pick out the works that contain elements of textile content or technique, such as Barbara Hepworth's pierced forms with stitched and tensioned strings. It is perhaps easier to understand the relationships between the two materials and to appreciate their long involvement through archaeology and the history of jewellery. There are examples of ancient garments, artefacts and jewellery in metal made using techniques that today we associate with textiles. This historical reference stabilizes the concept, especially when it is understood that this practice was across continents and civilizations.

The environment of the twenty-first century abounds with samples of this combination. In the domestic arena wire is fashioned using weaving, crocheting or knotting techniques into shopping bags, lampshades and furnishings. More industrial appropriations include the interlacing of wire for fencing, braiding into industrial-grade ropes, and many other applications.

Metal may be considered by some to be a bizarre material to include in any publication that may be of interest to those who work in cloth, whether in two or three dimensions. It is imperative to recognize the place of these materials in such a book, in order to appreciate that even one of the 'heavy brigade' of

Helen Weston, 'JACK AND JILL' and 'GOOSEY, GOOSEY, GANDER', 2000. Wall sculptures.
Materials: aluminium, brass, wire, monofilament. Dimensions: rod outreach 1.2m, height 1.2–1.5m.

sculptural materials can be employed by mixed-media sculptors to dramatic effect when innovative techniques are applied.

This book is different to others, and its underlying aim is not only to illustrate the exciting dynamics between various creative disciplines and to show how they all intertwine, but also to stimulate the debate that the enforcement of such boundaries and categories is restricting artistic endeavour. Therefore this book has been researched with the explicit aim that the only boundaries to an individual artist's practice are those set usually by outsiders for their convenience. Consequently, what may at first glance appear to be a disparate collection of artists, is in fact a strong, cohesive movement that forces the complacent to re-address what has become familiar. The following chapter will illustrate through technique and example how this philosophy is working in practice in metal.

Technical Information

There are three methods of working with metal that are traditionally associated with sculpture. The classic method is by casting molten metals; another popular method involves making components such as sheets, bars, plates and rods, these often being treated to a subsequent hammering and heating – thus forming wrought-iron objects. Repoussé is the third method, which involves hammering thin sheets into complex three-dimensional forms.

The artists in this book have an alternative approach to working with metal, and often opt to transform readily available metal forms into their sculptures. The properties of metal enable the artists not only to exploit the soft/hard dichotomy with textiles, but also to utilize the strength and rigidity that is inherent

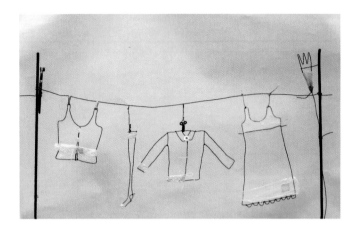

Jayne Lennard, 'WASHING LINE IN PARADISE', 2001.
Materials: wire, textile scraps, pegs.
Dimensions: 61 × 51 × 15cm.

in the material. Metal forms an ideal material to work with for the creation of sculptural forms with a mixed-media approach. From a structural viewpoint it can provide the supporting framework for other softer materials, and as a visible component it can make possible what would otherwise be a flimsy creation. Wire has become particularly utilized, as its pliable nature, when used in the finer gauges, makes it ideal for numerous applications. Some of the artists are drawn to metals whose appearance they can change through the application of further processes involving chemicals or through the use of heat. This strong desire to work on the surface texture of the metal probably stems from their textile background, which encourages close examination and manipulation of the surface of materials.

With the broadening remit of many educational establishments to view textile practice from a mixed-media approach, it is no wonder that metal has been brought into the fold of acceptable materials. The artists featured in this book, who incorporate metal in their sculptures, provide a clear affirmation as to the success of this approach. The three-dimensional approaches that are pertinent include borrowing techniques of building form with metal from traditional basketry sources; weaving and crocheting with linear materials; utilizing wire to create sculptural drawings in the air; and adapting traditional methods of working with sheet materials to engage with textiles. These ways of working will be discussed in the following chapter.

Properties

Metals are usually classified as ferrous or non-ferrous. Ferrous metals are those containing iron, which include, from the sculptor's perspective, steel, wrought iron and cast iron. Non-ferrous

metals are copper, brass, tin and bronze. Many metals are actually alloys or composites, such as bronze, which contains copper and tin, and brass, which has copper and zinc in its make-up.

Consideration of the varying properties of different metals is vital for a successful outcome in sculpture: it is important to ascertain the malleability and strength of a metal in order to determine its suitability. 'Malleability' refers to a metal that can be manipulated, and in particular how long it can be manipulated before it breaks; whereas 'strength' means its ability to withstand stress and maintain its shape. There is a variable breaking point in metals; for instance, some have a tendency to weaken gradually as they are compressed and expanded, while others deteriorate slowly due to atmospheric conditions or through age. Some metals will only be fashioned into a form if pinned on a board or restrained in some way, but once released they lose their shape; others are rigid enough to maintain the dictated form.

COPPER

Copper is a metal favoured by artists for a variety of reasons, including malleability, availability and price. Commercial copper is an almost pure metal that is easy to manipulate: a fine-gauge copper wire is adaptable for weaving or crocheting; copper piping can be employed as an armature or a visible structure; and copper sheeting can be used in a myriad of ways. Of all the metals, copper is probably the material that is least expensive; it is also readily available from plumbing and metal merchants, handicraft suppliers, sculptor's resource outlets and do-it-yourself shops. Obviously not all types of copper are accessible at every outlet; for example, fine copper wire or thread for weaving small-scale sculptures or stitching may need to be resourced at specialist handicraft shops. Generally speaking, copper, in whatever form, will be more reasonably priced at plumbing and metal merchants rather than at art suppliers; however, this good news usually means a larger quantity of material may need to be purchased.

Carole Andrews has been fortunate to acquire commercial sponsors for her work: D. Anderson and Son. The company manufactures different types of roofing felts, including copper and aluminium. Andrews finds that her gigantic sculptures, often measuring over 2m high, use a considerable amount of material, and without her sponsors she would struggle financially to produce such large-scale work. For 'Poise', Andrews bent lengths of copper to form a basic structure that she then smocked over with roofing felt and nylon stitches. This was a divergence from her usual approach, which concealed the framework under the surface, thereby forming a traditional armature.

Copper sheet is available in three different states: hard, half-hard and soft. The hardness is linked with annealing and rolling.

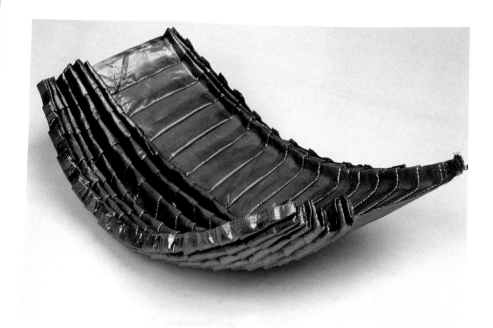

Caroline Murphy, untitled, 2001.
Materials: pleated copper sheets,
metallic chiffon, wire form, bondaweb.
Dimensions: 30 × 22cm.

The sheet is manufactured in gauges eighteen to thirty-six, with the thinner gauges (twenty-eight to thirty-six) being exceptionally soft and easy to cut with scissors. Thin copper is also available on the roll.

Caroline Murphy uses copper sheet as an armature for her pleated sculptures. She attaches luxurious materials such as leather, velvet and metallic chiffons and silks with 'Bondaweb' to the metal while it is flat, and then folds the new laminate to form pleats. The contrast in texture creates a powerful visual and tactile dynamic, which echoes her original inspiration – leaf forms.

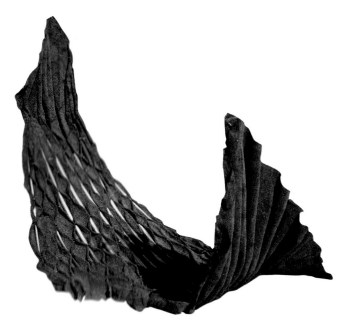

Carole Andrews, 'POISE', 2000.
Materials: smocked roofing felt,
copper piping and nylon stitches.
Dimensions: 60 × 40 × 30cm.

BRASS

Brass is a composite metal made from copper and zinc, and consequently it is quite malleable. One of its attractive qualities is the variance in tone. The strong yellow brass has a high zinc content that makes it malleable, with a low annealing temperature. This metal is particularly suitable for cutting into strips and weaving. Its strength means that it is highly suitable for use as a framework. Brass fittings and joining mechanisms often appear decorative in nature, as the colour draws attention to the eye. Brass wire has a long history of being used for picture hanging. It is available at ironmongers or craft outlets in the form of small coils or on spools; it is generally quite expensive.

ALUMINIUM

Aluminium sheet is ideal for large sculptural pieces where a body of metal is required to make a statement structurally and visibly. Its lightweight, malleable nature and resistance to corrosion make it eminently suitable for a variety of applications. Helen Weston adopts this approach to stunning effect, achieving striking sculptural forms made from sheet aluminium or steel. She purposefully chooses to use what may be called historically industrial materials, to question domestic structures. For instance, in 'Familial

Disjuncture', Weston married aluminium, steel, fibre and wire together to powerful result.

'Spirit of the Flow – Ripple': in this wall-based relief, the shape of the work was defined with strips cut from sheet aluminium. These strips formed the edge of the sculpture, and were determined by making a mock-up out of cardboard. A metal fabricator replicated it in aluminium. Holes were pre-drilled into the metal ready to receive the wire stitches that held the body of the textiles together.

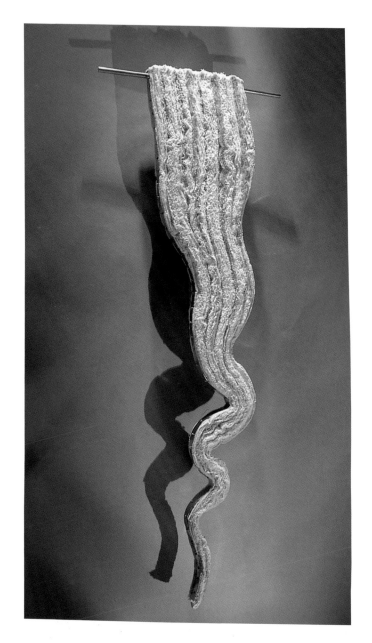

Jac Scott, 'SPIRIT OF THE FLOW – RIPPLE', 2000.
Materials: waste textile selvedge,
aluminium sheet, rod and wire.
Dimensions: 143 × 52 × 4cm.
Photographer: Andrew Morris.

STEEL

Stainless steel is a metal that is readily available from stockists in a variety of forms, including rods, tubes, sheets and wires. The wire can be particularly suitable for creating lightweight armatures. Rods can be utilized not only in a strong framework, but also as an integral part of the design.

Carole Andrews uses steel tubing to build armatures for her large-scale sculptures. The gauge of the tube is dependent on the scale of the piece. She can weld the steel armature together in her own studio if the height is below 3m, otherwise she commissions her local steelworks to fabricate the form: she chalks the shape she requires onto the steelworks floor, where the technician bends and welds the frame to her specification. She then covers the tubing with chicken-wire mesh and roofing felt, and to secure these, she manufactures large steel hairpins from wire.

Metallography is a large subject, and the potential mixed-media sculptor who would like to incorporate metal in some form in their work would benefit from researching the subject in more depth in specialist publications.

HEALTH AND SAFETY

▪ Wear protective gloves when handling wire, cutting sheet materials or meshes.

▪ Cut sheet material with metal shears or a guillotine to achieve a clean edge. More complicated shapes can be cut with a jigsaw.

▪ Rough edges on metal can easily cause cuts, so file down carefully.

▪ Maintain tools in good condition – sharpen regularly when necessary.

▪ Protect working surfaces when soldering.

▪ Strictly follow the manufacturer's instructions when using chemicals for controlled corrosive effects. Good ventilation and the use of chambers are essential to minimize health risks.

Working with Metal

Sheet metals generally need to be softened to achieve a workable state, and this can be effected through a process called annealing. This involves the application of heat, or rolling the metal through a machine similar to a mangle. The gauge or

thickness of wires or sheets is of great significance in determining the working properties of a metal: the more malleable it is, the finer it can be drawn or rolled. Generally, rolled sheet metals are called foils, with the thinnest gauge at forty being domestic aluminium; one of the thickest is copper roof flashing at twenty-four gauge. Note that the thicker the metal, the lower the gauge.

Annealing

Annealing is the process by which metal, having become hard and brittle during working, is softened and made workable again by applying heat. Any type of flame torch can be used for heating the metal: for a slow and even heat, make sure the flame is large and fluffy with a yellow tip. For annealing sheet metal, gradually move the heat over the entire surface; with non-ferrous metal be careful to take its conductive nature into consideration. When annealing wire, coil it tightly, especially if it is a finer gauge, to avoid its overheating and melting. The process of annealing is performed most successfully when the light conditions are such that the colour of the metal is most easily distinguishable – therefore a dimly lit environment is desirable. Ferrous metals are heated until they become a bright red colour, and are then left to air-cool. Non-ferrous metals are heated until the piece is a dull red in colour, but they are then cooled quickly in water.

The heating can discolour the metal, which may require cleaning through a pickling process.

Pickling

Pickling is a process intended to clean a metal after it has been heated. To do this, the metal needs to be submerged in a pickling solution until it is clean; a suitable solution can be made using ten parts water to one part sulphuric acid. The solution will be more potent if it is placed in a heatproof dish and heated on a gas or electric hob. Use tongs made of wood or heat-resistant plastic when removing the object from the solution – do not use metal tongs, as these may mark the metal permanently. The object must be thoroughly rinsed with water after its removal from the pickling solution, and then dried.

Rolling Metal

Sheet metal can be stretched thinner and longer if it is put through a rolling mill. The mill is hand-operated, and basically consists of a pair of parallel, highly polished steel rolls with a gap between them that can be adjusted. The metal is stretched only in length as it passes through the rollers: thus the width of the rollers determines the maximum width of the sheet.

Wire can also be rolled flat and stretched, but this should not be attempted unless it has been annealed first. Afterwards the wire will probably need annealing again to restore its softness. The mill will also make the wire curved, so this may need attention.

Helen Weston uses a rolling mill to create the distinctive metal forms in her sculptures. Each sheet of metal is rolled independently. When her work demands a pairing of forms, as in 'Familial Disjuncture', she carefully rolls the sheets in order, to make sure they retain the same degree of curve. If there are any other processes necessary to be performed on the metal, such as drilling and engraving, then these have to be completed before the rolling takes place. Drilling the holes requires accurate measuring and some patience, as only two to three holes are drilled at a time. If she is working on a multi-layered piece, then all these layers have to be held tightly together and drilled at the same time, to guarantee that each set of holes is in line, ready for joining.

Methods of Joining Metal

Metal can be joined in a variety of ways, including: the employment of screws, rivets, or nuts and bolts; through the process of soldering or welding; or for linear forms, through weaving or stitching.

Screws

Screws are connecting devices for joining two pieces of sheet metal together by turning a screw into two pre-drilled holes. The hole for a screw must be drilled until it is the same diameter as the main body of the screw; its teeth then thread into the metal as it moves through the hole. To join two metal sheets together and align the holes, sandwich them tightly between a G-clamp or vice.

Rivets

Rivets are a connecting mechanism which, when hammered through a predrilled hole, will join two pieces of metal together without soldering. The hole for taking a rivet must be larger than the diameter of the rivet body, but smaller than the head. Join two sheets of metal by sandwiching them tightly together and inserting the rivet then, to 'upset' the rivet, hammer the end flat. The back needs to be against a metal block or anvil in order for the head to flatten into an even circle over the metal. A rivet gun provides an alternative method for fixing rivets. Rivets make a strong joint, and this technique of joining can be adapted to most metals.

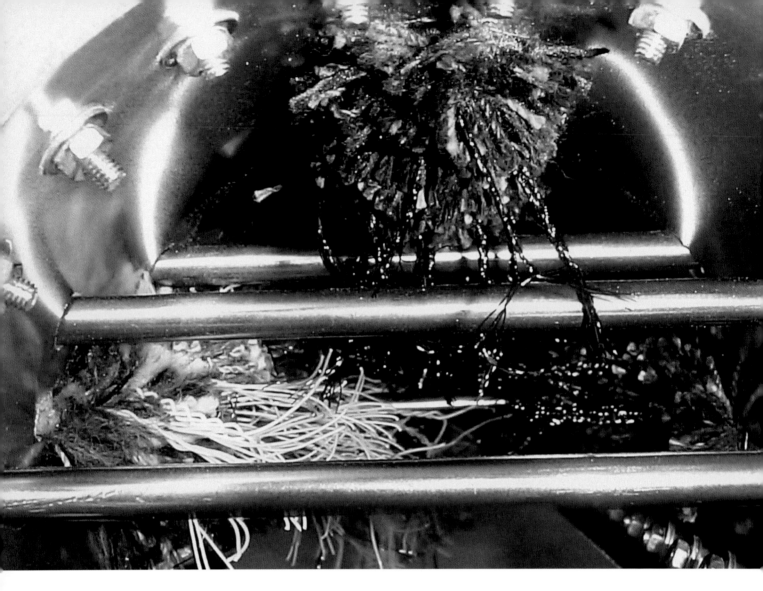

Helen Weston, 'FAMILIAL DISJUNCTURE SERIES' (detail), 1999.

Soldering

Soldering is the most common way of joining metal components, particularly wire. Alternatively, unseen joins can be made using masking tape, or by binding the parts tightly with a fine wire or thread. Glue can offer another alternative. Some of these methods are not as permanent as others, and experimenting to find the right one is advisable.

Soldering is the joining of two pieces of metal by means of a melted alloy. Welding is the fusion of two pieces of the same metal by melting and then mixing the adjoining edges. Welding is a difficult process to master and of limited value to mixed-media sculptors who employ either textile techniques in their work or use the material directly with other materials. Therefore, it will not be covered in this book.

Solder falls into two categories: hard and soft. Hard soldering is performed at temperatures over 538°C (1000°F) and uses alloys of silver and gold, which have different melting points. Soft soldering is effected at temperatures under 204°C (400°F), and uses metals such as pewter, lead and non-ferrous metals, with the exception of aluminium. Soft solder is not as strong a bond as high-temperature soldering. When deciding which metal to select for soldering, careful consideration is necessary with regard to the melting point of the metal itself. The joint needs to fit together perfectly. The surfaces of the joint must be clean and free from dirt, grease and oxides. Rubbing the surfaces with emery paper helps clean the metal, but flux is usually necessary to prevent oxides forming, and to provide some bite for the solder. For hard soldering, the flux agent is borax mixed with sufficient water to make a paste; for soft soldering a solder must be purchased that specifically suits the metal to be joined.

Soldering is a fiddly task, and one that is deceptively hard to master. Practice, and a clear understanding of the procedure, will help towards a satisfactory result. Heat is applied to all the

constituent parts with a soldering iron. All the metals to be joined must be heated to the temperature at which the solder will flow, and a good joint will only be made when all the surfaces are at the same temperature: therefore it is important that the tip of the soldering iron should be directed to the mass area of metal, and should maintain an even heat there. This heating should be done as quickly as possible in order to deter oxides from building up and the flux from being consumed. When the operation is complete, the flux should be removed in boiling water. The metal may need pickling to remove any discoloration. Excess solder can be cleaned off by filing.

Weaving

Weaving describes the process of interlacing different strands of material, usually at right angles to each other, to make a fabric; the vertical strands are known as the warp, whilst the horizontal strands are the weft. Metal is ideally suited to this process. The scale of the work can easily be manipulated from miniature pieces to sculptures of great magnitude, as the strength and rigidity of the material lends itself well to being used in different sizes. The nature of the material also includes a resistance to detrimental weathering, and thereby opens up opportunities for installation outside.

Weaving in metal can be achieved either by using wire, or by cutting strips from sheet material. Traditional weaving techniques used in basketry or on a loom can be adapted to this material.

Stitching

Stitching is not an obvious technique for joining metal but, as the sculptors featured in this book illustrate, it is not only possible, but often highly appropriate. The simplest way of stitching with metal is by using a metal thread. However, these threads do require careful handling as they are fragile and can easily break. Both machine- and hand-sewing spools are readily available from handicraft outlets and thread suppliers. The beauty of their application is the metallic lustre they bring to any work in which they are used.

Thin-gauge wire can also be used for stitching. This gauge of material is harder to manipulate but is stronger, and therefore in the context of sculpture, probably more applicable. Kieta Jackson sews her woven coils together with a fine copper wire; this secures the form in its shape, and acts as a decorative embellishment.

'Spirit of the Flow – Ripple': the wall-based relief was created from selvedge textile waste stitched with wire to hold the layers together between the two aluminium sides. It was a time-consuming process, as every piece of textile had to be individually pierced with the wire. Tension across the sculpture was maintained by the wire stitches being secured at the end by a tight coil.

Jac Scott, 'SPIRIT OF THE FLOW – RIPPLE' (detail), 2000.
Photographer: Andrew Morris.

Wire

Wire is a simple, commonplace material that holds tremendous potential for creative personal expression. Its habit of being employed in numerous everyday situations means it is readily available in a wide variety of metals and sizes. The main advantage to the sculptor is its ability to retain its shape. This property offers not only the opportunity to use it as an armature, but also to create a visible framework: a way of drawing in the air with line. Both Jayne Lennard and Samantha Bryan utilize this property to good effect in their work.

Samantha Bryan initially does simple line drawings for her designs: working out the relationship between the negative and positive spaces. The wire performs a vital element in her sculpture as it evokes the deliberately spindly quality she wants to have in her fairy sculptures. The approach she takes for each piece breaks down into a variety of processes. The metal parts are treated differently: the brass structures are soldered together using a blow torch, whilst the parts made from iron are brazed or bound with glue and wire. The surface qualities of the metal are vital to the overall effect of the work, so Bryan spends a long time searching for the right part to complement the structure as a whole.

Brain's Advanced Flying School for Fairies

Loop-the-Loop Division

Samantha Bryan, BRAIN'S ADVANCED FLYING SCHOOL'
(detail), 2002.
Materials: wire and metal with mixed-media.
Dimensions: 80 × 45 × 15cm.

Stretching Wire

Wire can be made thinner by the use of a drawplate and a pair of draw-tongs. The drawplate is a solid, heavy piece of hardened steel with a sequence of graduated holes tapered to reduce the diameter of the wire. The plate is fixed firmly in a vice to facilitate smooth, successive drawings of the wire. By pulling the wire through the holes with the tongs, which are serrated to maintain a strong grip on the wire, a controlled stretching and thinning is achieved.

Weaving with Wire

Wire can be used to weave on a loom or a tapestry frame, or with basketry techniques in order to create three-dimensional forms. The difficulty encountered in manipulating the wire into the weave depends on the gauge selected: the thicker the wire,

the more challenging the operation. Selection of the right gauge wire is therefore essential, and adequate sampling of material and process is the only way to find out if the choice is correct. There is no magic formula in wire sculpture that can be dictated for instant success, as the creative outcomes are personal to each artist and to what they are trying to achieve. Experimentation should be regarded as one of the most exciting and rewarding parts of the artist's creative journey, and therefore should be embraced at every appropriate opportunity. The properties of wire are ideally suited to constructing form: the wire will hold its shape after bending, and offer support for other materials. These properties can provide an excellent base on which to build sculptural forms.

Lucy Brown uses very fine stainless-steel wire as the warp on large steel tapestry frames. She weaves recycled garments, employing the wire to enable her to contort the textile weft elements into distorted forms. Brown's work addresses issues of female identity and the obsession with thinness. The techniques she has developed with weaving wire and fabric have enabled her to produce slender forms that resonate with ideas on such issues.

Helen Weston wove copper wires into a 5m length of fabric on a sixteen shaft computerized loom to produce a herringbone structure weave for 'The Proctor'. This metal cloth was moulded and stitched with cotton-covered wire.

Kieta Jackson weaves wire on a tabby loom. She prefers to use copper wire for its pliable nature and wonderful colour, which she can adulterate with ease by applying various ageing processes. Jackson is also drawn to gold, but the financial investment in such a precious metal means she uses brass instead; this has similar properties to copper. In 'Woven Fish' she used 22 standard wire gauge (SWG). The copper was woven into a 3m length and then coiled around itself in a spiralling motion, echoing the conical structure of the sea creatures that inspired its creation. The spirals were held in place with copper wire stitching. The ends of a larger size wire (18 SWG) were interwoven, and splayed out away from the form, and were then beaten flat on an anvil. The work was treated to a heat process to alter the colour of the copper.

Inevitably a profusion of ends is produced in the process of weaving. The ends can be neatened in several ways, for instance by soldering, or by weaving back through, following the pattern to lessen their impact. The bulk of the ends of thicker wires needs different treatment when finishing off; therefore soldering or some design detail needs to be addressed in the early stages of designing.

RIGHT: Helen Weston, 'THE PROCTOR' (detail), 2001.
Materials: aluminium, black steel, wire.
Dimensions: outreach 1.5m, height 1.1m.

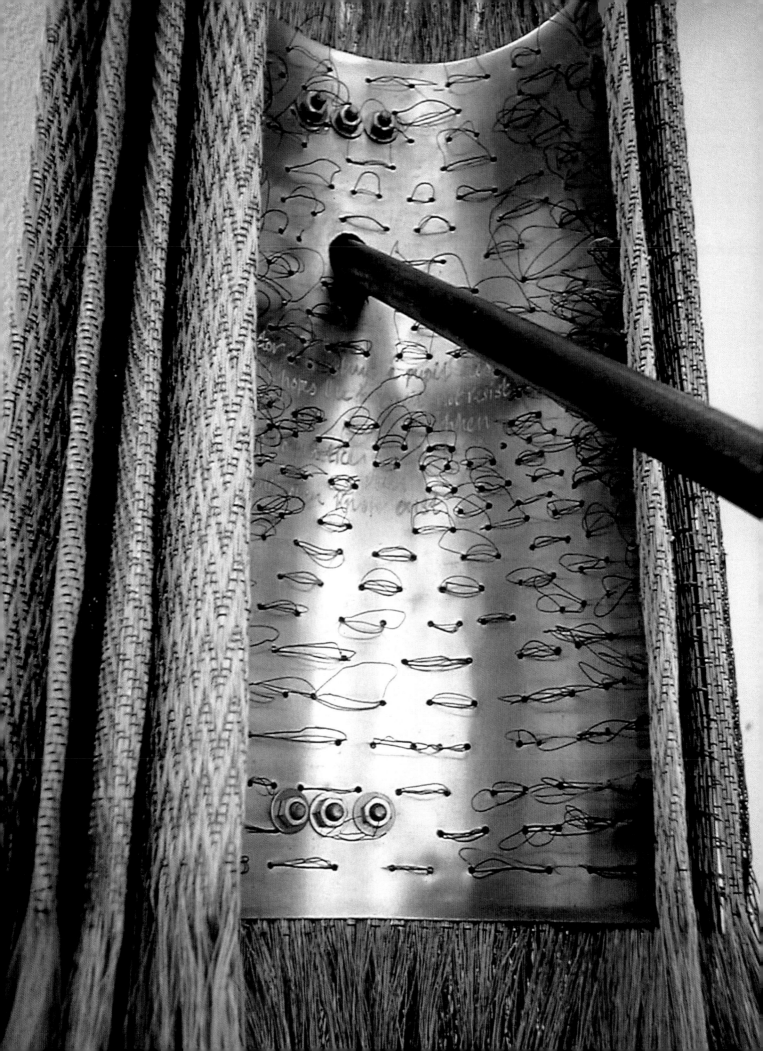

Kieta Jackson overcomes this design dilemma by carefully planning ahead, developing the ends into a decorative feature. She often keeps the ends quite long, and hammers them flat on an anvil.

Three-Dimensional Weaving

Metal can be a more troublesome material to weave than natural materials, as the nature of its surface is smooth and often slippery. Additional apparatus for holding the elements in place during construction is helpful: masking tape, clips and pegs can all be usefully employed. A good tip for cutting circular shapes from wire is to work with the coil, and therefore the inherent curve assists in the shaping. Cutting straight lengths from a coil is difficult, and should be avoided if possible. It is worthwhile making a jig for any multiple work, or utilizing existing formers.

Weaving in three dimensions is an easy way of building forms in wire. Traditional techniques for making baskets can be adapted to the new materials, and different weaves produce radically different outcomes. Some simple ones are discussed here. The twinning weave is developed through the interweaving of two elements around the stakes. The weave forms a strong and decorative form. Randing, by contrast, uses less wire through its use of a single element, but in consequence is less robust, and the weave pattern can appear less tidy unless good

Kieta Jackson, 'WOVEN FISH', 2001. Materials: copper wire. Dimensions: 38 × 28 × 28cm. Photographer: D. W. Jackson.

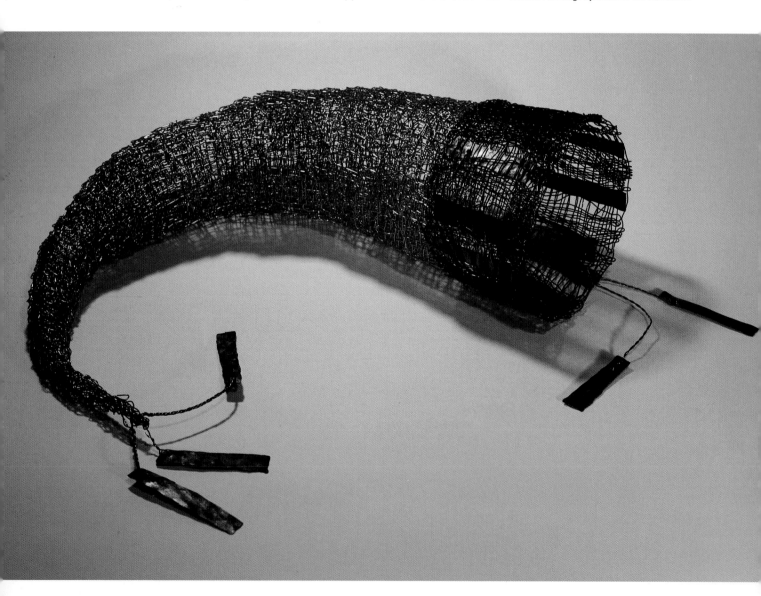

tension is maintained throughout. Other techniques can be developed in wire: for instance three-rod wale, which produces an even stronger, 'fatter' form from three elements.

Coiling is an ancient method of creating three-dimensional forms, dating back to prehistoric times. The process focuses on a continuous spiral, but this can be adapted to other shapes if desired. The principle involves coiling a single element (or multiple elements made into a single one) that is then stitched or tied in place or secured in some fashion (clips, or suchlike) at fixed points around a base, or from a centre formed by the single element. The form gradually builds as each coil is secured. This is a very expressive and responsive way of working, and is one that is often chosen to execute in metal, as the basic form that is made during this process is strong and easy to adorn with other matter. It may be necessary to use some device for holding the coil in place, for example pegs, when work has temporarily ceased, otherwise it may uncoil.

Crocheting with Wire

Crocheting is a technique for making material surfaces through the interlocking of loops from a single element. It is very suitable for using with wire, as it can be added to at any point and in any direction: this offers tremendous creative potential for the mixed-media sculptor. The wire, by its more rigid habit than yarn, enables the work to maintain a three-dimensional form.

HEALTH AND SAFETY CONSIDERATIONS WHEN WORKING WITH WIRE

■ It is advisable to wear protective gloves when handling wire. Kieta Jackson prefers not to wear gloves when crocheting with wire, despite the process blistering and cutting her hands. She finds the protective barrier inhibitive to maintaining the tension and reduces the sensory experience that is integral to her practice. She overcomes this by crocheting for only a day, then changing to weaving to give her hands a rest.

■ Hard wire has a tendency to fly into the air when cut, so place a sheet of cardboard over the loose end to weight it down.

■ Cut wire with wire cutters. Thicker gauges will require filing and then snapping, and the sharp ends being filed off.

No special tool is required above a traditional crochet hook, its size dependent on the desired appearance of the outcome. It is vital that the wire chosen to crochet is pliable enough to be constantly twisted and pulled. The process can be very tough on the hands, and sensible precautions are advised (*see* Health and Safety points).

Kieta Jackson, untitled, 2001. Detail of crocheted form.

Finishing Processes

The Manipulation of Corrosion

The deterioration of metal is referred to as 'corrosion'. This phenomenon is a chemical or electrochemical reaction with the environment, which is often accompanied by the development of a surface oxide or encrustation. This ageing process affects most metals, with iron being the most corrosive, and platinum, gold and copper less affected. The propensity for corrosion should be taken into consideration and metal selected according to purpose and siting of the final outcome. Some artists have found the idea of exploiting this property of metal, through artificially simulating the process, has added a new dynamic to the finished work.

Patination

'Patina' in the strictest sense refers to the coloured, usually green or brown, incrustation on bronze caused by oxidation, but its usage has been extended in common language to refer to a pleasing alteration of surface colour or texture due to age, use

or exposure. Recipes for patination should be sought from specialist metal sculpture books. Their application can be a hazardous process if not carried out with full adherence to health and safety considerations.

Kieta Jackson specializes in the controlled destruction of the surface of her woven and crocheted metallic forms. Her rationale is to echo the corrosive forces of the sea, as her work is rooted in sculpture that resonates with oceanic influences. Jackson experiments with different household chemicals and heat to find out their chemical reactions on the metal. She has discovered that a solution of vinegar and sodium chloride (salt) takes between one and two days to oxidize, and delivers a suitable outcome. Toothpaste provides another readily available substance: if left on copper, it produces a red tinge to the metal.

In contrast, Belma Lugic has developed processes that work on the interface between etching and patination. Lugic became interested in the relationship between metal and acid while learning the etching process with copper plate. In etching, the design is made on a plate by scratching through an acid-resistant coating with a needle. The plate is then submerged in an acid bath where the lines of the design are eaten away by the chemical; the longer the plate is submerged, the deeper the lines become. For Lugic, the fascination was with the ferric chloride solution rather than the plate. The solution can be reused many times for etching, but with each application the solution becomes more loaded with the copper content that has dissolved from the plate. Eventually the ferric chloride becomes unusable for etching due to its saturation with copper, a state of affairs that prolongs the process prohibitively.

Lugic took the solution and poured it over copper plates, where she left it for over a month to form a crusty green surface. This was collected, mixed with water into a paste and applied with a brush to a design drawn onto a metal plate. The paste oxidizes with the metal and dries quickly. Later, Lugic sprayed the whole sheet of metal, including the pasted metal areas, with a fresh solution of ferric chloride. This started the process of oxidation over the entire surface of the metal. For the artist, the process symbolized the concept of loss, which underlies her work, through disintegration of the metal surface. The atmospheric conditions of Lugic's studio dictated the time the process took – two to eight weeks was the variance. The whole surface became crusty and flaky. Wax was employed as a retardant to try and slow the process of oxidation, but Lugic found this just lost the natural, flaky surface. She experimented with different combinations of metals and chemicals, using patination recipes for altering the colour of the metal.

The practice of finishing metal surfaces is a science in itself, and requires serious attention if the surface area is to be one of the main features of the completed work. Intricate sculptures that have borrowed techniques such as weaving or crochet to build their form, may be difficult to 'finish' with traditional metal processes. Care must be taken with such structures, as the nature of the construction may be damaged with finishing by machine buffing and polishing. These types of fabrication usually require less 'finishing', provided the base material is clean. Coated wires have a permanent colour and polish and therefore should require very little, if any, treatment provided the wire has not been subjected to heat or acid processes. If uncoated copper or brass wires are dulled through annealing and pickling, then it should be possible to restore their surface by rubbing them gently with fine brass wire brushes.

Kieta Jackson treats her fine, delicate interlaced forms by carefully rubbing the surface area with a series of fine-grade sandpapers, using the roughest grade first and gradually working down to the finest. She also finds wire wool and various proprietary metal cleaners helpful.

Sculptures that use sections of sheet metal will need the surfaces treated before assemblage. For small sections of sheet material, rub the surface with an abrasive paper or cloth to remove any scratches – make the action follow the same direction. Gradually decrease the grade of the abrasive paper until the scratches are removed and the whole surface has an even patina. Commercial polishing compounds are readily available, and the manufacturer's directions should always be strictly adhered to for a successful outcome. These compounds will deliver varying effects, depending on the application. Wash off the compounds with a solution of soap, hot water and a few drops of ammonia, using a soft brush and a scrubbing action. Rinse again in clean hot water and then dry thoroughly to prevent water spotting.

Helen Weston finishes her sculptures by trimming any uneven curvature or roughness with an angle grinder. A band sander performs the last stages, creating a matt finish. To polish the metal she finds commercial products like 'Silvo' useful, but for an alternative, she cleans with toothpaste.

All annealing operations should be done in advance of the finishing processes as the heating inevitably leads to unsightly discoloration. These blemishes and any scratches should be removed during the finishing procedures.

Samantha Bryan, 'BRAIN'S FAIRY VISIBILITY RESTORATION DEVICE' (detail), 2001.
Materials: wire, metal and mixed-media.
Dimensions: 50 × 55 × 25cm.

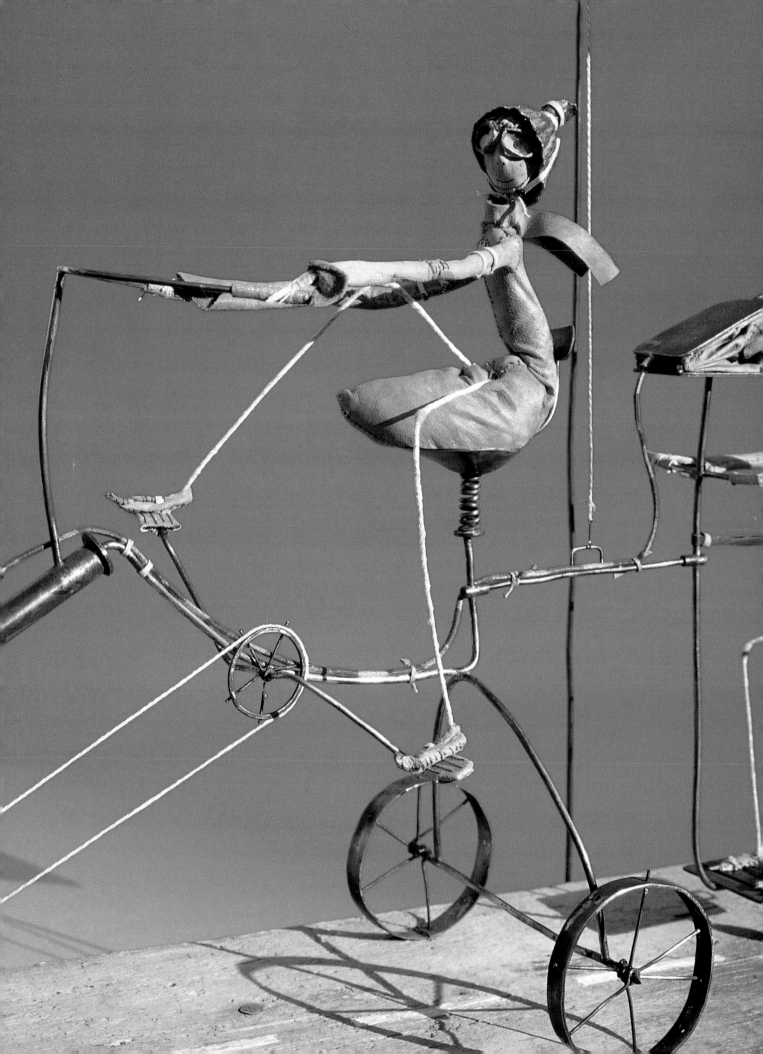

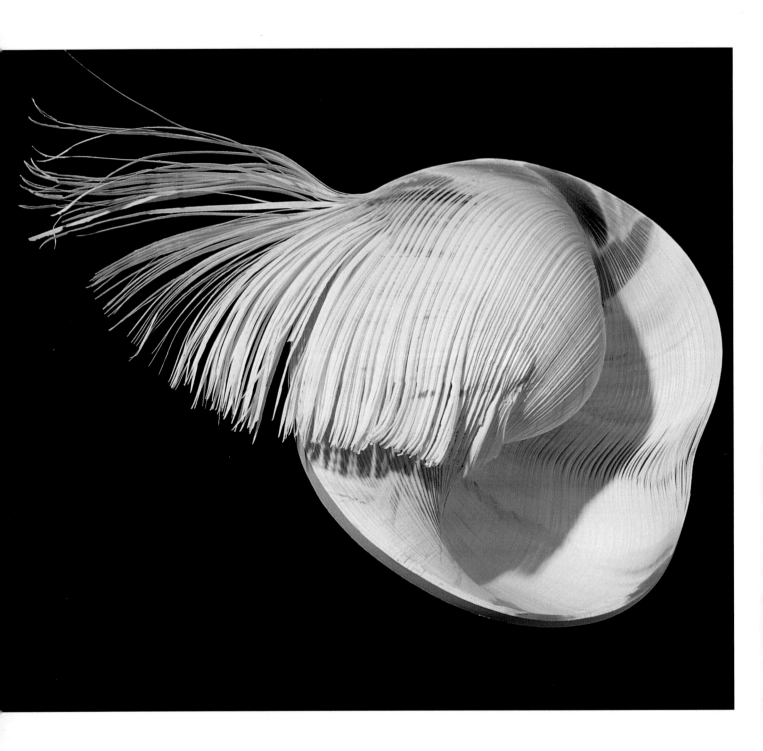

Karin Muhlert, 'SEA-CELL', 2002.
Materials: recycled machine-made paper.
Dimensions: 22 × 13cm.
Photographer: Malcolm Thomson.

PAPER

Paper is an ancient material that has gained in popularity as a sculptural medium over the last forty years. Its history dates back over two thousand years, with fragments of paper made from vegetable fibres being discovered in China. The growth in the nineteenth century of the printing trade led to a higher demand for paper, so an economical and plentiful raw material had to be found. It has been recorded that naturalists first suggested wood could be a suitable material for making paper after they observed wasps building nests from dry wood. The outcome of the wasps' nest-building was a papery, durable, water-resistant home that later inspired chemists to develop mechanical processes for making large quantities of paper.

The East has always had an affinity with paper, and creative expression in three dimensions that can be identified with origami

Jac Scott, 'OPPOSING VIEWS' (detail), 2001. Materials: rolled newspaper, PVA adhesive. Photographer: Andrew Morris.

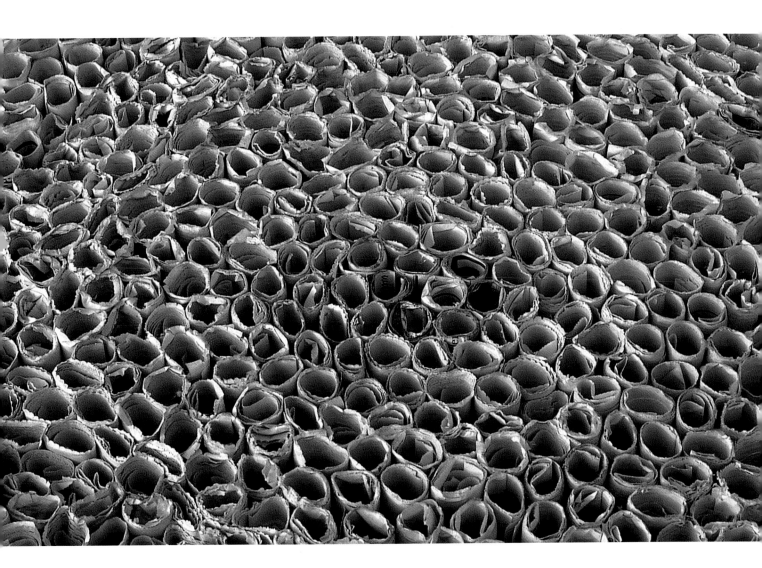

and the proliferation of Japanese artists who adopt paper as their primary material. Chika Ohgi is a renowned artist creating ethereal installations made from constructed paper. Lesley Millar wrote about Ohgi's work in the catalogue *Textural Space*, in 2001:

> Chika Ohgi's works are constructed from paper that she has made herself from kozo, ganpi, cotton and ramie. The final installation is in her mind as she makes the paper. For her, the space and the work within the space take on equal value, the form and the space it will occupy becoming one integrated whole. The particularities of the handmade paper create edges, which in a peculiar way seem to form an indistinct outline, creating an ambiguity between object and space. The positive/negative relationship of form in space is diffused, the cast shadows inform our understanding of the piece.

The Western view is a somewhat more complex and less ethereal philosophy. A major attraction for sculptors is the ease of application through the engagement of processes that enable lightweight forms to be built quickly. Paper can be used for creative expression by the sculptor in a myriad of ways. The manipulation of the two-dimensional plane into a three-dimensional object, as in the art of origami, is an ancient technique that first inspired Carole Andrews to create sculpture from paper.

The reawakened interest in paper in recent years is particularly focused on creativity with paper pulp, which opens up possibilities with casting methods and papier mâché. These processes can be manipulated to produce sculpture that is lightweight, has a rich or subtle surface texture, and the potential for the interplay of light and other materials.

Technical Information

Properties

Paper is a man-made substance made from natural materials such as wood, straw, flax, hemp or cotton. In the simplest terms, paper is made by breaking down the fibres of the plant material to expose the cellulose; these broken fibres are then beaten to a pulp and mixed with water. When the water has evaporated from the mix, the resultant material is called paper. Commercial paper is manufactured in a similar way to the handmade method. In industry the wood pulp is chemically and mechanically refined down to a spray that is applied to moving belts of felt.

In general, handmade paper is more attractive to artists, as its properties include strength, longevity and texture. A high cotton rag content is preferred, as the fibres are long, strong, and resistant to atmospheric ageing: the paper is therefore of a high quality. Rag pulp performs best for stability in the form, whilst wood pulp has a tendency to become brittle and discolored. Another advantage of rag pulp is its natural property of a high cellulose content which, after being beaten, binds the fibres together to form a material that does not require the addition of adhesives.

A beater is an essential tool for the papermaker as it acts like a mill, breaking down and crushing the natural fibres to a smooth substance. But beaters can be expensive, and an adequate substitute for small-scale operations can be a heavy-duty kitchen blender or processor. However, this equipment does affect the fibres, making them shorter, and therefore the pulp is lumpy. Linen and flax make good rag pulp, as illustrated by the work of Gill Wilson.

Gill Wilson follows a process of pulping similar to the Japanese method of 'Washi' to create her stunning 'Wallboxes'. She works exclusively with plant fibre such as flax, yucca and straw, boiling, then rinsing and hand-beating the material to reduce it to cellulose fibres, which are then bleached and dyed. The result can vary

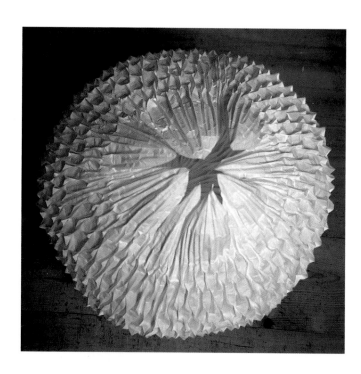

Carole Andrews, 'SPHERE', 2001.
Materials: smocked paper and glue.
Dimensions: 35 × 35 × 40cm.

from a smooth surface, to one that is richly textured. Wilson builds up layers and deeper textures with the pulp by employing different tools to make marks and breaks in the paper surface. The sharp angles of the 'Wallboxes' are achieved by bonding the paper over a wooden frame: this produces a taut, three-dimensional work.

Gill Wilson, fibre boiling
in stainless steel pan.

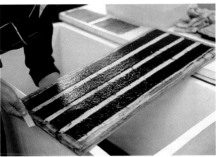

Gill Wilson, paper fibre
draining on a screen.

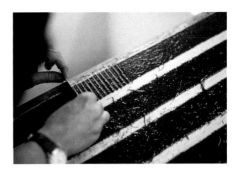

Gill Wilson, manipulating
the wet paper fibre.

Working with Paper

Paper Pulp Casting

Paper pulp casting is different from papier mâché, as the paper itself is manufactured from raw plant matter as part of the process; it is therefore said by some to be a purer form of sculpture. In papier mâché the method recycles existing paper. The process of casting with paper pulp can be used for the creation of one-off pieces of sculpture, or the manufacture of multiples. Casting with pulp is a simple procedure. A dry plaster mould makes an ideal mould for casting (*see* Making Moulds, page 80).

The surface quality of paper can be manipulated to different effects. For smooth, finer finishes, squeeze out the excess moisture by clamping an inner mould to the original and compressing the pulp. If a more rugged surface is desired, then pack the pulp onto the mould and leave it to dry. Be careful to press the pulp into the corners, and avoid making the layer too thin and therefore fragile. If a smooth finish is desired, or a texture on the mould is to be clearly defined on the paper, then complete the process by pressing absorbent cloths repeatedly over the pulp to assist the drying out stage. This action also compresses the fibres, resulting in a stronger structure. If a rough finish is required, do not press the surface: the pulp will therefore remain saturated for longer, and it will take more time for the water to evaporate from it. The paper will shrink as it dries, pulling away from the mould. To slow the drying out process, place damp cloths over the assemble.

Paper is not suitable to cast solid, as the centre of the piece can remain wet and will therefore deteriorate.

Ready-made pulp can be purchased from craft suppliers and specialized outlets (*see* Suppliers, page 153).

Diane Reade utilizes ready-made cotton pulp to create reliefs that, when joined together, form a facsimile sculpture of the original inspiration. Her interest is with the juxtaposition of concealment and revelation in her sculpture, and she has developed techniques that produce paper sculptures that play with light and texture to create controlled illusions. Thus, in order to unite two surfaces (handbag and contents) into one plane and to create an embossed paper image, she has developed the following process: first, she rolls out a bed of clay, into which she embeds the surface of the handbag and its contents – this forms a negative mould. The sides of the clay are built up higher to contain the plaster that will form the first mould – a positive of the clay impression. Using dental plaster for a fine and strong mould will pick up intricate details from the clay. When the plaster is set, the mould is removed from the clay bed and allowed to dry out. Soft soap is then applied as a releasing agent to assist in the separation of the next casting. Clay walls are built up around the mould to contain the second application of plaster. The plaster mould forms the positive cast, which echoes the original clay impression.

After the second casting is set, the two parts are separated and left to dry. The positive plaster cast is treated with a releasing agent, spray wax polish, before applying the paper pulp. The pulp is carefully built up in layers, with the excess water being gently pressed out. The paper is allowed to dry out before it is removed from the mould. Reade then reforms the paper relief into a bag shape by folding, bending, creasing, gluing and trimming.

Paper Laminating

Laminating is a process of building form with paper fragments or strips onto a suitable armature. These pieces should be soaked in a paste of glue (wallpaper paste with a fungicide and water). It is important to build up the layers gradually, and to let each one dry to avoid moisture retention in the centre. The form will dry from the outside surface and, if the wet layers are too thick, then the inside may remain moist and will be liable to rot. Any type of

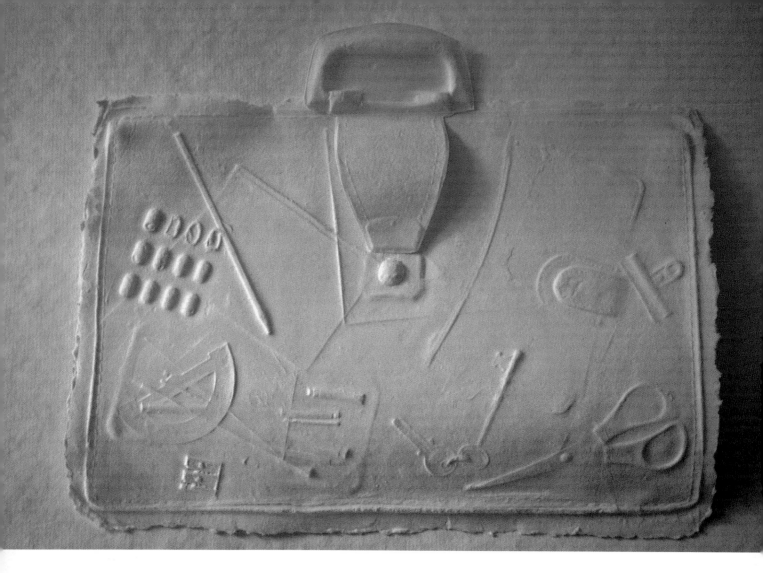

Diane Reade, 'BRIEFCASE', 2000. Materials: handmade paper. Dimensions: 70 × 55 × 7cm.

paper is suitable to make a laminate, and creativity can be fully explored with collage techniques and the inclusion of other planar derivatives such as photographs, prints, paintings, cloth and so on. Once the form is completely dried, it can be treated to a variety of treatments, including varnishing or painting.

Papier Mâché

The term 'papier mâché' is often misused, and sometimes incorrectly used to describe the lamination process. 'Papier mâché' is a French term, and the true meaning is 'paper reduced to a pulp'. This method of creating form from paper pulp dates back to ancient times in the orient, and is suitable for casting and modelling sculpture. The process involves soaking the paper to produce a soft, dough-like substance. Boiling may assist this process for heavier weight papers. The addition of a fungicide – carbolic acid or formaldehyde – is advisable.

There are two schools of thought about adding a water-soluble adhesive at this stage: the pulp will retain its shape, once pressed, without glue, and for many purists this is the only approach; however, the mixing of a water-soluble adhesive will act as a binding agent and therefore make a stronger form. Inert fillers can also be added to alter the consistency of the dough, such as sawdust, French chalk, pumice powder, dry powder paint or casting plaster – note that the plaster has the effect of drying the dough more rapidly.

Once thoroughly mixed, the dough can be carefully pressed into or over a mould, or alternatively modelled over a pre-assembled laminate. Large sculptures will require a reinforced structure, such as one from galvanized chicken wire, to be made. A laminate layer is advisable before applying the pulp to disguise the armature and strengthen the form. Always remember to allow each layer to dry thoroughly before applying the next. A gentle heat can assist the process, but proceed with caution, as high temperatures tend to cause unwanted shrinkage. The

amount of time for drying varies enormously, as it is dependent on the atmospheric conditions of the studio, the bulk of the dough, the type of adhesive, and the nature of the fillers. Papier mâché is an excellent way to recycle paper scraps.

Papers suitable for recycling into pulp include tissues, office waste (computer and photocopying paper), wrapping and brown parcel paper, art papers (watercolour and pastel) and stationery waste (notepaper and envelopes). Newspapers and magazines can be used for papier mâché and are an obvious source of material, but the disadvantages include the propensity for the paper to deteriorate rapidly: it becomes brittle, yellow and prone to acid attack, and it is therefore not suitable for a long-term quality outcome. If it is necessary to use newspapers or magazines, then boil the paper in strips for an hour in a solution of one tablespoon of washing-up detergent to two litres of water; the ink will rise to the surface during boiling in the form of scum, and this should be removed as it appears. It is also important to rinse the paper pieces well after boiling, and before making into a pulp.

The papier mâché process was used to create the paper insert for 'Spirit of the Flow – Pool'. The insert was made from scraps of black sugar paper, torn into small pieces, soaked, and then blended in a liquidizer. The pulp was pressed over a mould created from an inverted plastic bowl and a cardboard rim stuck together. The layer of pulp was quite thick, and was left rough to simulate the stone surface that inspired it. The paper was dried out slowly, and varnished with a water-based, matt varnish that not only made the structure stronger, but also produced a low sheen, reflecting the idea of water over the stone surface. The sculpture was developed from the study of the evolving void created by water movement and stones in a local river bank.

Jac Scott, 'SPIRIT OF THE FLOW – POOL', 1999. Materials: recycled, felted, woollen blankets, handmade moulded paper, nylon thread, stone and haematite chips. Dimensions: 39 × 15cm. Photographer: Andrew Morris.

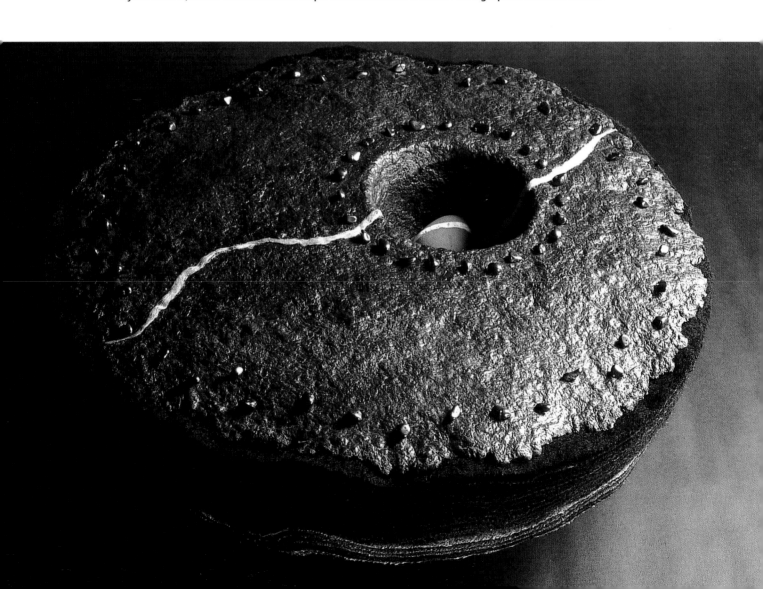

Making Moulds

Mould making is one of the traditional methods used in sculpture. The process described here will produce a mould suitable for casting paper pulp, both from virgin plant material and papier mâché, but it could also be adapted for casting other materials. All kinds of usable items can be commandeered from the household and domestic rubbish: identifying the desired form or forms is the secret, then applying the techniques of mould making as described below.

The shape of the mould is determined by the selection of forms/objects chosen to be appropriate for the outcome. Constructions made from waste matter, such as cardboard, plastic containers and polystyrene, will need to be coated with several coats of varnish to seal the construction, and then sprayed with a silicone spray to assist in the release of the latex mould. Although a plaster mould may be taken at this stage, it is advisable to produce an intermediary in the form of a latex mould. Latex is the liquid form of rubber, and is employed as a mould-making material in traditional sculpture. The latex is brushed over the construction in several layers; each of these should be allowed to dry before the next is applied. A layer of loose-weave fabric, such as scrim or muslin, can be used to strengthen the latex on a third application. Apply about six layers of latex for a firm rubber mould. The latex will need to cure to form rubber before being removed from the construction. (*Refer* to the chapter on rubber for more in-depth information about working with latex.) The rubber mould is flexible and therefore may need the support of a further plaster mould to maintain its structure.

The rubber mould should be up-faced, and a barrier made around the edge to hold the plaster mix. Pour the plaster mix (use fine casting plaster, or dental plaster and cold water) into the hollow mould; gently tap the sides of the mould to dislodge any air pockets. Let the plaster set. (*Refer* to the chapter on plaster for more detailed information.) Allow both moulds to dry out thoroughly.

Use the moulds by placing the latex on top of the plaster mould to ensure a stable form. Spray the rubber with a specialized release agent to avoid sticking, then coat the mould with the paper pulp. Press out the excess moisture with cloths or sponges – this also pushes the pulp into the smaller crevices, and helps the fibres bond together.

Modelling Paper Pulp

The definition of modelling is the use of a malleable material to create a form that is three-dimensional. Here the term is applied to the making of form with paper pulp that is made from plant material and then used to build up a form either from the

employment of a removable mould or an armature. This type of paper construction follows the more purist's line of the sculptors' dictum.

Susan Cutts makes her paper from abaca fibres. The pulp is made from the actual fibres, or from processed sheets called 'linters'. The linters are beaten into a pulp with a Hollander beater and, by altering the beating times on the machine, Cutts can manipulate the degree of shrinkage of the paper. She makes the

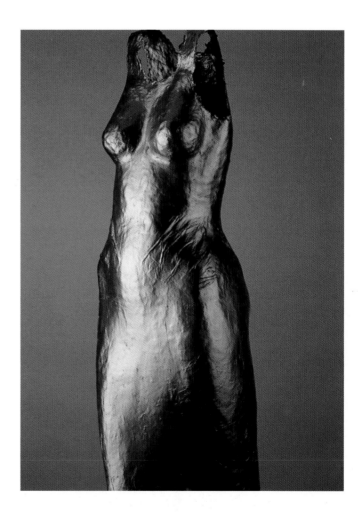

**Susan Cutts, 'LITTLE BLACK DRESS', 2000.
One of a series of ten little black dresses.
Materials: handmade abaca paper, acrylic paint.
Dimensions: 120 × 40cm.
Photographer: Simon Margetson.**

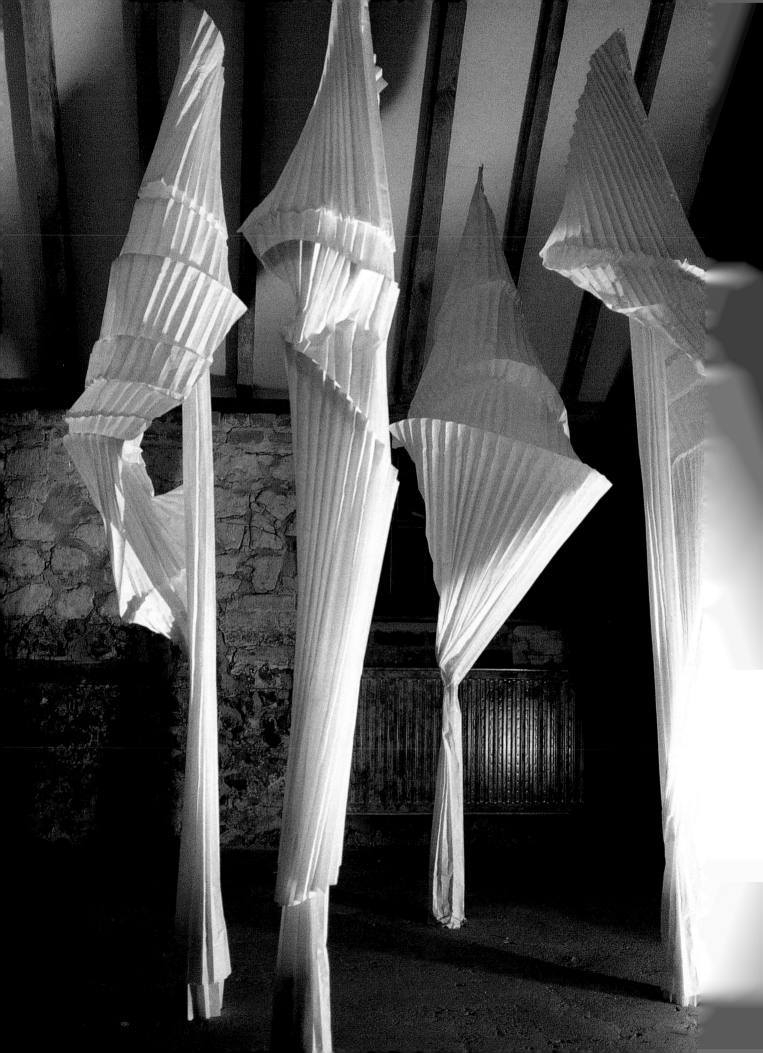

pulp into numerous sheets of very fine paper, as these are easier to model and will create a more delicate finish. Working with hundreds of wet sheets for each form means it is necessary to freeze large batches. It is important to Cutts to avoid using adhesives in her sculptures, so her approach is to work with a series of moulds made from a basic short-fibred cotton linter. The moulds are waxed all over to assist in their removal, and the thin sheets of paper are gradually built on top of the mould. Once the top layer is dry, the mould is removed. By working on the outside of a mould, Cutts finds she can model the paper into drapes, creases and other fabric effects. The moulds are designed to bear the weight of the sculpture whilst it is wet, which can be a challenge in paper, and the removal of the mould can be dramatic, as in theory the mould is bigger than the form, as the paper will shrink as it dries.

Paper Manipulation

Carole Andrews began her career as a sculptor, exploring the sculptural potential of paper through the art of origami. She found that this craft taught her the principles of control of a two-dimensional material, evolving through folding, into a three-dimensional form. Her work now utilizes this knowledge of manipulation to other materials, but it is her work with paper that is the focus in this chapter. 'Chinese Lanterns' is a collection of paper sculptures measuring about 2m high. Andrews was inspired by the paper lanterns used in the Moon Festival in Hong Kong and by the garden plant, *Physalis franchettii*, for this work. The sculptures are constructed of paper, reinforced with PVA glue, and supported on bamboo poles set in cylindrical concrete bases.

Karin Muhlert transforms mundane recycled machine-made paper rolls into hauntingly beautiful, delicate sculptures that resonate their organic inspiration. She views the rolls as both literally and metaphorically a blank page on which to develop her own creative handwriting in three dimensions. The tightly rolled paper is pulled, hammered, sliced, chiselled, dented and twisted to form the desired shape with power and hand tools normally associated with other crafts. Mallets are used for hammering, and power saws, electric sanders, angle grinders and chisels are all employed to sculpt the paper into shape. Muhlert prefers the natural matt appearance of the paper's surface, so she stabilizes the forms discreetly with cascamite applied to the underside.

'Aeonian Voyage' was sculpted over a long period of time. Muhlert has used the form as a base on which to carve her emotional reactions to the passages her life explores. Some of the marks evolved as gentle resolved lines; others were violent cuts that left deep incisions on the surface.

Coloured and Textured Paper

The sculptor's remit is different to that of artists who focus on the two-dimensional plane, and this is evidenced clearly in this chapter on paper. The relationship to form and the surrounding space, light and texture is of paramount importance in the three-dimensional perspective, and consequently the colour of that form is also a powerful element. Although paper can be easily coloured and texturized with the addition of dyes and other materials, it is worth considering the impact that this may have on the finished piece. Notably the mainstream of thought

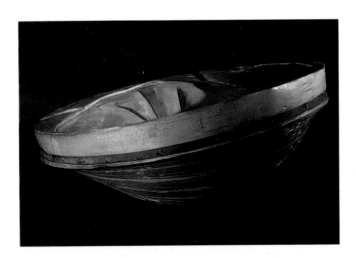

Karin Muhlert, 'AEONIAN VOYAGE', 2000.
Dimensions: 30 × 68cm.
Photographer: Malcolm Thomson.

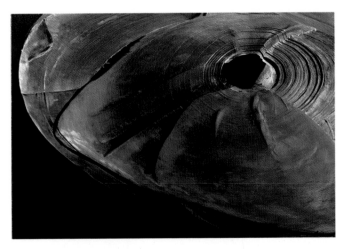

Karin Muhlert, 'AEONIAN VOYAGE' (detail), 2000.
Photographer: Malcolm Thomson.

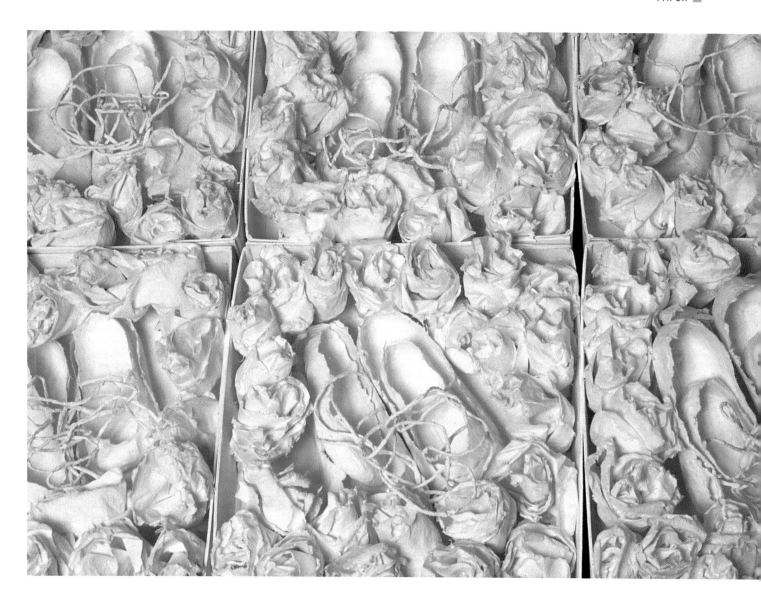

Susan Cutts, 'ASHES OF ROSES', 2002.
Work in progress.
Photographer: Duncan Baron.

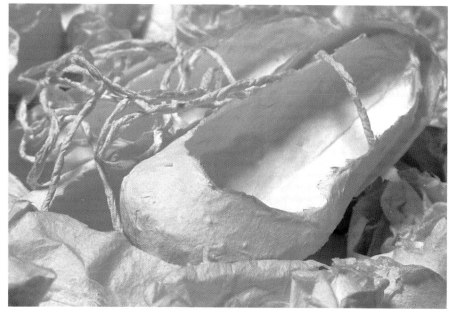

evident in the sculptors featured in this book is to celebrate the natural 'colour' and texture of the paper, without the addition of additives; the outcome reveals a 'truth-to-materials' approach in their philosophy. For those seeking more colourful work the process is easy.

One of the simplest methods of making coloured paper sculptures is to recycle coloured paper using the papier-mâché method. However, this method requires practice and adherence to colour mixing theories to ensure that the desired hue is achieved. By applying these theories, as one might with paint, the range of delicate tonal differences is possible. In some types of paper, such as tissue, the colour bleeds easily and the structure breaks down quickly, which makes the operation simple. Thin coloured card may take several days of soaking to be soft enough to pulp, and the colours are not always easy to mix. Remember that the pulp, when saturated with water, is a darker, more intense tone of colour than when it is dry.

Adding powder paint, inks or food colouring to the paper at the pulping stage will be a fast, controlled method of colouring the paper. Mix the colour first and sample it on some spare mix to avoid disasters. Textile dyes are concentrated, and although they seem expensive, they are usually good quality and go a long way as compared to inks and paints. Natural dyes can be derived from numerous plants, spices and drinks. Tea and coffee are well known stains that will colour paper, and boiled onion skins and beetroot also work well. Blend the pulp and natural dye together: if a surface colour is required rather than a solid colour that runs throughout the piece, then paper is ideal for the application of all varieties of paints and finishing substances. This method of adding colour is very controlled, and can impart further emotional content and referencing into the work.

For many years paper sheets containing organic matter, such as petals, herbs, feathers and leaves, have been fashionable. Such additions change the nature of the paper, and experimentation is essential when applying this idea to sculpture. Creating a flat piece of paper, where all the materials are pressed into a

HEALTH AND SAFETY

Unlike the many other processes and materials discussed in the technical chapters in this book, paper in sculpture has few health and safety issues. The following points are worth considering, but on the whole the material is user friendly and presents no serious health risk.

■ When using a liquidizer, ensure the lid is firmly fixed in place before starting the machine. Never remove the lid while the machine is turned on.

■ Use good practice, as advised by the iron manufacturer, when using a hot iron to achieve a smooth finish on the paper.

■ Water presents the biggest health risk through spillage and consequent accident. Generally mop up any excess water as you work, and avoid puddles on the floor.

■ Remember that electricity and water do not mix. Always turn appliances on and off with dry hands.

level plane, is very different to using the same pulp, without additives, around a mould or armature. The organic additives may be difficult to manipulate, bending and breaking, and therefore sampling is essential. The addition of fabric scraps (fine gauzes, nets and open weaves work particularly well) into a mix may in fact have the opposite effect, not only creating a complementary change in surface structure, but also acting as a strengthening device to the form.

To achieve a smooth finish on the paper, use a warm iron while the surface is still damp, but beware of burning the paper.

ARTISTS

'Of course,' said Gudrun, 'life doesn't really matter – it is one's art which is central.
What one does in one's life has *peu de rapport*, it doesn't signify much.'
'Yes, that is so, exactly,' replied the sculptor.
'What one does in one's art, that is the breath of one's being.
What one does in one's life, that is the bagatelle for the outsiders to fuss about.'

Women In Love
D. H. LAWRENCE

JAC SCOTT

My own practice reflects a fascination with the relationship of multiple components orchestrated to form sculptures containing social commentary. The selection of materials is determined by the demands of the concept, rather than the doctoring of a prescribed formula adopted repeatedly, as the materials act as both a means and a metaphor. Imagery is considered with regard to its suitability and strength, its ability to carry the message. An enduring creative exploration is the development of innovative methods of construction which allow matter to metamorphose into sculptural forms completely alien to their previous role. This manifests itself in different states including extremes in scale that challenge the aesthetic and constructional framework. Outcomes span the range from intimate miniatures to the remoteness of giant forms.

The investigation of boundaries, both in artistic discipline and in material, continues to form an intrinsic part of my work. This focus is articulated through theoretical and practical research. The practical employment of the manipulation of material edges builds a unique structural vocabulary that develops sculptures where the edge forms contours around and within the work, creating pattern and rhythm.

'Office Block' was exhibited at the Victoria and Albert Museum in 2002. The sculpture was inspired by the magnificent collections of dress at the museum, which focused my attention on the concept of image and identity inextricably linked to clothing. The business

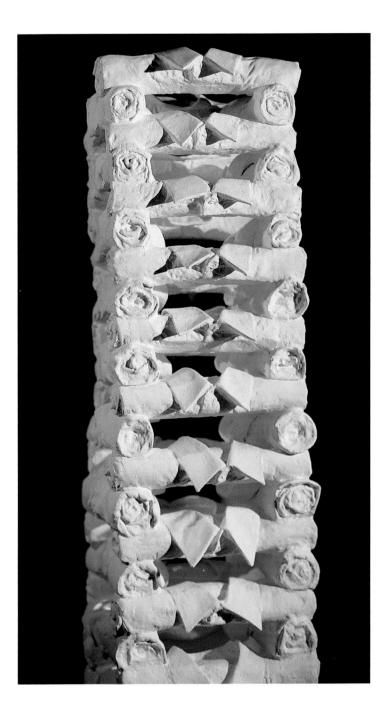

Jac Scott, 'OFFICE BLOCK', 2002.
Dimensions: 166 × 38 × 36cm.
Photographer: Rachel Elliot.

suit is a universally recognized uniform, a symbol of respect and of patronage of business ethics and practice. I elected to reduce the uniform into a white office shirt, as adopted by many 'white collar workers'. Indicative of today's corporate culture is the reliance on a multi-layered structure in both the built environment and the staffing pyramid. 'Office Block' is a physical translation of the commonality of the office workers' experience. The modular structure, employing multiples of recycled office shirts, saturated in plaster, forms a visual metaphor for the corporate ladder.

There is a thread running through much of my work that exposes a remit developed from strong conceptual foundations, and which aims to engage the viewer to relate to uncomfortable subject matter. The spectrum includes an environmental discourse through the study of materialistic societies whose culture nurtures a cycle of accumulation and rapid disposal of possessions, believing this to be an essential pattern for prosperity. A preoccupation with the perceived value of waste by society, and with waste's potential as a resource, is a persistent underlying theme. The act of transformation of redundant matter – a reclaiming of discarded materials and their history from society, reducing them to anonymity, then nurturing a rebirth to a hybrid form – is a primary focus.

In 'Wasted. "Are you sitting comfortably?"' the collection of work was based on the theme of home comforts. We live in a society preoccupied with creating a home that speaks of comfort and luxury, filled with the 'absolute necessities' of life, including the essential 'comfy' chair. The identification of the form of a chair to be an accessible representational mode through familiarity, was heightened by its strength not only to carry the burden of the message, but also its ability to impact the importance of that message through gigantism. The audience was challenged directly with the subtitle and subversively through the unconventional use of waste materials. Discarded matter as diverse as compost, plastic carrier bags, foam, newspaper and aluminium cans were assembled to form giant chairs. The sculptures purposefully delighted in embracing wit and humour to ignite responses. The aim was to create art to which the audience could form an intellectual attachment, whilst informing and entertaining them about a most unappealing subject – their rubbish. The potential for evoking a dialogue with the audience is vital in the philosophy to inform and empower the individual to align to a communal sense of purpose to make changes, and therefore make a difference to waste management practices.

In contrast, I have also addressed issues of human waste, focusing on the mass slaughter instigated under the banner of 'ethnic cleansing'. A response to the collection of anthropologist Edith Durham, at Bankfield Museum, Halifax, led to the creation of the commemorative sculpture 'Echo of the

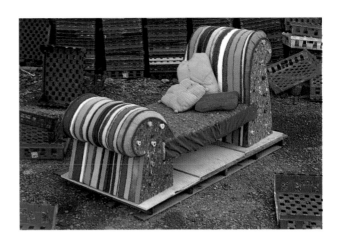

Jac Scott, 'WEAR NOT, WANT NOT', 2001. Dimensions: 250 × 113 × 90cm. Photographer: Andrew Morris.

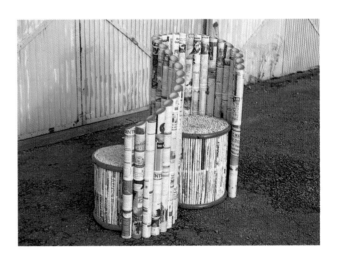

Jac Scott, 'OPPOSING VIEWS', 2001. Dimensions: 170 × 160 × 80cm. Photographer: Andrew Morris.

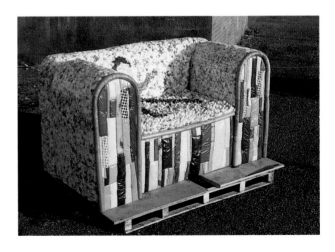

Jac Scott, 'ARE YOU SITTING COMFORTABLY?', 2001. Dimensions: 226 × 128 × 122cm. Photographer: Andrew Morris.

Lost Souls'. A distinctive Albanian garment, a *giubba*, and a pair of traditional shoes, were selected from the Durham Collection, the pattern transposed to cloth, petrified in plaster, painted and then suspended. The imagery implies the body has ascended from the clothing, whilst the blackness resonates funereal connotations. A ghostly ambience is created by the simplicity of the form juxtaposed with the empty shoes on the ground. The absence of the body intensifies the emotions in this memorial. *Note*: an image of this sculpture can be viewed in the chapter on plaster.

There is a plurality in my philosophy that while I endeavour to confront difficult subject matter in my practice I believe in balancing this with a playfulness with celebratory issues. It is the challenge of engaging the onlooker, whatever the subject, without the excuse of perfunctory shock tactics so readily wheeled out by some visual artists, that requires the manipulation and utilization of the tools of communication: humour, wit, surprise and intrigue are my preoccupation. Thus my work is a diverse collection of sculptures, including the frivolous wall relief, ironically titled 'Shocking. Girls just want to have fun' (made from thousands of dyed pink tampons). The piece forms a humorous self-portrait, and approaches the subject of waste from a truly lighthearted, female perspective. The intention of the piece is to lure the innocent bystander with the vibrancy of the colour and the warmth of the texture of the materials. It is only on closer inspection, and with the reading of the poem that accompanies the work, that the content of the work becomes evident. This playfulness is an essential ingredient in my approach, and is also illustrated in the sculpture 'Barbie Keeps Her Appointment With Womanhood'. The miniature doll's chair is made from pink tampons and plastic tubing, and it celebrates the rites of passage of girls to women. The journey of a girl to womanhood is epitomized in the Barbie doll – associations of figure, lifestyle and aspirations all congeal in a plastic form with impossible proportions. The sculpture's social commentary is poignant, yet the execution is aimed at amusement – a marriage I embrace.

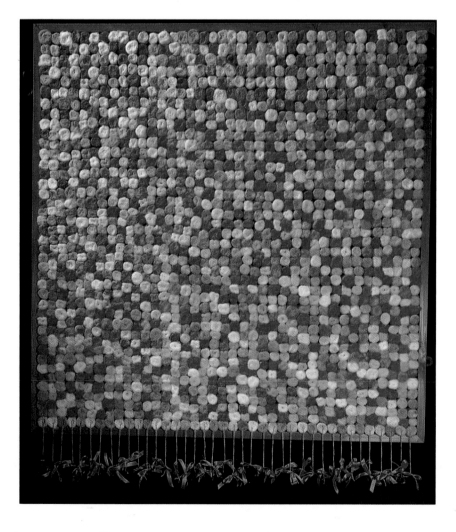

Jac Scott,
'SHOCKING.
GIRLS JUST WANT
TO HAVE FUN',
2001. Dimensions:
115 × 104 × 5cm.
Photographer:
Andrew Morris.

Jac Scott,
'BARBIE KEEPS HER
APPOINTMENT WITH
WOMANHOOD', 2001.
Dimensions: 14 × 8 ×
7cm. Photographer:
Andrew Morris.

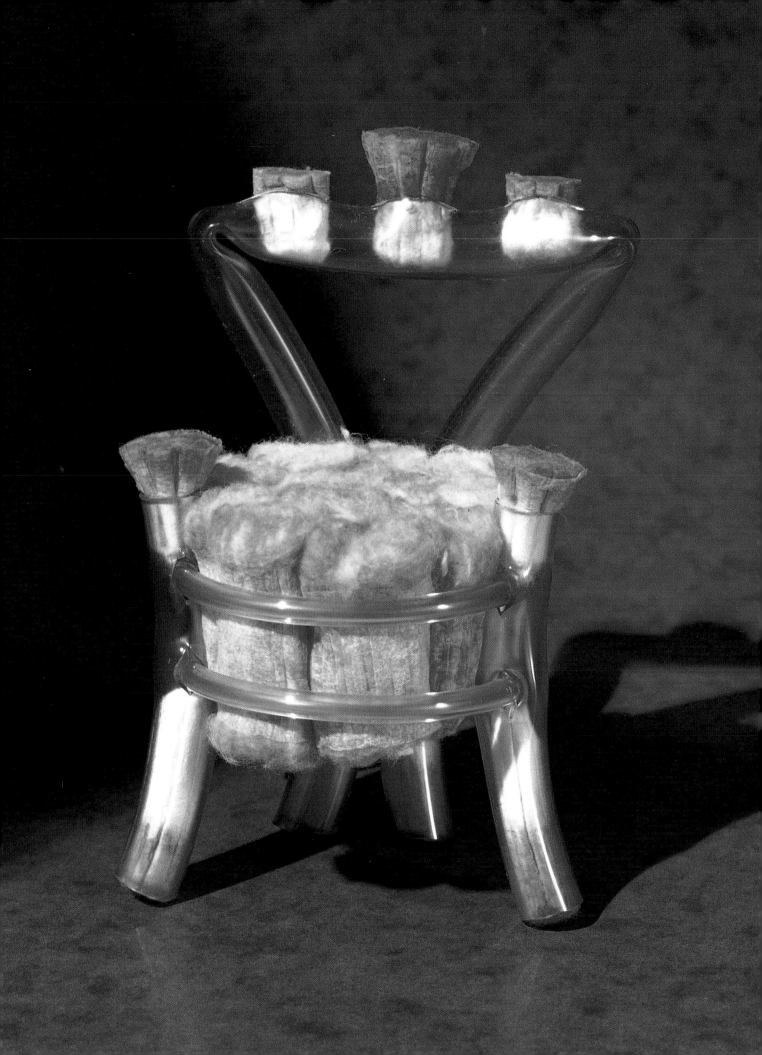

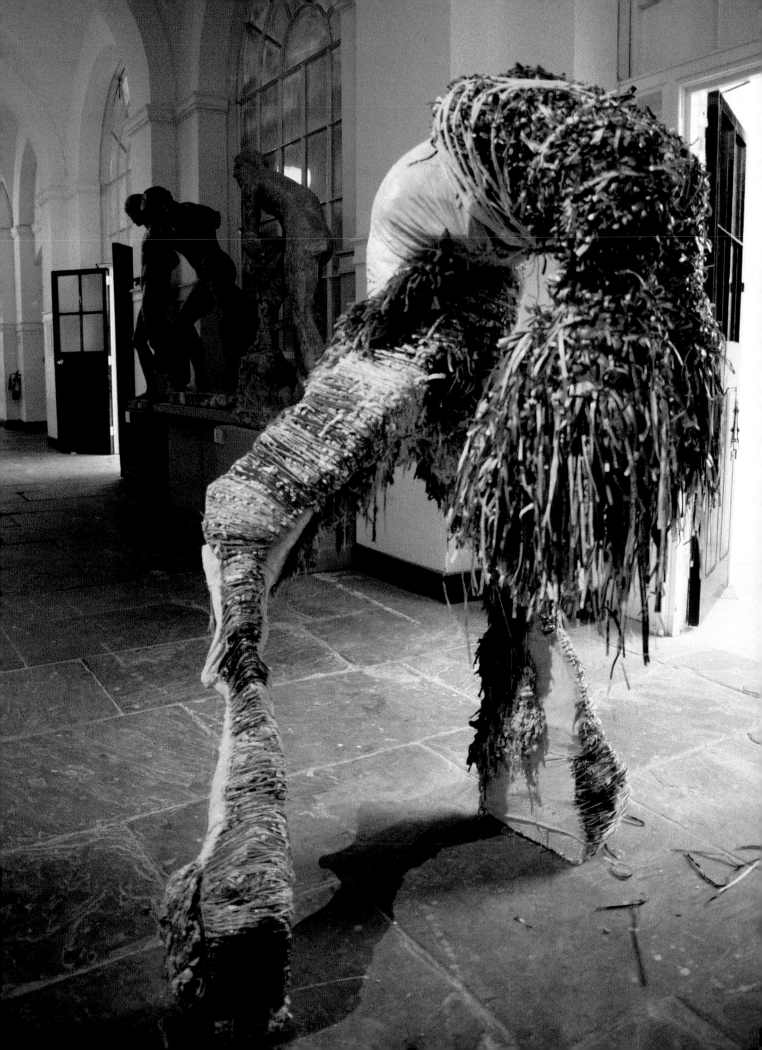

GEMMA SMITH

Gemma Smith's noble, powerful sculptures occupy space with immense presence. The work's magnitude demands a positive physical affirmation and intensity of vision from even the casual viewer. The corporeity of Smith's creations transgresses all disciplines, evoking a dynamic statement of the self, rather than some predetermined formalism. Smith relates to the physical world, through exploration of the human form and metaphysical concepts through referencing primeval sources, gods and myths from the ancient world. She aims to communicate a sense of humanity that cuts across time and geography. She writes of her philosophy:

> By involving myself in figurative art I confess a narcissistic fascination with the self. … I seek to mirror
> myself so as to understand the stuff of the world that surrounds me. I try to exploit the brain's ability
> to empathize as an emotional and spiritual being through projecting a sense of the physical.

The combination of inspiration from the ancient world and ontology, together create an intimate language that when mixed with Smith's repertoire of materials, produces transformed and transfigured sculptures, paradoxically evoking physical strength and emotional vulnerability. The strong animal influence in form, pose and stature pervades the work, producing unsettling undercurrents.

Smith utilizes a diverse complement of materials: plaster, cement, steel, straw, paint, plastic, and a full range of textile materials in her work, executed using a wide range of processes. She writes:

> Textile and textile accessories – beads, buttons, clips, bindings,
> threads – have potential energy in all of their states. From
> massy raw material, through processes of weaving, knitting,
> printing, dyeing and felting – and still when they are
> constructed into 'tailored' objects they have the potential for
> movement and transformation. A substance which has all of
> these routes of thought and association for the viewer is both
> exciting and demanding for the artist.

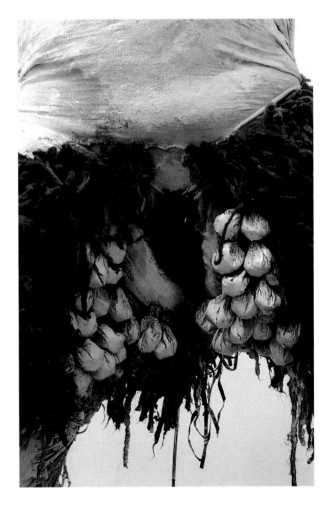

Gemma Smith,
'HEADLESS WOMAN', 2001.
Dimensions: 190 × 155 × 120cm.

Gemma Smith,
'HEADLESS WOMAN'
(detail), 2001.

For Smith the material has become integral to content as well as form.

> The function of the textile material within each of my pieces has changed over time. I have progressed from focusing on the contained sensation in a sculpture, to obsessions with symbolic material, and back towards a concern with the power of materials as form. The first time I used textile as a building material in 'Two Women', I found solutions to construction problems, and the resultant visibility of the sculpture's 'guts' gave an identity to the emotional content of the work. As the process developed, I pulled the binding materials to the surface and enjoyed a fetish-like indulgence in significantly sourced materials. Building with trash novels and magazines, discarded clothes and bedding in 'Headless Woman' and 'Big Man', where the qualities of each material were specifically exploited, allowed a period of confessional art making without the narrative form of 'Two Women'.

The artist has an all-enveloping relationship with her work, which extends to the movement that her body makes when building her sculptures. This performance she now documents:

> I was becoming more aware of transitory performance in my practice. This refers to the development of an internal awareness of my own movement while drawing or making, and to the mediated private performances, which I present as photographic document. The interplay between time and movement in ordering my space, materials, processes and ideas informed a closer relationship between what had been disparate elements. … this cycle of sculpture into movement, into instruction for 'watched' movement, is completed when the original sculpture is finished as a self-aware object.

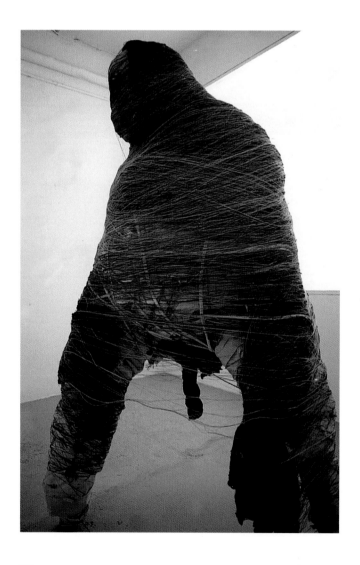

Gemma Smith,
'BIG MAN', 2001.
Dimensions: 150 × 105 × 90cm.

Gemma Smith,
'FLUFFY GIRL', 2002.
Dimensions: 100 × 50 × 40cm.

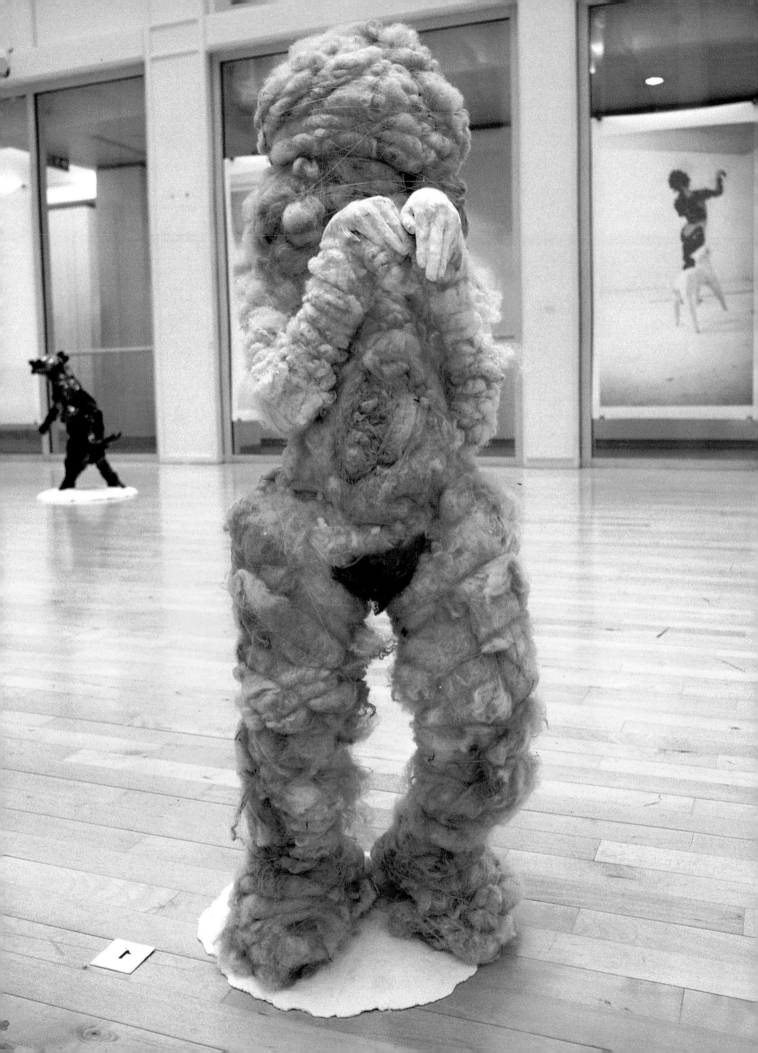

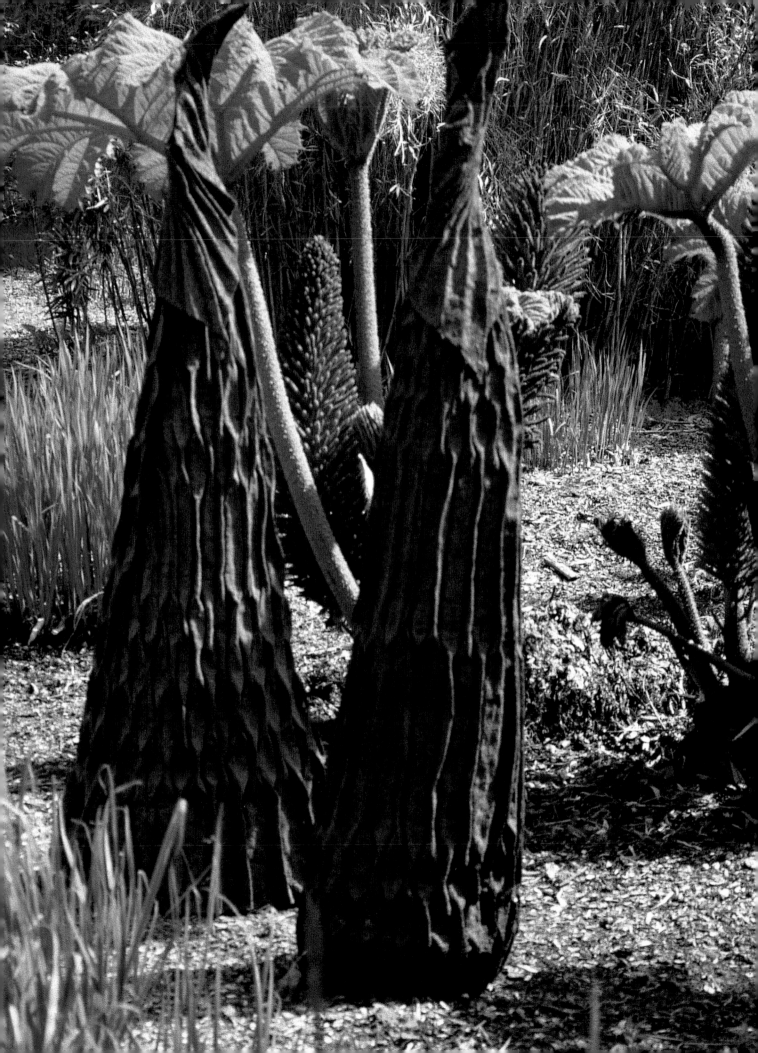

CAROLE ANDREWS

Carole Andrews is a sculptor who puckers, pinches, twists and teases two-dimensional industrial materials into monumental sculptures. Her fascination with folding techniques began with paper and a mastering of origami in order to control and define form. The next challenge was to address scale and location: to devise methods and sort materials that would take the sculptures to grandiose proportions and give her the freedom to involve the exterior environment. Hi-tech roofing felt over a steel armature combine to produce robust forms that occupy space with immense presence. Paradoxically, the techniques Andrews employs are traditionally associated with feminine pastimes, needlework, smocking, embroidery and pleating, whilst the materials are harsh, industrial stalwarts. Andrews considers this relationship integral to her practice. She says:

> Constructing sculpture is like a conversation. I ask the questions, and the medium responds
> and reacts according to its physical characteristics. In this way the material is controlled while
> its potential is revealed and explored. The finished work evolves through this conversation.

Inspiration for Andrews' work comes from the natural world. Her observations of the minutiae in nature – the texture of a reptile skin, structure of a seedpod, the habit of a sea creature, formation of a plant, or metamorphosis of a butterfly – form a germ of an idea that informs the creative journey to an abstract, three-dimensional statement. The dramatic transformation of scale, from small organic form to towering structure, dominates both the environment it is placed in, and the viewer who is forced to contemplate the power of nature from an unfamiliar viewpoint. Andrews writes of her passion for nature:

> Nature is powerful. Species have flourished for countless years. However, mankind arrogantly assumes dominance over nature,
> interfering in landscape and natural re-generation.

The sculptures respond to their setting like a chameleon. Sited in woodland, they take on the character of tree trunks; in an urban location they stand as stone, yet in a modern office interior the hard reflective surfaces age the sculpture to appear as some ancient throwback from the past.

Carole Andrews,
'SENTINELS', 2000.
Dimensions: height
1.75m.

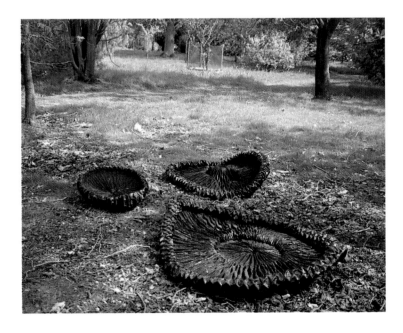

Carole Andrews,
'COELENTERATES', 2000.
Dimensions: diameter
1–2m.

NICOLA MORRISS

Nicola Morriss' practice embraces a philosophy that engages with social and domestic issues, together with a lacing of gender politics. Her remit is broad, and encompasses a diverse repertoire of materials including plastics, wood, textiles, ceramics, living fauna and flora and the borrowing of techniques and processes from a variety of trades including electrics and engineering. Her direction responds to the demands of each sculpture or installation as appropriate. Her sculptures are visual metaphors both potent and apposite. Morriss' approach operates on the interface between art and craft.

The artist has focused on the concept of relationship between ourselves and our homes. She explores the notion that one of society's preoccupations is the glorification and decoration of the home. Morriss believes this is a financial and social trap, and thereby places a flimsy textile house in a birdcage, animated by air currents from an electric fan – connotations to tents and their impermanence underline the reference to insecurity and the illusion of privacy. She explains:

> … my work addresses social and domestic matters, in particular our adored homes and the way we devote
> time and money to an inanimate place, rather than live life. We are increasingly shutting ourselves away inside
> …The birdcage as a beautiful object but unquestionable prison, crops up repeatedly as a metaphor for the
> home, and questions/reflects upon issues of our presumed but fragile security, both physical and monetary.

Nicola Morriss, 'HE WATCHES HER,
WATCHING HIM', **2001. Dimensions:
varying heights up to 1.5m.**

Nicola Morriss, 'HOUSECAGE:
STOKEWOOD COTTAGE', **1999.
Dimensions: 50 × 30cm**

Nicola Morriss, 'GLOVE', 2002. Dimensions: 120 × 58 × 35cm.

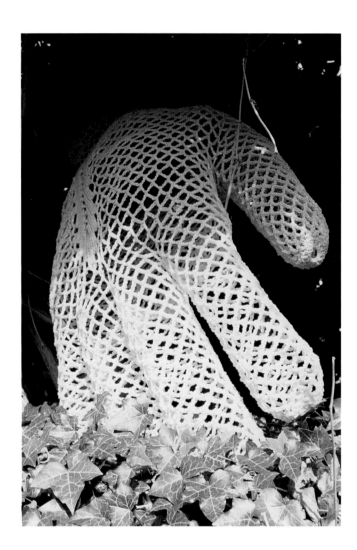

A natural extension of her domestic focus has been the observation of the divisions in male and female roles. A residency with a company that manufactured insulation materials for the building trade provided an opportunity not only to investigate the artistic potential of the company's product range, but also to explore this concept. 'He Watches Her Watching Him' employs muslin 'skins', in the form of figures, filled with rapidly expanding foam made by mixing the industrial chemicals polyol and diphenylmethane diisocyanate. This substance is similar to the aerosol foam used by builders for filling in holes. These hybrids were adorned and dressed in beachwear to show off their tattoos and tanned bodies, the 'tanning' of the polyurethane foam resulting from the exposure to ultra-violet light. Morriss writes:

> I am conscious of the history and associations of the
> various processes/crafts I use, in particular the strong
> divisions into male and female roles. My work often
> combines traditional male preserves of engineering,
> with textiles predominately a female craft. … I liked
> the perversity of me patiently sewing away at these
> skins of figures and heads whilst in a highly
> automated, all-male industrial premises, and then
> filling them with the commercial product.

Morriss' fascination with the power of manipulating the scale of commonplace objects and thereby dislocating the perception of the viewer, is expounded to great effect in 'Glove'. This new work alludes to society's tendency for romanticizing the past, with a particular focus on the importance once placed on etiquette and dress codes in the nineteenth century through to the 1950s. A treasured pattern book of crocheted lace gloves, belonging to one of the artist's great aunts, inspired Morriss to develop a body of work exploring issues symbolized in the delicate lady's accessory. Morriss comments: '… it is a memento mori to all those elegant niceties of etiquette and being proper and ladylike, that ruled the lives of my great aunts and to which I was subjected as a child.'

Morriss manipulated the pattern and materials to achieve a giant-sized glove made from thick, dishcloth cotton that was impregnated with polyester resin. This created a lightweight, weatherproof sculpture that captured the delicacy of the original design whilst maintaining the artist's desire to present such work in a garden setting. 'Glove' is displayed amongst woodland and flowers, a scene indicative of the romantic English garden with overtones of the Pre-Raphaelites, the Brontës, and populist sentimental poetry of the period. In contrast, the role of such accessories in the twenty-first century is clearly a practical one, as the artist explains:

> Gloves use to be as much fetish items of women's clothing as shoes, but sadly are now relegated only to keeping the
> hands warm. Gloves were strictly worn by both sexes up to the First World War, so as bare flesh was never touched!

The artist finds the rhythm of crocheting engaging, and delights in the parody of the scale and material she is working with to create her art. Historically, pastimes such as needlework and crocheting were strictly in the feminine domain, performed as indicators of the subservience of women. The artist's subversive, yet charismatic approach to her work, engages the viewer to reconsider the issues her work addresses, whilst marvelling at her craftsmanship.

KIETA JACKSON

Kieta Jackson's sculptures resonate oceanic influences from her childhood in the South West of England. The sculptures are evocative of lobster pots, fish traps and fishing nets. Inspiration comes from localized studies and global research into the devices Man has developed to capture and harvest sea creatures. Her interest lies not only in the basic structure of these vessels, but also in their purpose of trapping, holding and containment. Jackson's research extends to the corrosive forces of the sea. She writes:

> In the interests of ocean archaeology and because of the corrosive impact of the sea, I apply chemical solutions onto areas of my work, creating rusts and verdigris along with the heating and beating to distress the work further.

Her fascination with developing basketry techniques in metal has led to experiments combining traditional weaving techniques with crocheting, plaiting and knotting. The work shows a strong craft sensibility, with delicate and sensitive referencing to the subject matter. The sculptures occupy space in a harmonious relationship with their conical interior and spiralling shell. The softness of the forms contrasts with the visual and physical weight of the materials.

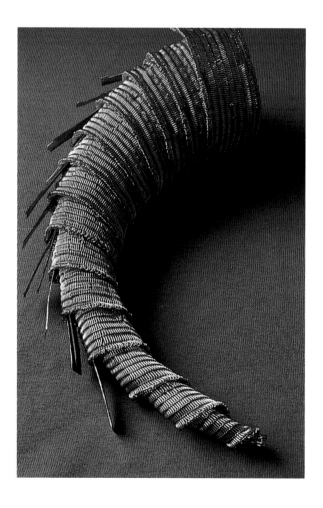

Kieta Jackson, untitled, 2000.
Dimensions: 38 × 20 × 20cm.

HELEN WESTON

Helen Weston creates abstracted objects from metal and fibre that hint at a human presence, both from a psychological and a physical perspective. Her work is conceptually rooted in the domestic environment: the social structures of the traditional nuclear family. The potency of her sculptures comes from the juxtapositioning of the incongruous materials, which emanate a sense of foreboding. The choice of metal, with its industrial connotations, is a deliberate contradiction to challenge the viewer's preconceptions of domesticity. Weston explains:

> The objects allude to an internal, emotional and domestic space, and investigate issues of power
> between male and female, parent and child, with a particular emphasis on the relationships and
> dynamics within the structure of the family. This is achieved through the object's presence in
> relation to the viewer, as well as through their detail in terms of material and technique.

Weston often utilizes traditional nursery rhymes to evoke misplaced innocence through titles, such as 'There was an old woman who lived in a shoe', 'Goosey, goosey gander' and 'Jack and Jill'. The more obscure rhymes, such as 'The Proctor', an early twentieth-century story

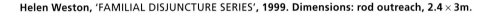

Helen Weston, 'FAMILIAL DISJUNCTURE SERIES', 1999. Dimensions: rod outreach, 2.4 × 3m.

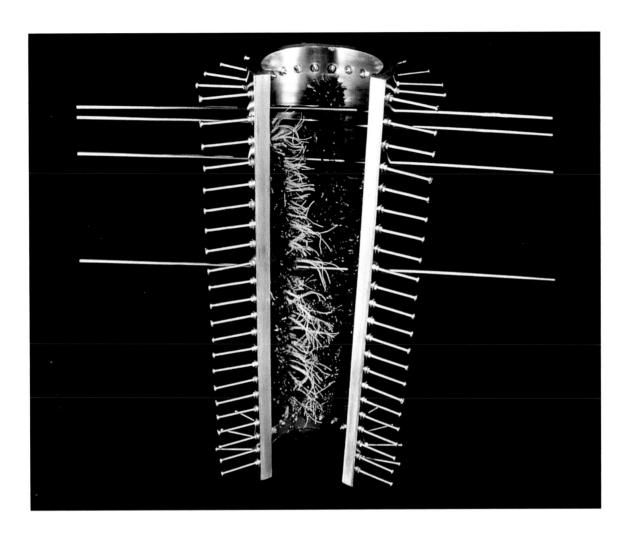

Helen Weston, 'FAMILIAL DISJUNCTURE SERIES', 1999.

by Edward Gorey, inspires alarming sculptural dynamics. The artist purposefully makes the sculptures physically menacing, rather than endowing them with enchantment as the rhymes prescribe. She wants to raise taboo issues that are symptomatic of dysfunctional family relationships. Her thinking behind such concepts is clear:

> … nursery rhymes familiar in childhood and manipulating adult readings of these texts, the suggestive sinister implications scratched out from beneath the façade of innocence are opened up. This precipitates a deeper investigation into the tyranny frequently occurring within the nuclear family.

In 'Familial Disjuncture' the artist employs techniques of metal fabrication, plaiting and gun-tufting. Weston's background and training is in textiles, yet the predominant material in her work is metal: aluminium, brass, steel and copper. She writes:

> … the tufting is inlaid into sheets of aluminium … it contrasts sharply in aesthetic with the austere quality created through the use of the metal sheeting. My work looks at secretiveness within structure; it investigates aspects of spillage and seeping, and the illusion of escape from such containing structures. The tufting's soft and organic fluffy quality and the decorative embroidery incorporated in some pieces alludes to something that is comforting, and inviting touch. This is contradicted by the enamelled wires that spill out of the pile, adding an air of danger – of unfamiliarity, of shock and discomfort.

CAROLINE MURPHY

Caroline Murphy's sculptures are founded on the principle of the reconciliation between opposites: soft, fragile textiles enjoying a symbiotic relationship with sheet metal. A lifetime's fascination with the collecting and researching of found metal objects has informed Murphy's work to focus on the challenge of marrying metal and incongruous materials. The deterioration of the metal is an absorbing preoccupation that translates into pared-down statements of an abstract nature with a strong surface texture. Murphy explains her passion:

> As a child I was obsessed with collecting found objects, particularly pieces of beaten metal,
> for example cans and fallen car exhausts. It is the surface qualities within these found
> objects that continue to fascinate and feed my passion to describe them within my work.

The study of leaf structures inspired the artist to develop a collection of sculptures that encapsulated the proud veining of the leaves through pleating, and to evolve the form with direct referencing. The sculptures' dynamic interior and exterior contrast in colour, texture and material, enticing the viewer to embrace their haptic sensibilities. Murphy employs a diverse range of materials including leather, metallic chiffons, plush velvets, luxurious silks and shiny, sheet copper.

Caroline Murphy, untitled, 2001. Dimensions: 14 × 8cm. Photographer: James Forbes Smith.

KARIN MUHLERT

Karin Muhlert's paper sculptures resonate with the ebbing and flowing of all life, and the rhythm of growth and decay. There is a time-less beauty that pervades her work: a simplicity of form that at a distance belies an intricacy of making. Her intuitive eye and crafts-man's skill takes the mundane and unremarkable base material of recycled paper rolls, and transforms them into exquisite, beguiling sculptures. For Muhlert, inspiration is from the wealth of organic forms shaped by the incessant impact of the forces of nature. Muh-lert is drawn to nature and the natural, which is echoed in her choice of material. She writes:

> Out of a mundane common material evolves a body that is equally vibrant, as it is fragile. The surface texture – that
> consciously evokes resemblance to the layered Mother of Pearl, the annual rings of trees, the rippled surface of a deserted
> beach at low tide, or the eroded surface of a limestone rock – hugs the eye and desires the hand to glide over it.

Muhlert's work presents a celebration of the potential of paper as a material for creative expression. The paper rolls are collected from recycling centres and paper mills. They are unwieldy and weighty to work with, but possess no preconceived notions as an artistic base material, and therefore the outcomes are revelatory. She approaches the rolls with the eye and skills of a sculptor, using both hand and power tools to slice, dent, twist, hammer, chisel and manipulate the paper into shape. She says of her approach:

> The paper that I use has both literally and metaphorically provided me with a blank page to explore my ideas,
> but it is also a base which has a life and history of its own. For my sculptures I have used unwound, narrow
> rolls of recycled, machine-made paper to shape non-functional objects in various scales that have encapsulated
> my emotional reactions to my personal life experiences. My sculptures have become my handwriting.

**Karin Muhlert, 'SEA-CELL',
2002. Dimensions: 19 × 68cm.
Photographer: Malcolm
Thomson.**

WANDA ZYBORSKA

Wanda Zyborska's contemplative sculptures are manifestations of her investigations of borderlines. Fascinated by the politics of gender, she chooses an unfamiliar visual language to address such issues. Pastoral detritus is assembled to stunning effect to create malleable forms that can be presented in a myriad of ways. The artist's peripatetic life is reflected in her work by its unsettled nature. The performance of moving the work to a new site, to create a transient 'installation', is continual and absorbing. Her practice functions on the interface between sculpture and performance: both the making and installing are documented to form intrinsic parts of not only her practice, but also the piece of work as a whole. The flexibility of the presentation formula is deliberate, as Zyborska explains:

> The shapes are mutable and undetermined. Many of the pieces are capable of being displayed in an infinite variety of ways.
> In fact it is almost impossible to place them exactly again as they were before. They are never finished, just temporarily at rest.

Zyborska's unusual choice of base material – recycled rubber inner tubes from vehicles, particularly tractors – is complemented by the employment of industrial fixings and mechanical linkages. The industrial dynamic and masculine overtones of the materials are

Wanda Zyborska, untitled (performance 5 on A55), 2000. Dimensions: 244 × 145cm.

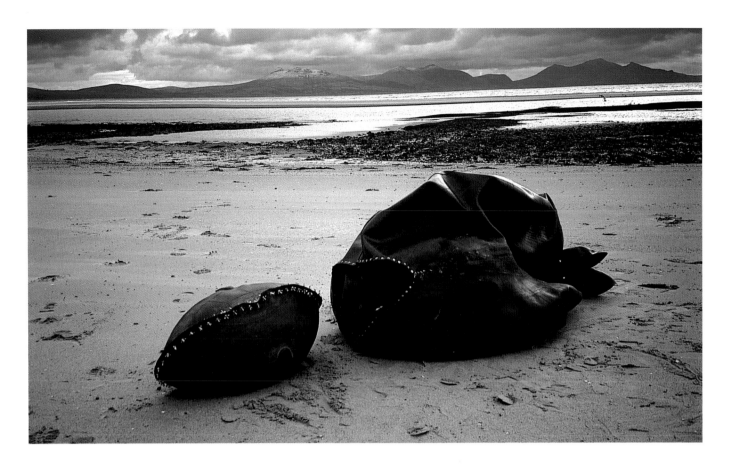

Wanda Zyborska, untitled (performance 4 at Llanddwyn), 2000.

paradoxically married with a traditionally feminine pastime: needlework and mending. The artist uses blanket stitch with a nylon thread to form seams and joins. She writes:

> The work inhabits the boundaries between genders. It is large and powerful, and some of the
> shapes are phallic. The nuts and bolts are masculine, and in some instances sharp and aggressive.

Omnipresent in Zyborska's sculptures is an innate sense of the body. The texture of the rubber may be likened to that of skin. Zyborska is attracted to damaged and repaired rubber tubes: she purposefully selects the highly patched, the flawed and the logoed to enhance the epidermal referencing. The soft, sensual rubber and the curvaceous line of many of the artist's sculptures evoke a feminine body, but Zyborska is always embracing ambiguity, and defies the safe gendering of her art by inclusion of a masculine presence. Most of her sculptures remain untitled, and her attitude is subversive in any attempt to impose a finite identification; she explains:

> The curves, bulges, crevices and folds in the work might be feminine – they threaten to engulf rather than
> penetrate the viewer – but they are also powerful and bulky, with a hunched and brooding presence. They
> could be seen to have a masculine persona ... I have deliberately engendered an ambiguity towards materials
> and process so that they defy simple gender categories or stereotypes. Just as people respond to scale,
> consciously or unconsciously they respond to what they perceive to be the gender of a work of art.

Zyborska's research into boundaries extends into the relationship of space between an art object and the viewer: the human body. People measure the physical world in relation to their own bodies. Controlling this space brings into play ideas of the creation of oppressive environments and the invasion of personal space. The large scale of Zyborska's work demands not only a space around them in order for them to be seen, but also to have them in focus. Narrowing the gap between elements alters both the perspective and the emotional reaction.

MADDI NICHOLSON

Maddi Nicholson creates plastic inflatable sculptures that are audacious both in scale and concept. Her work forms a personal narrative from childhood desires, through the years of teenage *angst* to the adult blooming of an artist. The spontaneity and vibrancy of her inflated works can be compared to Claes Oldenburg's everyday objects that formed gigantic parodies. His ability to visualize and make oversized spoofs of familiar objects has been subverted by Nicholson, who transforms childhood plastic toys of innocence and play into iconic symbols of power and sexuality: her own hallmark. The artist's fascination with inflatables stems from an unrequited childhood passion to own such objects. In adult life the collection has amassed to fill every cupboard in her studio; Nicholson says of her passion:

> My interests and my work have always concentrated on the kitsch and the bizarre. The interest is
> fuelled by the plethora of inflated PVC objects and other plastic 'toys' on sale in 'pound shops' and
> seaside stores, and which I have enthusiastically collected; plastic food to blow up dolls.

Nicholson's success lies in the ambiguity presented in form and concept. The first impression of her work is one of boldly coloured, gigantic toys fashioned just for fun – but the artist has redefined their purpose to act as potent symbols to deliver issues. Such

Maddi Nicholson and Stuart Bastik, 'BUNNY', 2000. Dimensions: 6 × 5 × 12m.

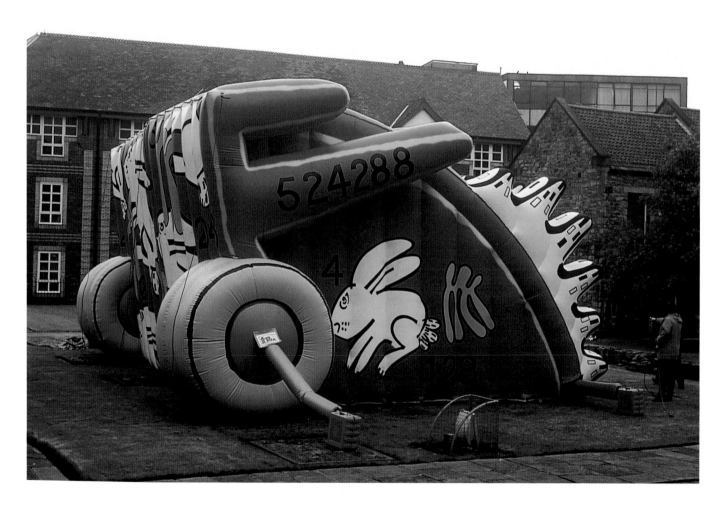

extraordinary artistic statements have considerable impact and are easily accessible to an audience, as both their size and form invite interaction and response, sometimes literally, as some pieces borrow the 'bouncy castle' formula, inviting admittance. Nicholson's work has multiple motivations, including examining issues such as rites of passage, gender and power, genetics and breeding. She reflects on her interest in adolescence:

> Looking at the period of a young girl's life when she moves from childish things to more adult thoughts. It's a peripatetic time, between two areas of life, fitting within neither particularly well. A time of great potential, optimism, insecurity, and ill-placed confidence. The outward manifestations of this period of change are almost a hybrid, a mixture of two different elements, the creation of a strange creature.

The transfiguring of animals is a recurring theme. The artist's rural childhood on a smallholding in Cumbria inspired the 'Going, Going, Gone' collection, which elevated the pastoral lamb into 7ft (2m) high monsters on wheels. Metaphorically, the lamb symbolized youth, optimism and opportunity, and ultimately the transience of life. Nicholson draws reference to concerns with genetic intervention through the manipulation of the animal figures to produce mutated forms: a two-headed lamb.

The artist has utilized her background in textiles, expanding her repertoire to include industrial materials and processes. Her approach to materials is from a two-dimensional perspective, as her primary focus is painting. Images derived from the paintings are inkjet printed by industrial machinery onto plastic. The journey to develop her work as a three-dimensional object is a challenge that she relishes. Nicholson explains this in simple, yet poignant terms: 'I'm making my drawings come to life by filling them with air.'

Maddi Nicholson, 'GOING, GOING, GONE £1.99 LB' collection, 1998. Dimensions: heights up to 4m.

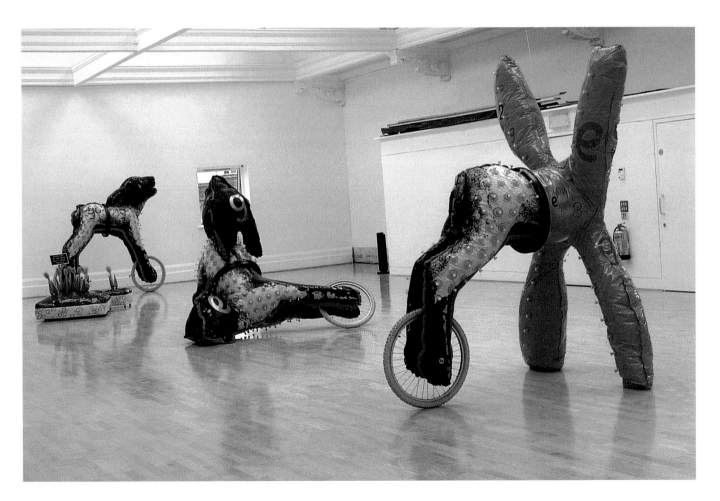

SARAH CRAWFORD

Sarah Crawford's sculptures are brightly coloured, whimsical forms of domestic and feminine adornments. They may resemble tea cosies and ladies' bags, but functionality, affordability and fashion are not considerations for the artist. Questioning the role and appearance of these items is from a humorous standpoint, rather than a feminist crusade. She writes about the choice of utilizing the bag shape:

> The pieces are bags in that they can contain objects, but the most important thing to me about them being bags was the possibility for being silly about their use or context; the one-offness (pricing) and materials of my bags means they don't get used, but that gives me more freedom for notions of use. 'Hairy String Bag' is so called because of its expanding qualities – like a string bag for onions or something – very everyday – but it is so un-everyday because it's almost too spiky to carry. 'Backless Evening Bag' is backless, like an evening dress, but it's a cheap pink shower curtain, so very unglamorous, and everything will fall out because it is backless.

Crawford's playfulness with the audience reveals a quirky sense of humour and a love of building intricate constructions with unlikely combinations of materials: sheet plastic and rubber, plastic cable ties, acupuncture needle tubes, drinking dispenser tubes, fishing line, PVC cord and nylon washers. These mundane materials are presented in hot colour combinations evoking gaiety and celebration. Fundamental to Crawford's practice is the fascination of the creative journey with materials through innovative methods of construction and joining. The challenge is to use unconventional, flimsy sheet materials, and through the employment of textile techniques – folding, smocking and pleating – create forms that have a strong visual and tactile presence. Her work never disguises its methods of construction; for instance,

**Sarah Crawford, 'RUBBER TEA COSY',
1999. Dimensions: 22 × 17 × 17cm.
Photographer: Richard Stroud.**

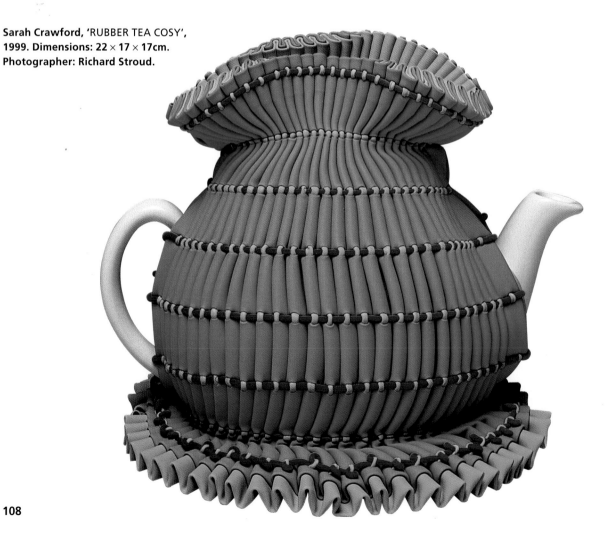

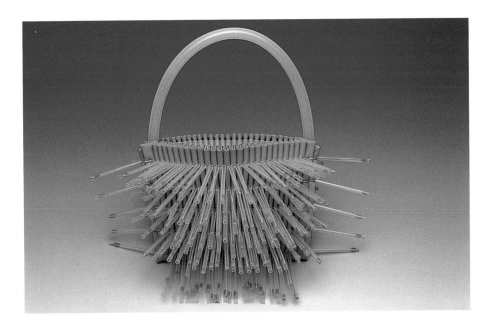

Sarah Crawford, 'FRINGED BAG', 2000.
Dimensions: 24 × 20 × 18cm.
Photographer: Richard Stroud.

joins are celebrated and designed to enhance the overall impact of the piece, often through forming the decorative element. She writes:

> The visual qualities of a join are as important as the construction and appropriateness of the materials. My joins are part of the surface of a piece, never hidden, and often the only decoration in a piece, usually creating pattern. The joins and the pockets and creases that are created through pleating are my motif. They are repeated for constructional purposes, creating pattern.

The involvement of pattern in Crawford's work has evolved instinctively: she uses repetition to change the relationship the viewer has with a commonplace object. Crawford explains her approach:

> My brain wants to balance, mirror and repeat things. It is spatially mathematical (rather than numerically).
> It works in halves, then quarters, then sixteenths, dividing by folding (rather than measuring). If I pleat
> a sheet of PVC I can start in the middle and work outwards, echoing everything I have done on the left. Or
> I can start at one end, pleat a row and then pleat at the other end in its image. There are rules and a need
> to balance, but it is not an obsessive compulsion to repeat and repeat, it is just a visual language.

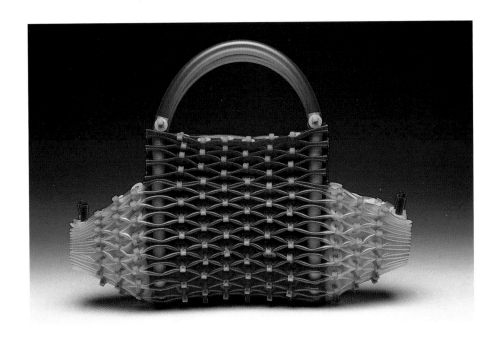

Sarah Crawford, 'BACKLESS EVENING
BAG', 2001. Dimensions: 22 × 30 × 12cm.
Photographer: Richard Stroud.

SIMONE COBBOLD

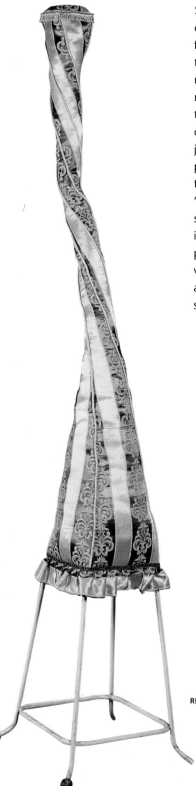

Simone Cobbold's sculptures are assemblages of discarded materials restructured into pieces of hybrid furniture. Cobbold's success lies in her innate ability to endow redundant objects, that others regard as rubbish, with a unique enchantment. Her personal narrative is informed and inspired by the sentimental notions associated with domestic space and its contents. The artist takes her waste materials on a journey of transformation in which they metamorphose into sculptures that capture figurative characteristics and sometimes a whimsical demeanor. Her 'family' of forms bizarrely expound the virtues of stained, scratched and worn furniture: the artist identifying more closely with the damaged than the pristine. Cobbold's approach is to present her reinvented forms with a redefined glamour, bestowing an elegance and purpose on items salvaged from a skip! Cobbold explains:

I work with secondhand furniture and fabrics. The pieces I choose to work with are rescued from skips, off the side of the road, or bought from junk and charity shops. Often the objects have been discarded because of 'faults', fabrics torn and stained, furniture sagging or scratched. It is this evidence of human use and contact that I find interesting, these 'faults' are the clues to each piece's life history, and will often determine their final character. The resulting forms hinting at a slightly sinister vision of femininity and the domestic space.

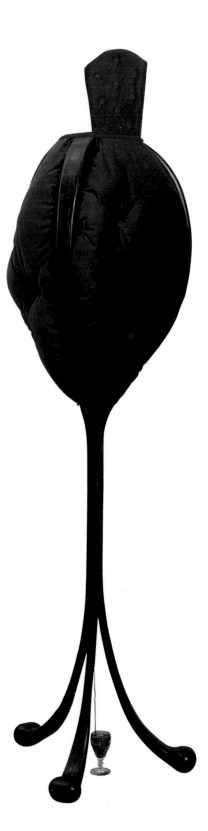

LEFT: **Simone Cobbold, 'DOLLY', 2000. Dimensions: 233 × 49cm. Photographer: Colin Campbell.**

RIGHT: **Simone Cobbold, 'VACANT', 1998. Dimensions: 174 × 49cm. Photographer: Colin Campbell.**

FAR RIGHT: **Simone Cobbold, 'TALL LADY', 1999. Dimensions: 357 × 38cm. Photographer: Colin Campbell.**

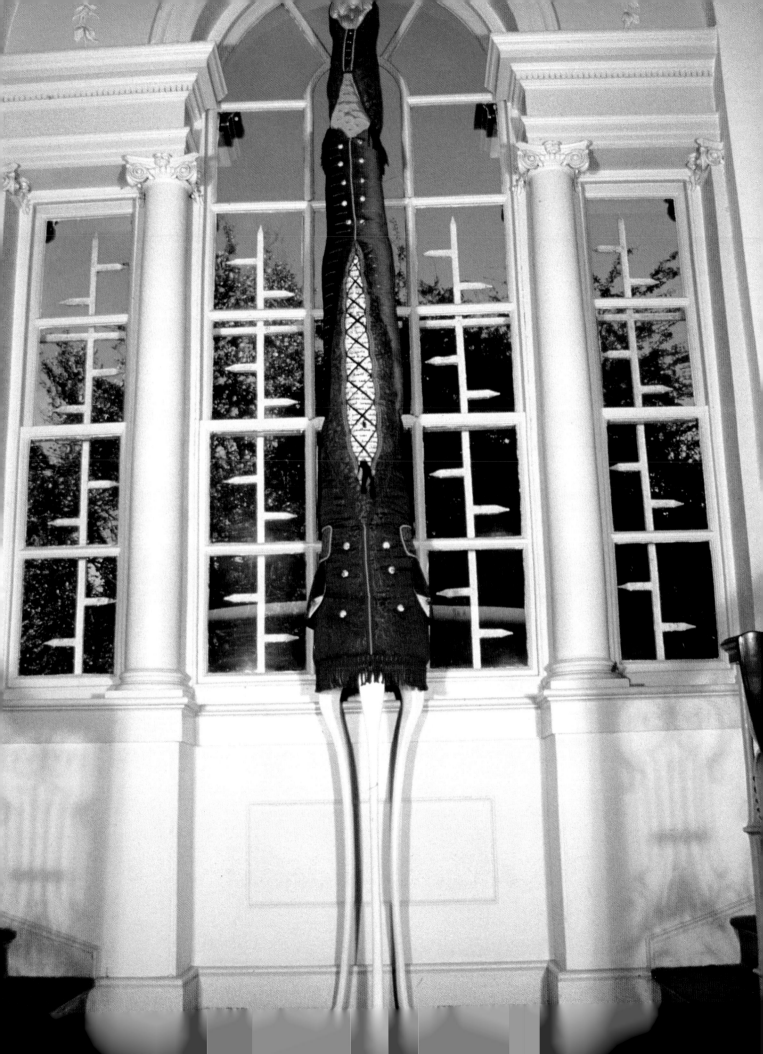

SHELLY GOLDSMITH

Shelly Goldsmith's work explores the theme of water in all its states, from liquid, solid and gas, and its subsequent mutations. She investigates this vast subject from both a global and an intimate perspective, researching weather systems, especially rainfall and floods, and more recently bodily courses, including amniotic fluids. Her fascination with the global rhythms and the continuous cyclical nature of these systems involves study of the relationship between the moon, the sun and tidal patterns. Goldsmith's approach is to take the simple and daily chore of a drink of water and explore the route of the flow of that water through the body and out back into the earth.

She writes of her interest in water:

> My current focus of interest is the never-ending ecosystem that acts as a metaphor for life and death – for the things that we do not have much control over! I have considered, for example, a glass of water after it has passed the lips. Our bodies are composed mainly of water, and since water travels constantly over the earth, we must be linked to everything else on earth? There are some things from which you cannot escape.

Her work has a strong textile bias, concentrating on tapestry as a technique to expound her theories, but Goldsmith's three-dimensional work challenges conventional orthodoxies. She explains:

Shelly Goldsmith, 'MONSOON CAPITAL', 1999. Dimensions: funnels 25 × 25 × 17cm. Photographer: Andrea Heseltine.

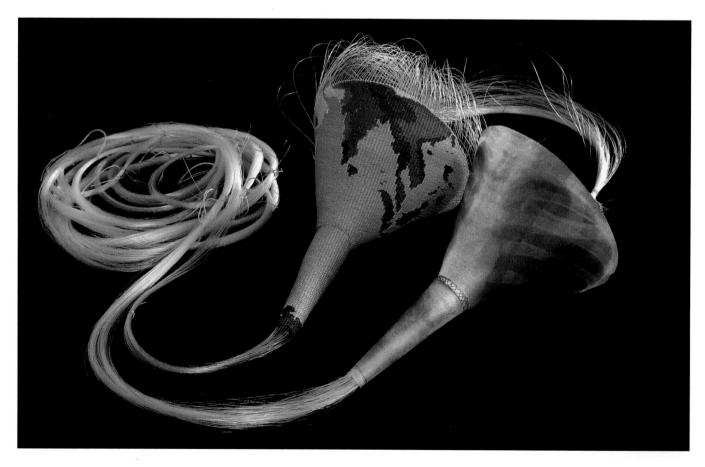

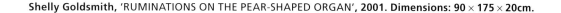

Trained in the traditional French Gobelin technique, I was taught that tapestries were hung on the wall, and that the warp threads were a structural necessity but were not to be seen. My recent work has challenged this dictum, and the tapestries have become tiny while the warp has become huge; also, they are very often free-standing. The urge to liberate the tapestry from the wall has become a recurring feature of my work.

Since leaving college she has redefined the traditional art form of tapestry weaving by deconstructing its fabric in the search for a more personal form of expression. The artist divulges her torment:

I have a love-hate relationship with the medium of tapestry, which creates an on-going debate with the boundaries that define the technique. During my formative years after leaving college, when I was exploring my territory and developing a visual language, I was known to deface it, to cut lengths of lovingly woven tapestry, to bleach out large sections of colour, and then use my own hair to sew it all back together again. All of this in an effort to find an appropriate answer to a visual question.

During a period of research at the Welcome Institute, the artist became absorbed in the study of the uterus (known as the 'pear-shaped organ'), its role, liquid elements and form. In traditional executions of tapestry weaving, the warp threads remain invisible. In Goldsmith's hands, for the sculpture 'Ruminations on the Pear Shaped Organ' (created in response to the research at the Welcome Institute), she has the warp threads flowing from the main body of the piece alluding to seeping, bodily fluids. Presented on a stainless steel table, this referencing to the clinical and the medical is evident.

Shelly Goldsmith, 'RUMINATIONS ON THE PEAR-SHAPED ORGAN', 2001. Dimensions: 90 × 175 × 20cm.

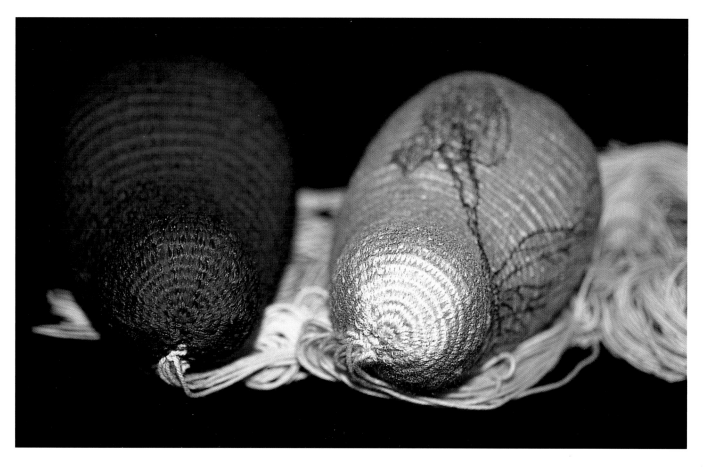

MARY COZENS-WALKER

Mary Cozens-Walker's work forms an autobiographical collection of sculptures executed in plaster, paint, papier mâché, yarn and textiles; it is a substantial body of work bordering on the confessional, as the narrative reveals both milestones and trivia in the Cozens-Walker household. The closely observed minutiae of her domestic life are documented in figurative sculpture that demands a closer inspection. Her training in painting underpins her work, but it was not until the potential of stitch was explored that she felt liberated. The use of stitch provided a rich source of texture, and another layer for discovery for both the artist and the audience. The window into her world, that she presents us, shows not only a humorous love of life but also a vulnerable frailty that reflects a humane observation and thus avoids such responses to her work as sentimental ornaments.

Cozens-Walker is steeped in European traditions in art, referencing an eclectic mix of influences: Rembrandt to Giacometti, cartoonists to wood engravers. She is greatly influenced by the old comic traditions of satirists such as Hogarth, Rowlandson and Gillray. She writes:

> The human predicament is touchingly vulnerable and funny, with possibilities of great heights
> and depths. Popular art has dealt with these aspects of life with honesty: the cartoons of
> Rowlandson and Gillray in the eighteenth century were powerful communications.

Other influences are cited as Joseph Cornell, with his boxed assemblages of everyday objects; Stanley Spencer, for his employment of pattern and texture in his paintings; Elizabethan miniatures; and seventeenth-century stumpwork embroideries. Cozens-Walker describes her approach:

> I paint with thread, and lay my colours down
> as much as I laid colours down with brushes
> and paint. This slow process allows me to make
> and compose much stronger images – stitched
> pointillism? It is of little interest to me to make
> stitched pictures – it is quicker to paint them!
> I decided to 'come off the wall' and make
> stitches 'earn their keep': thus the stitched
> element in my sculptures is often something
> you discover on second impact, by opening
> a door, lifting a lid, or switching on a light …
> It is at this point that the viewer is caught in
> my magic, humour and strong passions.

Mary Cozens-Walker, 'POMONA GREEN', 2000.
Dimensions: 13 × 13 × 28cm.
Photographer: Reeve Photography.

Cozens-Walker has developed a powerful, very personal aesthetic language that transcends the banal as it references the experience of the human condition and the situations common to most domestic households. She quotes Jeanette Winterson to explain her artistic philosophy:

> Art is about tapping into the human condition and trying to define those turbulent but often inarticulate emotions that beset everyone. Re-assurance isn't about the answers, but finding a language and a structure to your feelings.

'Pomona Green' was created after research into a seventeenth-century ceramic ornament in the FitzWilliam Museum in Cambridge. This whimsical self-portrait was inspired by the legend of Pomona, the Roman Goddess of Fruit, who was said to be so devoted to her orchard that she spurned all suitors until she was wooed and won by the God Vertumnus. The audience is invited, by the enchanting tale, as with many of the artist's creations, to allude to Cozens-Walker's own love story.

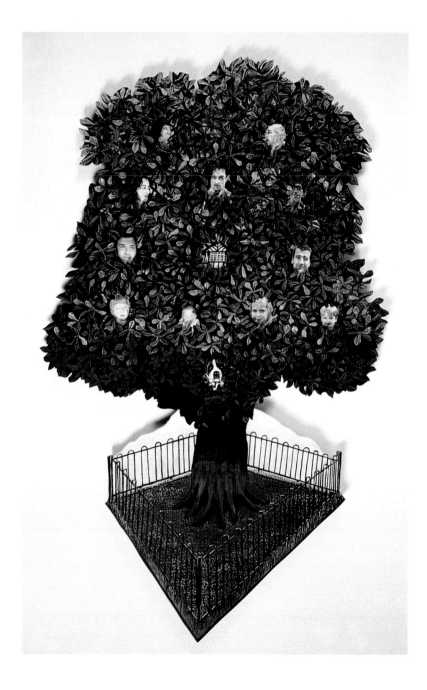

**Mary Cozens-Walker,
'KATZ FAMILY TREE', 2001.
Dimensions: 127 × 76cm.
Photographer: Reeve
Photography.**

FRANÇOISE DUPRÉ

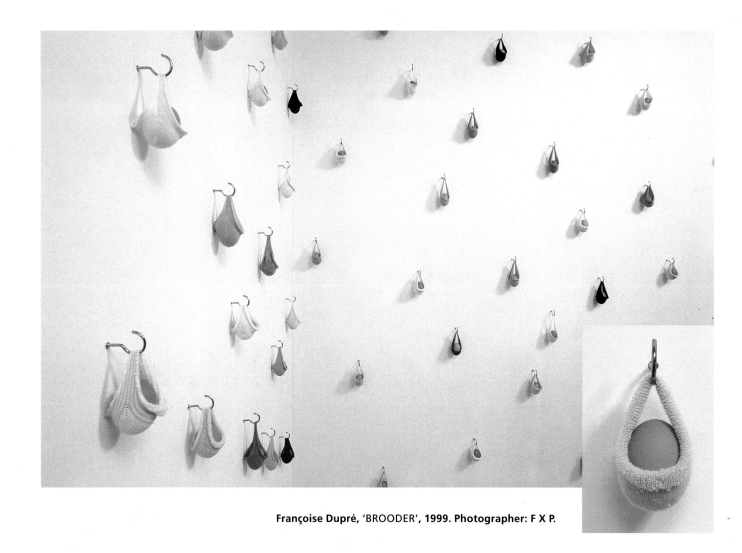

Françoise Dupré, 'BROODER', 1999. Photographer: F X P.

Françoise Dupré creates transient sculptures and installations that explore issues of otherness, displacements and cross-cultural experiences. Her French origins and British residency combine to influence her creative journey through bilateral referencing and the re-situating of the paraphernalia of daily life.

Dupré collects obsessively, an eclectic mix of objects associated with the domestic interior: scouring brushes, rubber gloves, children's tights and socks. These ready-made and handmade objects are transformed into fine art hybrids in multiple and repetitive statements by cutting, wrapping, stretching, clamping or pinning. The aim is to question the gender politics surrounding menial tasks, such as cleaning, and the semantics associated with the language of clothing.

In 'Brooder', five dozen fresh eggs were nurtured in cut heels of infant hosiery. The installation was part of a series of work that explored the concept of motherhood and domesticity. Dupré writes of her work:

> Domesticity, the construction of femininity and motherhood are issues that I have explored in my work for some time.
> My work is informed by feminism and my reading of psychoanalytical theory. Nevertheless it often has a personal
> origin, like my relationship with my mother, my dislike of domestic tasks, my identity and cross-cultural experiences.

'Brooder' was a natural development from a curatorial post for an exhibition for the Fetal Medicine Unit at St George's Hospital in London. The artist became absorbed in the way babies and children's clothes and toys contribute to the construction of a fixed sexual identity. This embryonic study led to 'Brooder', and a continuing fascination with children's hosiery. Dupré states:

> Brooder came about after spending time manipulating babies' and children's socks. The padded and soft heel of the sock appears strong, and once cut becomes a small nest, reminding one of a tale of the stork bringing the new baby. The egg is a very obvious choice, but one that I at first rejected, but chose at the end because it is a simple and clear metaphor for life, food and motherhood. The fresh heavy egg, often too big in a nest, stretches the fabric around the hook. There is an element of fragility and danger in the installation. The room filled with eggs is a brooder (a heated house for chicks), a factory farm. A brooder is also a person who broods, and the installation aims to raise questions about fertility.

Everyday cleaning utensils and aids are selected by the artist to explore with humour and imagination issues of domesticity. The tips of brightly coloured rubber gloves are used to strong effect in a recurring project called 'naturalization'. The temporary work is installed at selected sites around the world – from Grizedale Forest in the Lake District in England, to St Petersburg in Russia, and along a coastal walk between Bondi Beach and Tamarama Bay in Australia. The sculptures are pinned down in the ground for a momentary installation to startle the audience to reconsider boundaries between private and public spaces, urban and rural environments, art and daily life.

Françoise Dupré, 'NATURALIZATION', 1999.

JOANNA CHAPMAN

Joanna Chapman's sculptures are spatial materializations of her travels, both actual and imaginary. The sculptures are microcosms that articulate her personal relationship with landscape, particularly the Fens in East Anglia, where she lives. The land provides not only a rich, creative source for inspiration, but also much of the material, in the form of treasured found objects that she uses in her work. She writes of her appreciation for the geometric landscape:

> The Fens with their vast skies, omnipresent horizon and black fields are of a scale and flatness that seem alien to England.
> In the rigid geometry of the land, everything is reduced to regular shapes compressed between sky and earth.

Walking, collecting and recording are intrinsic activities in her practice. The land acts as a resource: her intention is to invoke it, not depict it. The sculptures are composites developed from creative journeys with base materials, found objects, photographs and stitching. Chapman employs wax as a material for petrifying elements and achieving a subtlety of texture and colour. The wax 'calms' the components, evoking a serene ambiance around and within the form. The artist values this transformation; she writes:

> Something magical happens when the wax is poured, partially submerging the objects;
> they then seem to take on a new quality, as if they are trapped in sediment, mud or frozen ice.

Photography and drawing are used in Chapman's work to capture evanescent moments witnessed on her journeys across the land: fleeting light and colour changes. The immediacy and speed this process of documenting change provides is in stark contrast to the slow, intricate craft of the making process of each piece. The images themselves are often incorporated inside the reliefs, as they are considered to have elemental status rather than just referential.

Joanna Chapman, 'WINTER MUD, SUMMER FIELD', 2000.
Dimensions: 124 × 22 × 6cm.
Photographer: Miki Slingsby.

Joanna Chapman, 'TIDE', 2000.
Dimensions: 71 × 71 × 8cm.
Photographer: Miki Slingsby.

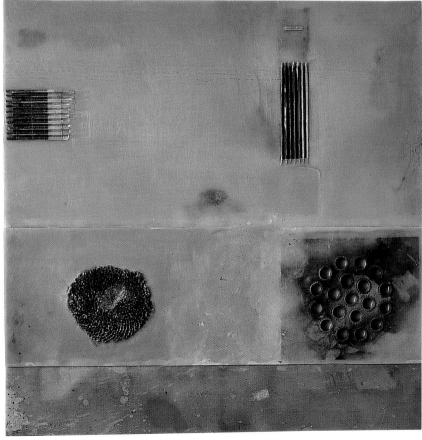

Joanna Chapman, 'BIRD MIGRATION',
2000.
Dimensions: 71 × 71 × 8cm.

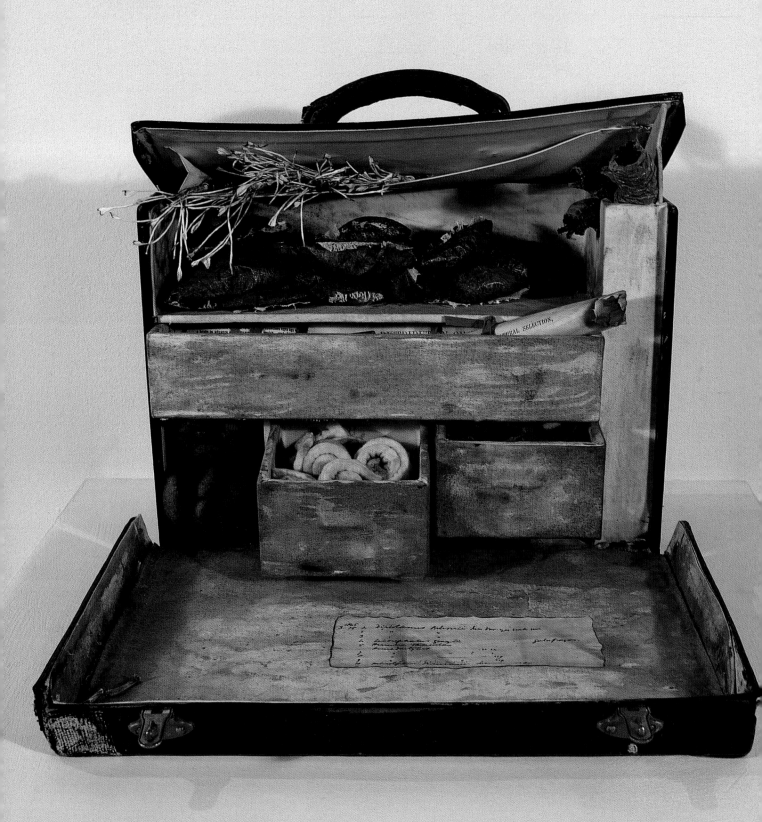

PENNY BURNFIELD

Penny Burnfield's work is a physical manifestation of her need to try and make order out of a chaotic world. She is interested in the human compulsion to collect, classify and categorize. Burnfield's scientific mind led her originally to train as a doctor, but after early retirement she changed to a career with a stronger creative focus. However, this primary knowledge has since evolved in her work, informing her practical exploration of material and process to create multiple pieces that resonate with her medical insight. The ambiance surrounding her sculptures hints at surrealism and the distant sounding of Joseph Cornell's assemblages. The sculptures are paradoxically alluring and disturbing at the same time. Studying the sciences of medicine, embryology, evolution, palaeontology, botany, zoology and archaeology has led to the creation of work with titles such as 'Darwin's Box', 'Specimen Collection', 'Relics' and 'Ancient Preserves'. Each collection is carefully made using a wide variety of materials such as felt, yarns, paper, paint, wax, dye, raffia, thread and wire, and techniques including dyeing, felting, stitching, binding, wrapping and burning. These are presented as organized modular installations of groups of sculptures in accepted formats – in glass jars, on utility shelving, in medicinal cases and simple wooden boxes. Labels form an essential ingredient, often unintelligible to the casual observer, as the artist utilizes the system to privately identify to herself cryptically the places, times and knowledge relevant to the item.

Burnfield writes of her creative philosophy: 'Like the alchemists of old, I see myself as the "base material" which I hope to transform through my work.'

LEFT: **Penny Burnfield, 'DARWIN'S BOX',
2000.
Dimensions: 43 × 43 × 36cm.
Photographer: Garrick Palmer.**

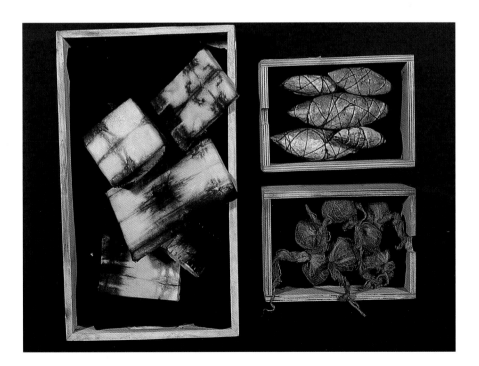

**Penny Burnfield, 'RELICS', 2001.
Dimensions: 90 × 100 × 43cm.
Photographer: Garrick Palmer.**

ANNIKEN AMUNDSEN

Anniken Amundsen is absorbed in looking at uncontrolled growth and mutations. Her visually compelling sculptures have a strong conceptual foundation based on medical literature, cell biology and oncology. Her research into cancer is underpinned not only with a personal response to the psychological forces that abound in this emotive subject, but also through the experiences and feelings of patients, relatives and friends affected by the disease. Amundsen writes of her fascination:

> The word 'cancer' itself makes most of us shiver with fear. It is a word and an illness that gives close associations to pain, sorrow and death. What is cancer? Is it some kind of creature or monster that spreads its venom randomly in our bodies, or is it an other-worldly parasite that consumes human bodies one by one and proliferates in the inner darkness of the body?

It is important to Amundsen to use her sculptures beyond their obvious weird beauty to confront difficult subject matter. 'Invaders' is a body of work in which she confronts perceptions around cancer. In 'Invaders', she feels she is literally fighting against the merciless forces and invaders that her sculptures will eventually manifest themselves as. Her counterattack is through the struggle of wrestling with materials and techniques to the creation of the sculpture. Amunsden's choice of materials reveals an essential understanding of her work: they reflect the conditions she is addressing. Therefore, rubber and silicone have parallels with skin, insects, worms, medical tubes, veins and so on. Amundsen explains:

> These visualizations of cancer show a strategy of disarming the invader by making the invisible enemy visible, and lead an active psychological counterattack on the many wounds and scars of cancer.

She actively embraces aspects of uncertainty and unpredictability creatively, in process and technique. She says of her approach to the process:

> I find it stimulating to look upon the process of creation as a battle between me and the sculptures, achieved by continuously manipulating and forcing boundaries.

Amundsen is always striving to manipulate and challenge a traditional construction method with unusual juxtaposing of materials. Her current interest lies in utilizing a mixture of weaving techniques from the traditional floor loom, the tapestry frame, and techniques normally associated with basketry. The choice of materials – plastics, rubber, nylon and metal – delivers tactile sculptures that intrigue and disturb. Lesley Millar wrote of Amundsen's work in the *Invaders* catalogue 2002:

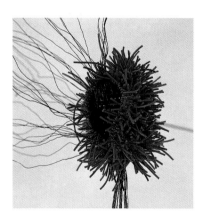

LEFT: **Anniken Amundsen, '1-09 GROWTH CONES' (detail), 2001. Dimensions: 180 × 15cm. Photographer: Kjartan Proven Hauglid.**

RIGHT: **Anniken Amundsen, '1-01 PARASITE', 2001. Dimensions: 185 × 60cm. Photographer: Kjartan Proven Hauglid.**

> Amundsen uses her understanding of popular culture and her knowledge of trauma to transcribe explicit medical imagery. She has devised a specifically personal, visual and textile language that allows her to create a representation of her inner reality, those cancer cells that were mutating and reproducing. The manner of making her three-dimensional textiles presents the viewer with a perception of both interior and exterior form. There is a sense that the outline is in a process of continuous change; the shapes created appear to be moving from the centre, outward, penetrating the surrounding space. And while 'they' are 'out there' we can, safely, look and respond.

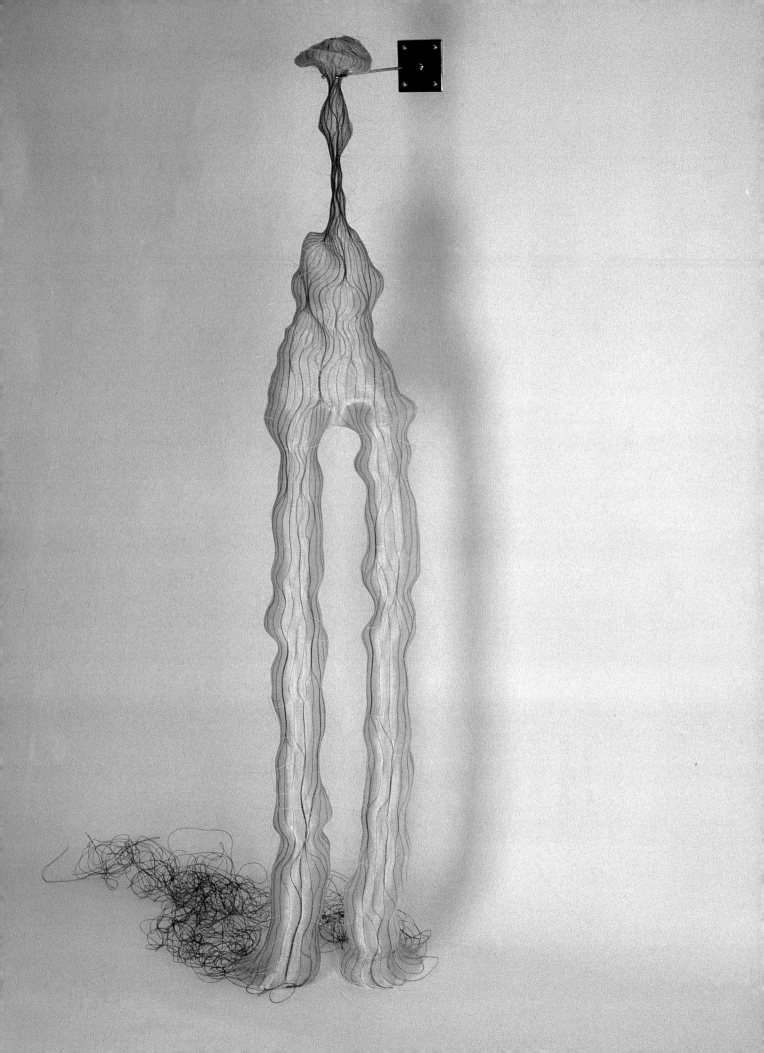

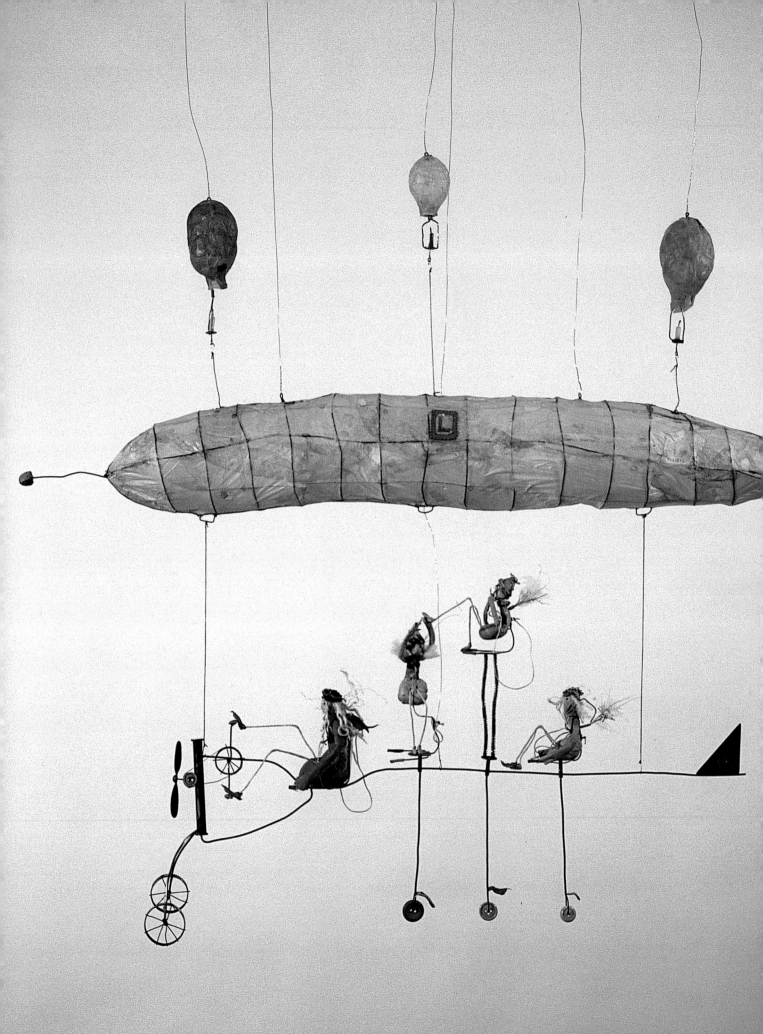

SAMANTHA BRYAN

Samantha Bryan's sculptures capture a fantasy world of Victorian gadgetry and fairytale adventures. The orchestration of the differing elements reveals a playful enjoyment of space, subject matter and a strong craft sensibility. Bryan's inspiration, she confesses, comes from an overdose of bedtime stories as a child, which have fuelled her overactive imagination to design and create sculptures that rekindle the mythical characters of her childhood. Bryan explains:

> The success of my pieces stems from my ability to step into my fairy shoes, therefore realizing the necessities and requirements that would be involved in fairy life.

Her sculptures are reminiscent of the humorous constructions made by the Italian artist Fausto Melotti in the 1960s. There is the same poise and delicacy in the sculptures, and an empirical approach to materials. The use of wire to form the outline of the figure, and sometimes a machine, not only acts as a basic armature or framework, but it also enhances the whimsical quality of the piece. The exaggerated lengths of the spindly limbs animate the characters in mildly eccentric poses whilst they busily perform their tasks. The sculptures are very intricate, made from tiny pieces of material and found objects: the attention to detail is delightful.

A lovable lunacy is revealed in the titles of the sculptures; for instance, 'Brains Fairy Visability Maximisation Device', 'Brains Fairy Flight Inducer' (helps train young fairies to fly), and 'Nemphy the Dream Catcher fairy', equipped with suction apparatus to capture bad dreams before they cause distress!

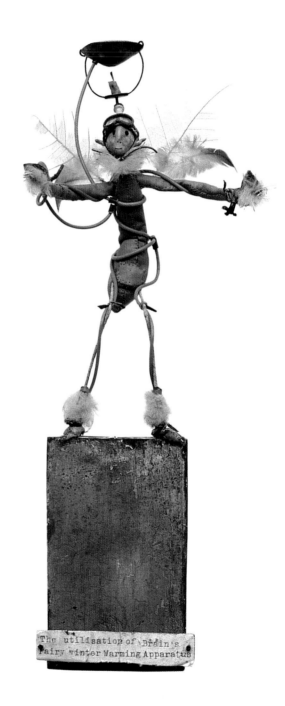

Samantha Bryan, 'THE UTILIZATION ON BRAIN'S WINTER-WARMING APPARATUS', 2001.
Dimensions: 30 × 15 × 7cm.

Samantha Bryan, 'BRAIN'S FAIRY FLIGHT INDUCER', 2000.
Dimensions: 100 × 80 × 20cm.

LUCY BROWN

Lucy Brown's work addresses issues surrounding female identity through the distortion of second-hand clothing. The sculptures form poetic visualizations resembling a shed skin, a metaphor adopted by the artist, to draw attention to the ambiguity between public image and the private self. Brown writes: 'Each form is a shed skin without a skeleton of bones for support.'

Her sculptures are poignant, yet amusing, with titles such as 'Second-hand knickers aren't very nice', 'Mutton dressed as lamb' and 'Indecent exposure'; yet paradoxically there are dark undertones of suppressed feminist issues. She is fascinated by the disembodied garment and its unknown history. This interest not only manifests itself in the transforming of the garment, but also with the wearing of it. This very intimate interaction with her materials Brown feels is vital to understand the power of the garment on the wearer. It informs the wearer not only of its original purpose, but also the potential for the revealing or concealing of the self. Undergarments are deconstructed, stretched and tensioned to display the previously unseen.

The construction, make-up and fabric of discarded clothing are all studied, and then manipulated to achieve a reinvented form. Female nightwear and underwear are shrunk and contorted using weaving techniques developed by Brown. Steel wire is often employed as a warp, for both its structural integrity and its assimilation with boning in traditional corsetry. The echoes of historical fashions for thinness resonate clearly in these subversive stitches. The details such as labels, collars and lace are untouched, whilst the body of the clothing is shredded into strips and woven to form a sculpted cloth. Her success is not only the ability to transform the most mundane piece of clothing through meticulous craftsmanship – such as a size eighteen nylon and polyester petticoat into an ethereal work of art – but also to engage the viewer to question society's obsession with women's shapes and the fashion for thinness. The weaving technique she has developed has led to a predilection for slender forms underlining the artist's message and comment on society.

Brown's research and inspiration extends to the investigation and analysis of marketing trends, and in particular of the presentation of women's clothes, in women's fashion magazines. The publications form a document reflecting the way that females aspire to be, both in image and in appearance, or controversially how the fashion press promotes this idiom. At the end of the last century, attention was focused on the morality of wearing real fur coats by journalists and the so-called 'super models'. A traditional wearable icon of the rich, the fur coat epitomizes the wardrobe of the wealthy. Brown was intrigued by the challenge of the use of real animal fur in clothing, and this stimulated the creation of 'Petti-Fur-Coat'

Lucy Brown, 'SQUEEZE', 1999.
Dimensions: 174 × 18 × 13cm.
Photographer: Sara Morris
(courtesy of the Crafts Council).

Lucy Brown,
'WEAR ME WITH TENDER
LOVING CARE', 2000.
Dimensions: 275 × 47 × 25cm.
Photographer: Bob Curtis.

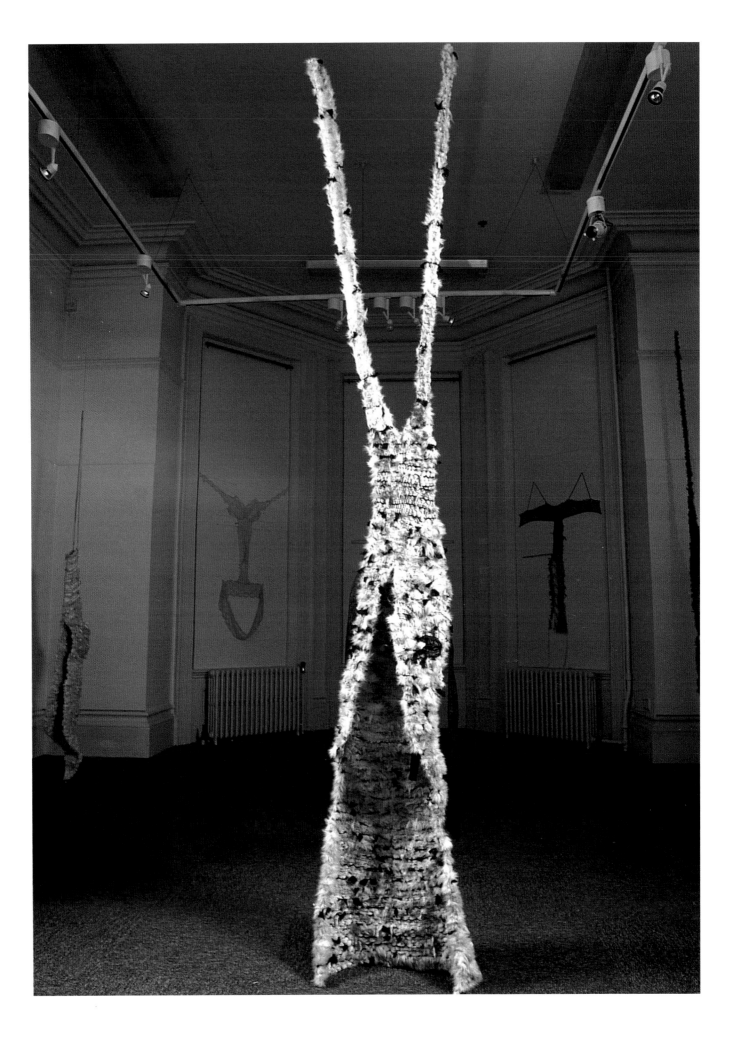

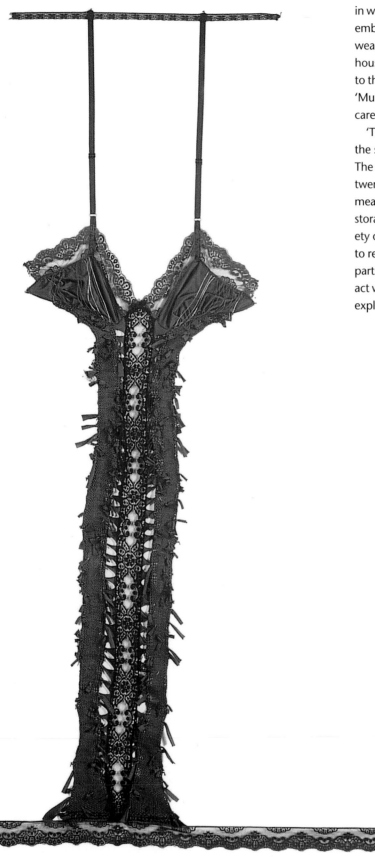

in which a fake fur coat was disfigured by dismembering and dis-embowelling, then it was cut into strips and sculpted with weave and wire to imitate an animal strung up in a slaughter-house. The issue has formed a recurring theme, with additions to the collection complementing and reinforcing the message in 'Mutton dressed as lamb', and 'Wear me with tender loving care'.

'The Bride's Clothes' was a collection of sculptures that took the symbolic garment of the wedding dress as its base material. The wedding dress holds a particular social status even in the twenty-first century. For Brown, the bride's garb is imbued with meaning, from its virgin white pretentions, through its cherished storage, and finally its destruction in divorce. She utilized a vari-ety of dresses, including a sari, to reconstruct the final outcomes to reflect their origins. The dresses were dismembered and these parts were kept and presented as pieces the public could inter-act with, by trying them on behind the finished sculpture. Brown explains her approach and thinking behind the collection:

> The ideas behind 'The Bride's Clothes' explore the changing attitudes to marriage in Britain's multi-cultural society. … The strips of mixed fabrics have been woven into a cotton and boning warp. The effect is an integration of colour, and the sequins from the sari add something magical. The colours that stand out are red, white and blue, and although not the true tones of the Union Jack flag, I feel that this draws on the idea of multi-cultural Britain.

Lucy Brown, 'S-T-R-E-T-C-H', 1999.
Dimensions: 130 × 125cm.
Photographer: James Newell
(courtesy of Maidstone Library Gallery).

SUSAN CUTTS

Susan Cutts explores the relevance of dress to identity, and the interaction between wearer and observer, through the use of familiar clothing and footwear. She investigates the fact that the orchestration and multiplicity of the form makes the individual components lose their original identity, and suggests an alternative image. She has put this to powerful effect, with multiples of white stiletto shoes evoking scenes of flocks of birds. In a similar approach, 800 black doll-sized dresses took on a menacing presence when used to impersonate vultures. She writes of these interpretations: 'I was interested in how the dress of a toy took on a sinister appearance, and yet the stiletto, by its very name a weapon, takes on the appearance of birds and swans.'

Cutts works exclusively with paper, challenging both the material and the process to stand alone in her sculpture. She likes to have complete control over her material, and therefore would find it unsatisfactory to use a ready-formed substance made by someone else. With paper she can manipulate the technique to achieve the desired results and build sculptures that at distance appear duplicates, but on closer inspection reveal subtle nuances.

The installation of a sculpture is of paramount importance to the piece, and considered by the artist to be a natural extension of the work, therefore Cutts always insists on doing this herself. She states:

> What is very important to me from the beginning is the display of the work. I am naturally untidy, can't draw a straight line, add everything up wrong, and hate conforming; but in my work, uniformity, symmetry and balance are vitally important. I will spend a long time measuring a room before siting the work. ... I have to have balance.

For 'Stiletto', over 500 shoes were installed, and she writes:

> I like to install my work myself, ... the opening of the boxes, tucking in tissue paper, and then placing the shoes on top. The shoes are not placed in straight lines

Susan Cutts, 'A DRESS, A DRESS' exhibition, 2001. Installation detail of stiletto shoes. Photographer: Nicki O'Neill.

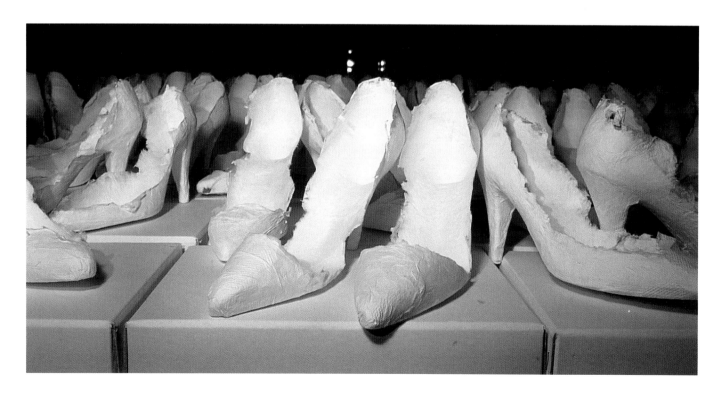

... shoes meander over the rigidity of the boxes, escaping their
captors, as we often cross the line of fire in life, in our work.

The installations are enhanced by the manipulation of light to create ambiance, with powerful shadows enticing the audience to contemplate the scene with questioning eyes.

Cutts chose the white stiletto shoe for a body of work that took five years to complete, not only for its elegant form, but for its associations with the feminine. She was absorbed by how the initial inspiration was transformed when consistently repeated in a group formation. The 'Stiletto' project developed to encompass its textile equivalent, the little black dress. Again the female staple garment was paraded as bodiless paper dresses, this time in straight lines. This regimentation was reminiscent of advancing armies or chess pieces. Minimalist tendencies were again employed, with a monotone palette and a simplicity of form.

In 'Ashes of roses', Cutts' penchant for a mathematical dynamic in her work manifests itself as ordered boxes of paper shoes and roses, in rows of seven, representing days of the week, and then in months, nine months, signifying conception to birth. Inspired by some research into the lives of women in the seventeenth century, Cutts examines the cycles of birth and death. In each box there is a pair of simple child's shoes with intertwined laces, a metaphor for the umbilical cord. Meanwhile the roses represent purity, death and marriage.

Susan Cutts, 'A DRESS, A DRESS', 2001.
Installation at the Mission Gallery.
Photographer: Nicki O'Neill.

Susan Cutts, 'DRESS UN DRESS', 2001.
Installation at the Mission Gallery.
Dimensions: each dress 60 × 40cm.
Photographer: Nicki O'Neill.

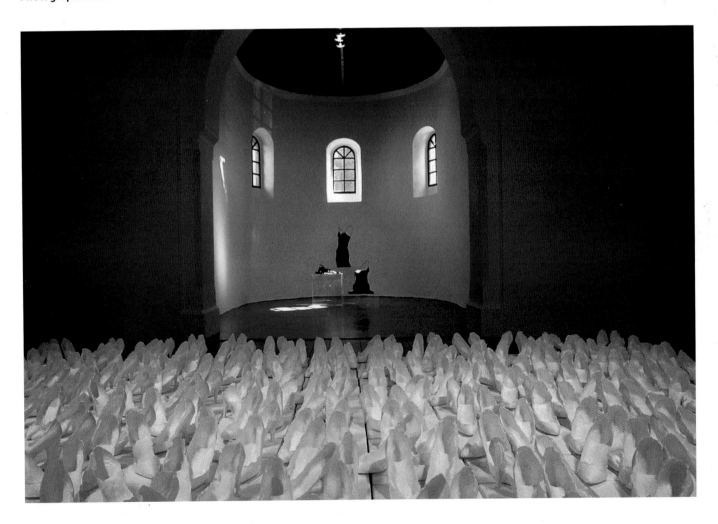

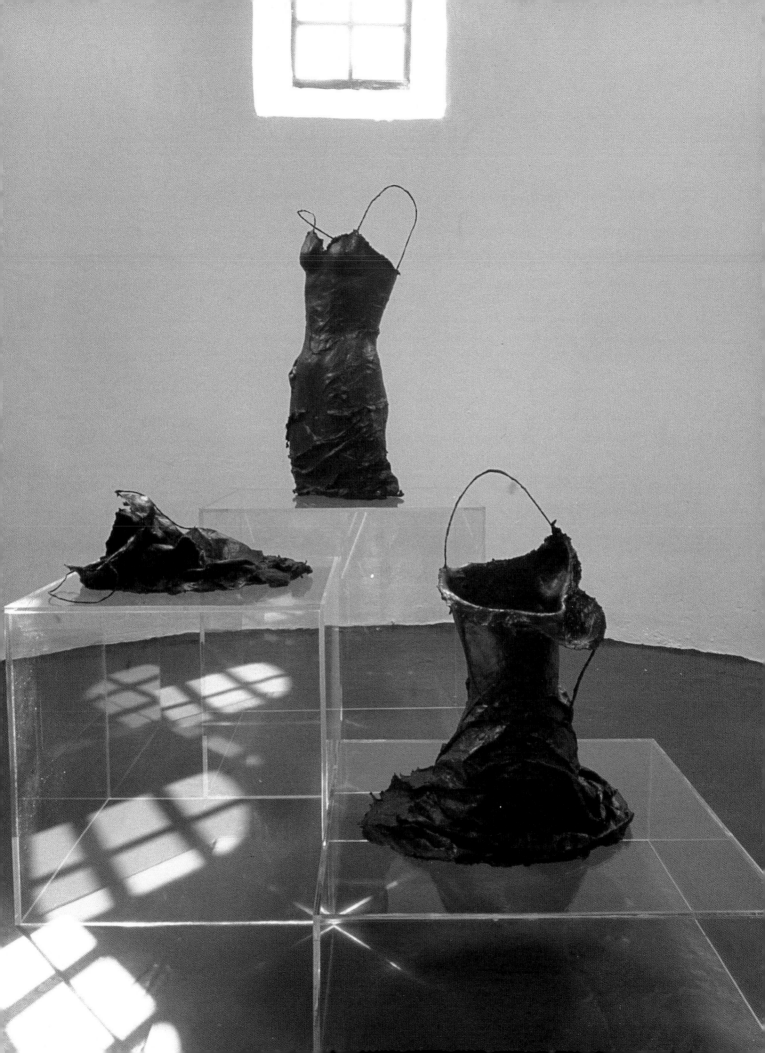

CAROLINE BARTLETT

Caroline Bartlett's work focuses on ideas related to the seductiveness of the written word. Her work explores the power and author-ity of text through the employment of visual components that hint at words, rhythms, codes, symbols, pages, columns and the alter-ation of text – overwriting and crossing out. Bartlett writes:

> It has been argued that communication media shape the sensorium, and that within Western culture, pre-eminence has been given to the authority of the written word as a system of knowledge, giving power to those who are able to decode it and control its dissemination, and that the communication media shapes the sensorium (Ong, 1991). This positioning has contributed to an outlook which places the senses within a hierarchy, giving primacy to sight (linked by Aristotle to knowledge) and privileging the intellect over the senses (Synott, 1991). The perception of the senses varies across cultures, affecting the way we perceive ourselves, and the world around us, and influencing all areas of cultural expression.

Caroline Bartlett, 'ON THE SHELVES OF MEMORY – TO MNEMOSYNE', **1998.**
Dimensions: 120 × 240 × 45cm. Photographer: Jerry Hardman Jones.

Caroline Bartlett, 'BODIES OF KNOWLEDGE,
VOLUME 7 – THE SHOE COLLECTION', 2001,
installed in shoe collection at Bankfield
Museum, Halifax.
Dimensions: 19 × 25 × 5cm.
Photographer: Jerry Hardman Jones.

Central to Bartlett's work has been the creation of strong, two-dimensional pieces in relief, using stitch as a structuring method of delivery. Her meticulous combining of complex layered printing with fabric manipulation techniques, especially pleating, are her hallmark. However, recently she has progressively stepped beyond this plane to consider a wider discourse, embracing a more diverse repertoire of materials and the use of sculpture as a form of articulation. Bartlett explains this development:

> The work moves from a two-dimensional layering of mark and stitch and surface into a three-dimensional layering, linking mark with volume and form, to create site-specific pieces incorporating a more mixed-media approach. Central to this is the exploration of the interrelationship between materials, processes, form and location, in the search for associations to make an object resonant in its environment and with the viewer.

Research into Lord Leighton and the Victorian preoccupation with Classicism led Bartlett to investigate Mnemosyne, the Goddess of Memory, for a body of work she was creating in response to Leighton House.

> Lord Leighton alludes to the tactility of cloth in his work, inviting our eyes to touch the picture. In Greek mythology Mnemosyne is often articulated with piles of draped fabric. I was interested in the metaphorical use of cloth as an embodiment of memory and suggestive of continuity whilst exploiting qualities of the ethereal and ephemeral as opposed to the solid and permanent. How to invite touch – and yet at the same time forbid it.

Diaphanous materials were explored to capture the essence of the concept. Fabric was cast and stiffened and organized as in a frieze, echoing the historical references.

'"On the Shelves of Memory" – to Mnemosyne' (Bachelard, 1969) comprises 492 archival labels suspended in front of partial forms, suggestive of parts of ceramic vessels, which are ghostly in appearance. In this work the artist extracted classification and labelling disciplines from conventional museum systems to detail possessions on the labels, whilst letting them also perform as a segmented, orchestrated, physical barrier between the cast, empty shells. Each label describes an artefact or group of artefacts sold from the collection in 1896, and they hint at a space vacated by an object removed. The labels gently dance in a draught, casting shadows flickering over the static forms behind. It is a contemplative work, poetic in its rhythmic repetition and articulation of the whole.

Bartlett has continued to investigate the boundaries of her practice with such work as the temporary installation of 'Codices', at the Abbey Gardens at Bury St Edmunds, where she stitched text into a lawn; and more recently at Bankfield Museum where she responded to a shoe collection with an intimate sculpture made from a book and paper.

JAYNE LENNARD

Jayne Lennard creates poetic visualizations from her observations of human idiosyncrasies. Her sculptures are born from an innate sense of the feminine translated into delicately refined figures or items of dress made from recycled materials. Metal forms an important constituent to her mix of materials, with wire forming the basic armature from which the sculpture evolves. Lennard's eye for balance within and around the sculpture is keenly expressed within the distorted proportions of the figures, their sylph-like bodies and giant feet and hands. The strongly defined linear relationship created by the wire framework balances beautifully with the decorative elements. Lennard's training in costume and theatre has informed her practice and enabled her to deliver whimsical characters that speak of a different time and place with echoes of another reality. The text is an important addition to her sculptures as it relates context and messages to the viewer. The capturing of the attitude of the figure is vital in understanding its essence. Lennard explains:

> The posture is important, and placing the sculpture can make all the difference to the finished look. The heads are minimal with one curl of hair, just enough for the onlooker to glimpse a sense of the essence of the character I am trying to portray.

For an exhibition focusing on the body, Lennard explored the relationship of females and their role models. The artist reflected the transference within society from the idolizing of the voluptuous to the idolizing of the anorexic form. She created a collection of sculptures of media icons, including Marilyn Monroe and Twiggy. For Monroe, she questioned the actress's epitaph of being the 'girl with the shape'; and for Twiggy, the treatment was to consider the notion that the adoration was a catalyst for a generation obsessed with thinness.

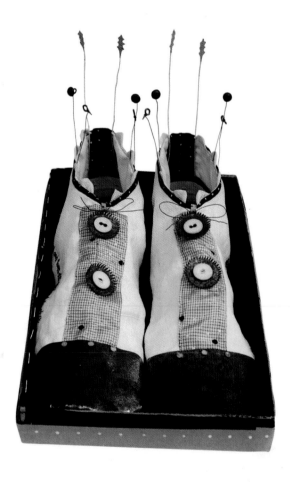

**Jayne Lennard, 'INSECT SHOES',
2001. Dimensions: 31 × 10cm.**

**Jayne Lennard, 'APRON LADY',
2001. Dimensions: 43 × 31 × 15cm.**

134

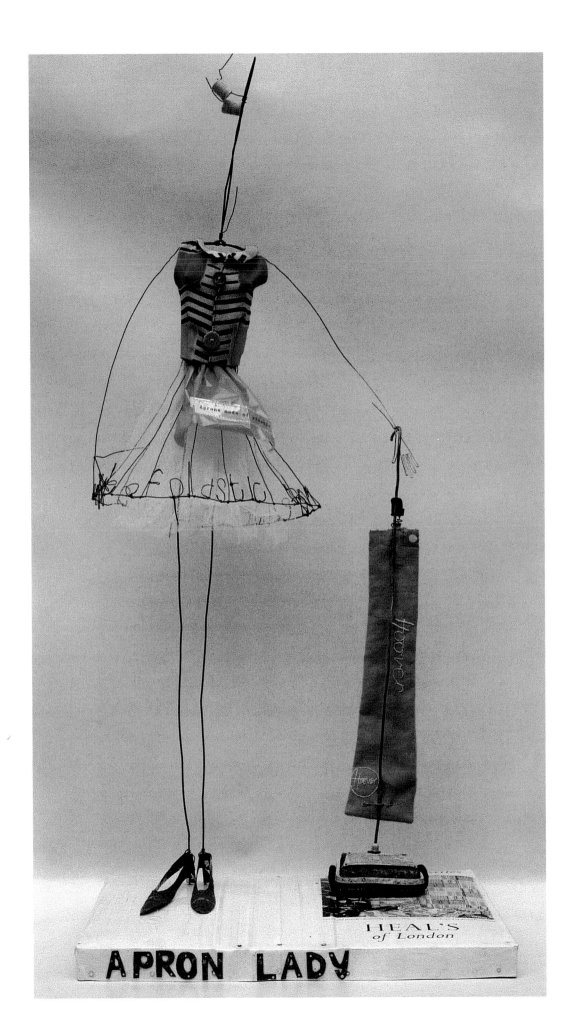

APRON LADY

HEAL'S
of London

ROZANNE HAWKSLEY

Rozanne Hawksley's haunting sculptures address issues that unsettle: death, suffering due to war, sickness, poverty, and the misuse of power. Her work forms potent symbols in her personal narrative, created from a compulsion to make visual and physical the emotions she feels. Her discourse illuminates a life plagued with ill health and tragic events that have empowered and inspired Hawksley to confront difficult issues. The sculptures possess a foreboding power that, on close inspection, reveal a slow, painful process of making, meticulous attention to detail, all underpinned with a strong conceptual foundation. The viewer is treated to a visual feast that is enticingly beautiful, yet macabre. Hawksley writes:

> Those pieces that have reference to Death are often highly ornate, using significant symbolism and allegory reflecting the darker Mysteries of Catholic Spain, extending into those of the subconscious, esoteric practices.

The Madonnas are a collection of arresting sculptures that amalgamate the artist's research into religious relics, icons and festivals across Europe, and her own response to personal tragedy and suffering. The artist expresses it poignantly herself:

> … a trio of Madonnas. The First one, of simplicity, calm and almost sexless. In her heart, the Seven Sufferings (of Mary). The Second, larger and coarser in jewelled lace. Her genitalia – her sex obvious. She was motivated by memories of Holy Week

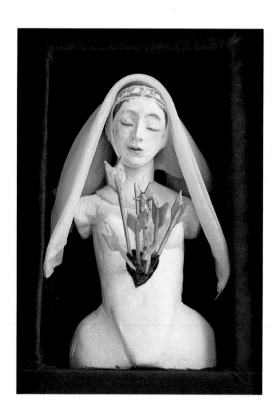

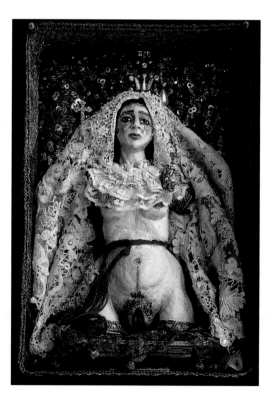

Rozanne Hawksley, 'OUR LADY OF THE SEVEN SORROWS', 2002. Part One of 'The Three Madonnas' series. Dimensions: 21 × 13.5 × 6cm. Photographer: Philip Clarke.

Rozanne Hawksley, 'NUESTRA SENORA – MADRE DE DIOS', 2002. Part Two of 'The Three Madonnas' series. Dimensions: 35 × 27 × 8cm. Photographer: Philip Clarke.

RIGHT: **Rozanne Hawksley, '… OF UBIQUITY AND CONTAMINATION', 2002. Part Three of 'The Three Madonnas' series. Dimensions: 40 × 25 × 14cm. Photographer: Philip Clarke.**

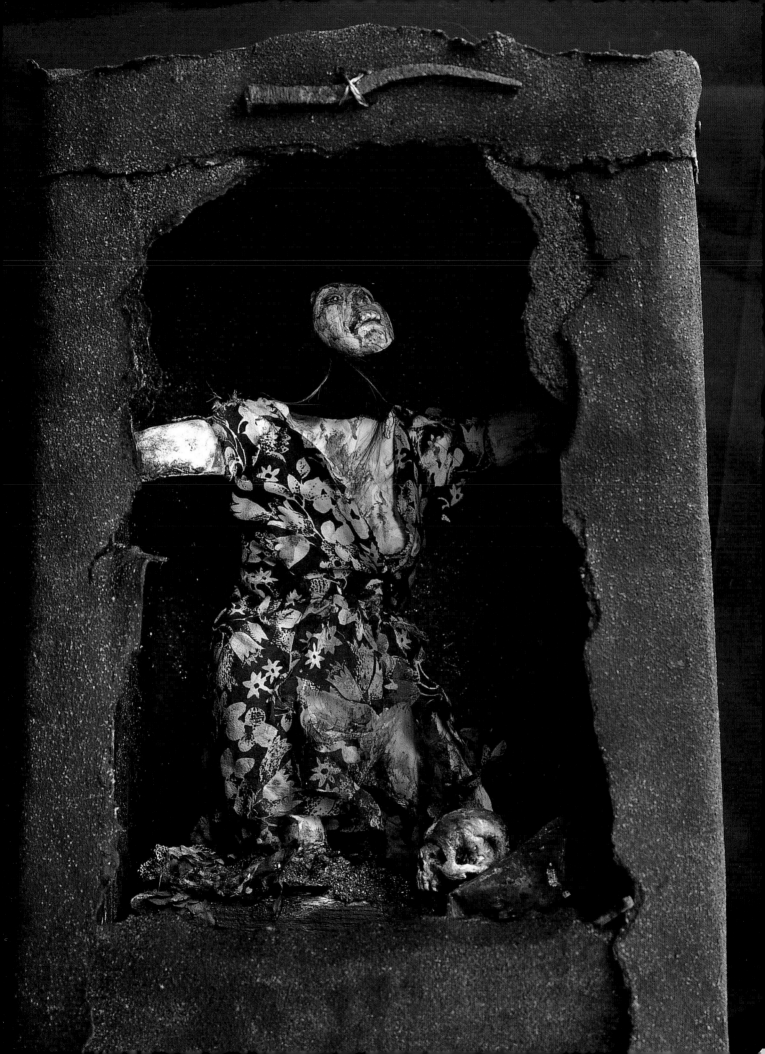

in Seville; watching one of the many processions. Our Lady bejewelled; venerated; ever young and pretty; richly adorned under her silver canopy, raised high on men's shoulders – next to me, a woman in tears, poor, worn out with work. She 'had a lot of children,' she told me. She wept for more than sentiment. … it's about giving birth, the hidden focus; the almost disposable woman. The Third – the universal wailing wife and mother of the dead – she almost made herself.

Hawksley's attention to detail is eloquently illustrated in her installation called '… a treaty will be signed some time today …'. The work articulates her personal response to the practice of numerous daily, shallow announcements and statements made by those in power during times of conflict. The potency of the piece is captured through the significant placing of key elements that are steeped in symbolism. Hawksley explains:

> These 'enclosed' spaces, often containing objects, can, like the reasoning behind the smaller pieces of work, only be made of significance by a) the reasoning, and b) the clinical decision about materials. For example: the white cloth with the distinct, equally spaced folds was absolutely vital to the message – echoes of a strong ritual underlined by formal piles of white papers waiting at either end of the table. The placing of two black chairs, black pens, waiting. The disaster of the world's state and its future further devastation piled in the middle of the table. Over it, out of the darkness a sword suspended – tipped with blood … The sound of time passing.

Rozanne Hawksley, '… A TREATY WILL BE SIGNED SOME TIME TODAY …', 1997. Photographer: Nicola O'Neill.

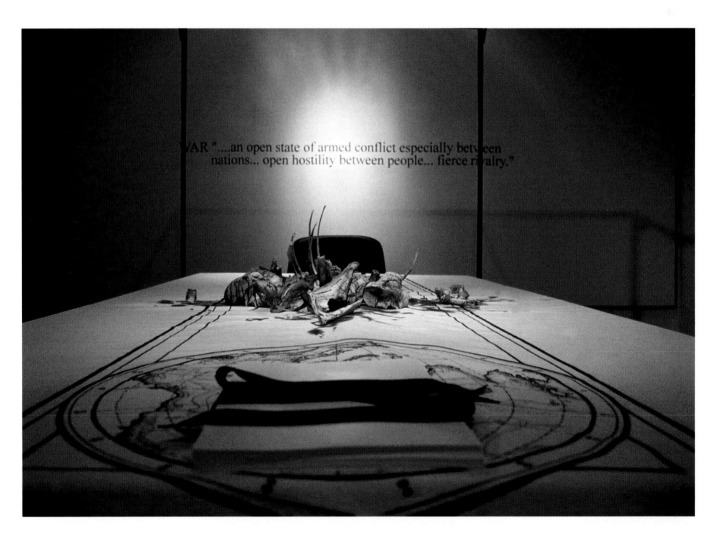

MAGGIE HENTON

Maggie Henton's central focus is with space, and the materialization and articulation of that space. The art of creating harmony of forms in space is manifest in a rationality in her approach to sculpture and installation. She explains this restraint:

> ... there is a paring away of the inessential.
> A careful selection is involved in their making;
> layered references and complexities are distilled
> to their essences. There is a search for stillness,
> for the space between.

For Henton, her conceptual framework relates to the understanding of a given site or space and its construction, whether in relationship to landscape or architecture. The vast Australian landscape, and in particular the desert, invited a new perspective to Henton's practice and proved to be a catalyst for a shift in her thinking and approach to spatial relationships. The investigation of the experience and concept of landscape resulted from the difficulty in visually absorbing the desert. She writes in her journal:

> What is this landscape like? This is a question I
> have been trying to answer. It takes time to learn
> to see this place, to find a way of describing it –
> nothing like Europe – flat orange, dotted with
> grey-green shrubs, impossible-to-tell distance,
> the occasional outcrop of rock emphasizing the
> flatness – vast – giant skies – I almost feel that
> I can see the earth curve – land and sky merge – infinite extension. The landscape changes – slowly, gradually,
> over hundreds of miles – draws you in; walking, footsteps mark the land, you feel its texture. Rhythm of footsteps
> mark the passage and its texture. The desert reveals itself in its detailed complexity to those who look closely.

**Maggie Henton, 'BOOK OF THE LAND', 1999.
Dimensions: 27 × 27 × 4.5cm.
Photographer: Michael Wicks.**

Following the Australian research, Henton responded with a collection of pared-down pieces of work in wood and some in textile, seemingly still and simple, yet on closer inspection, complexly textured and full of detail. 'Book of the Land' illustrates the beauty of this reductive approach. Henton elucidates about the collection:

> ... ideas developed whilst thinking about the desert: an 'empty' space full of detail. The work is a response to these ideas, rather
> than being about a particular place. It is the exploration of the question of whether a work can be simultaneously a flat
> expanding field, an 'empty' space, and an object; there is an attempt to reconcile this paradox.

> In these works the substructure of the grid and the square functions as a formal ordering mechanism, mapping the surface,
> measuring and ordering, artificial yet implying the infinite. In a sense these works investigate the topography of the object.
> Preoccupied with surface, they are nonetheless three-dimensional. Surfaces are written and overprinted with lines of travel.

Layers of repeated marks, dot and line, build rhythms that texture and ridge the surface, travelling over and through the forms. Information seeps through the layers of structure. The surfaces fold, bend and curve, creating objects and defining spaces.

Henton examines space not only through the materiality of her work, but also through her relationship to disciplines that address spatial issues, in particular architecture, and therefore her practice operates on the interface between installation and sculpture. The distillation of ideas to their essential ingredients finds form in a minimalist vocabulary that is simultaneously used and subverted in her investigation of the complexities and contradictions inherent in the ideas investigated. This is beautifully illustrated in 'Whitewash: Purity and Contamination', work that was prompted by the collection of decorative and applied arts in the Victoria and Albert Museum. The artist took, as a site of inquiry, the tension between architecture and the decorative. As a critique of modernist theories of purity – and specifically those adopted by architectural practices, which, acting to protect their borders, suppress the decorative – she created a work made up of multiple parts, presented in pairs, which construct a dialogue of textile and wall. The work and its title were prompted by Le Corbusier's essay in praise of whitewash:

> … we would perform a moral act: to love purity! … If a house is all white, the outline of things stands out from it without any possibility of mistake; their volume shows clearly; their colour is distinct. The white of whitewash is absolute, everything stands out from it and is recorded absolutely, black on white; it is honest and dependable … It is the eye of truth. Whitewash is extremely moral. (Dunnett, 1987)

'Whitewash: Purity and Contamination' epitomizes Henton's philosophy about the selection and application of materials and process. Her choice is based on the physical immediacy of the material, and its capacity for symbolic meaning; thus 'Whitewash' is made from materials normally associated with the construction of buildings: concrete, plaster and paint juxtaposed with the decorative – furnishing fabric and a canvas stretcher. She explains:

> In the work 'Whitewash: Purity and Contamination' the marks of wallpaper, the ghost imprint of the decorative, contaminates the pure white wall. A sequence of square blocks evokes both depth and structure. The form of the work makes not just a white surface, but an object, suggesting that the wall is not just a surface but a complex object with multiple meanings and histories.

Maggie Henton, 'WHITEWASH: PURITY AND CONTAMINATION', 2002.
Dimensions: overall, 182 × 25 × 5cm. Photographer: Michael Wicks.

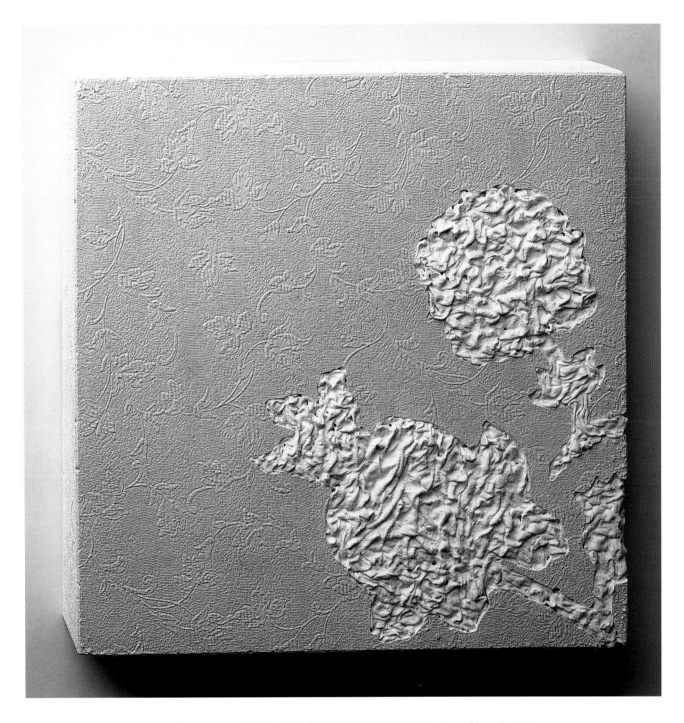

Maggie Henton, 'WHITEWASH: PURITY AND CONTAMINATION' (detail), 2002.
Dimensions: 25 × 25 × 5cm. Photographer: Michael Wicks.

DIANE READE

Diane Reade's delicate paper sculptures explore concepts of secrecy. Her fascination lies with the creation of sculptural pieces that juxtapose the relationships of concealment and revelation.

Reade explains her interest:

> To possess a secret is to possess power: the control of one individual or a group over another can be immense. The power of secrecy is derived from the insider/outsider relationship, who is in the know and who is excluded for whatever reason. Additionally, the way a secret is orchestrated is dependent on the relationship between concealment and revelation. How much of a secret do you want someone to find out in order to fire their curiosity and lure them to investigate further?

The handmade paper acts as a tactile foil for the complexities of the subject. The paper's luminosity responds accordingly when the hidden layers are revealed with the manipulation of light. A hallmark of her work is her approach to embrace the philosophy of 'truth to materials' by maintaining the purity of the whiteness of the paper, and by retaining its deckle edge. At first glance these sculptures appear as minimalist sculptures, executed through a meticulous craft technique, but this eloquence belies the detail in the pieces and intricate texture of the surfaces.

Reade has researched her subject from a global viewpoint, studying African traditions and culture; she writes:

> My research into visual imagery led me to look at notions of secrecy in African art. Secrecy is an integral part of tribal organization, social order and dissemination of information in the sub-Saharan tribes of West Africa. It orders knowledge, and is inextricably linked with their visual arts. Different tribes use the components of secrecy in vastly different ways. The Bamana tribe believes that freedom of information is dangerous, so they would hide their secrets by wrapping, containing, disguising and masking so as to mislead the viewer's perception of the contents. Even the container may be made by the artist to distract the viewer from its intended purpose. Partial revelation of the contents is sometimes suggested by a swelling in the surface or the positioning of a mirror over an opening, to indicate that there is something hidden inside. Unlike the Bamana from Mali, the tribes of Benin believe that their secrets should be revealed, even if only partially, and that their most important ones should be on view, only meaningful to those 'in the know'.
> So when is a secret being partially revealed or partially concealed? It is its context within each society that determines the answer.

The artist wanted to investigate these complex relationships through a visual perspective in a Westernized format – she chose to use the form of the common bag as her metaphor. She considers this an ideal physical manifestation to explore, with its strong semantic tones and obvious potential for concealment. Reade explains her thinking:

> I chose to base my work on our personal containers, particularly handbags because of what they mean to the owner and how they are viewed in society. They can be functional or symbolic, decorative or simple, show status or suggest particular lifestyles. They contain collections of objects personal to the possessor, some may be secret, others not, but all will 'say something' about the owner. There is usually a relationship between the contents and the style of bag.

Reade's interpretation was dynamic through a dialogue with light and paper; she built containers that played with illusion. The artist united the bag and its contents in one plane, embossing the paper by taking an impression of the container and the items. This process of creating a facsimile has been adopted repeatedly to produce a collection of work focused on the bag metaphor. The 'Granny by Day, Spy by Night' piece references a national news story that captured Reade's imagination: where a seemingly ordinary grandmother had been involved in spying over a forty-year period, and whose family were unaware of her clandestine past. She developed a sculpture that at first glance appears to be a stereotypical bag of 'innocent' contents, belonging to a grandmother, but when lit from within, reveals spying devices and weaponry. This delightful play with illusion intrigues Reade, and its application further articulates her discourse.

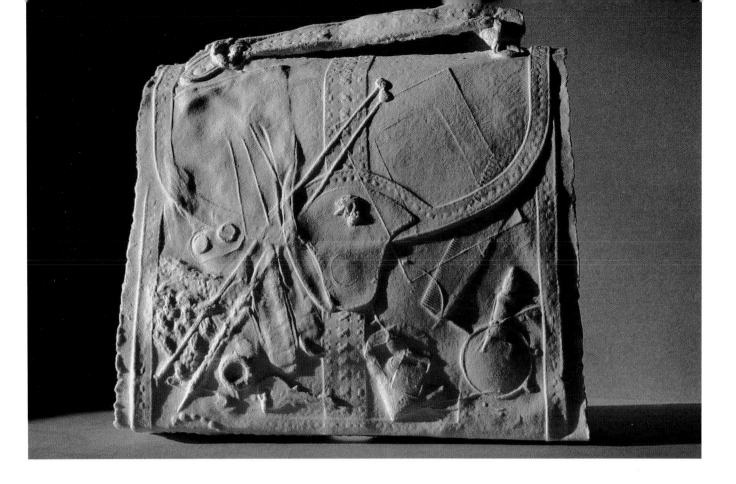

Diane Reade, 'GRANNY BY DAY, SPY BY NIGHT', 2000. Dimensions: 32 × 32 × 10cm. BELOW: Internally lit.

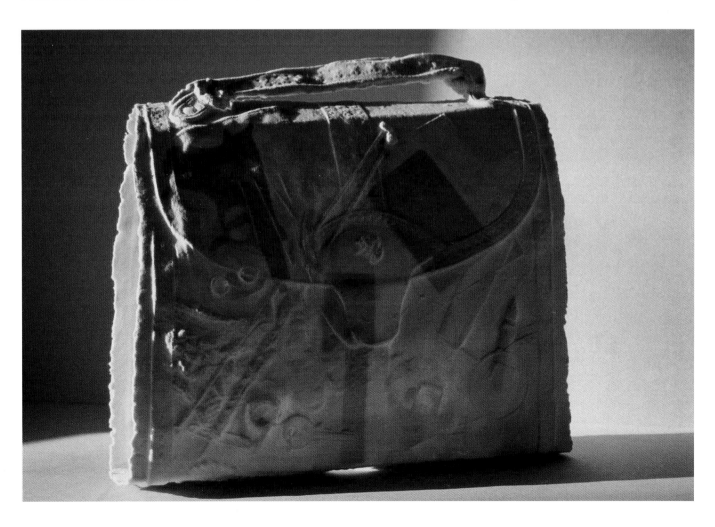

GILL WILSON

Gill Wilson creates wall-based sculptures that conceptually reference architectural landscape. Influenced and inspired by the work of architects and minimalist painters, the pieces resonate a hypnotic calmness induced by the rhythmic repetition of the linear relationships. Wilson first became entranced by the use of paper in textile art whilst at college, extending this research after graduation, to a research trip to Japan to study Eastern methods of traditional papermaking. She writes of her approach:

> The philosophical purity resonates through the physical process of papermaking and is central to my work. The singular beauty of papermaking is its characteristic of taking from nature a pure substance (plant fibre) that allows ideas and concepts to develop throughout its transformation into paper. Essentially the work is concerned with responses to the sensuous nature of the material – the textures and colours, as well as the manipulative qualities of the fibres, provide a range of expressive potential.

Wilson was drawn to paper for its diverse possibilities: a unique substance that can be used as a fine liquid or as a solid, malleable material. The artist has mastered processes to develop tensioned paper that dries so taught that clean, sharp edges are formed around the frames, imperative if the work is to remain 'architectural'. Wilson explains: 'I see the pieces as extensions of an interior space, rather than as a superficial adornment. They are intended to be quiet transitions that permeate a place like the addition of music or light.' Contrast between the angular structure of the sculpture and the fibrous qualities of the base material is deliberate. The surface of the paper is manipulated through process to produce a range of rich and subtle textures in neutral palettes with accents of bold blue or black. Control of the lighting can accentuate or flatten the textured surface and reveal the intricacy of the tones. This control adds a new dimension to the work and enhances the minimalist form.

Gill Wilson, 'WALLBOX' – series of four.
Dimensions: 20 × 15cm each box.
Photographer: Mike Simmonds.

Gill Wilson, 'WALLBOX' – series of three.
Dimensions: 108 × 18 × 6cm each box.
Photographer: Mike Simmonds.

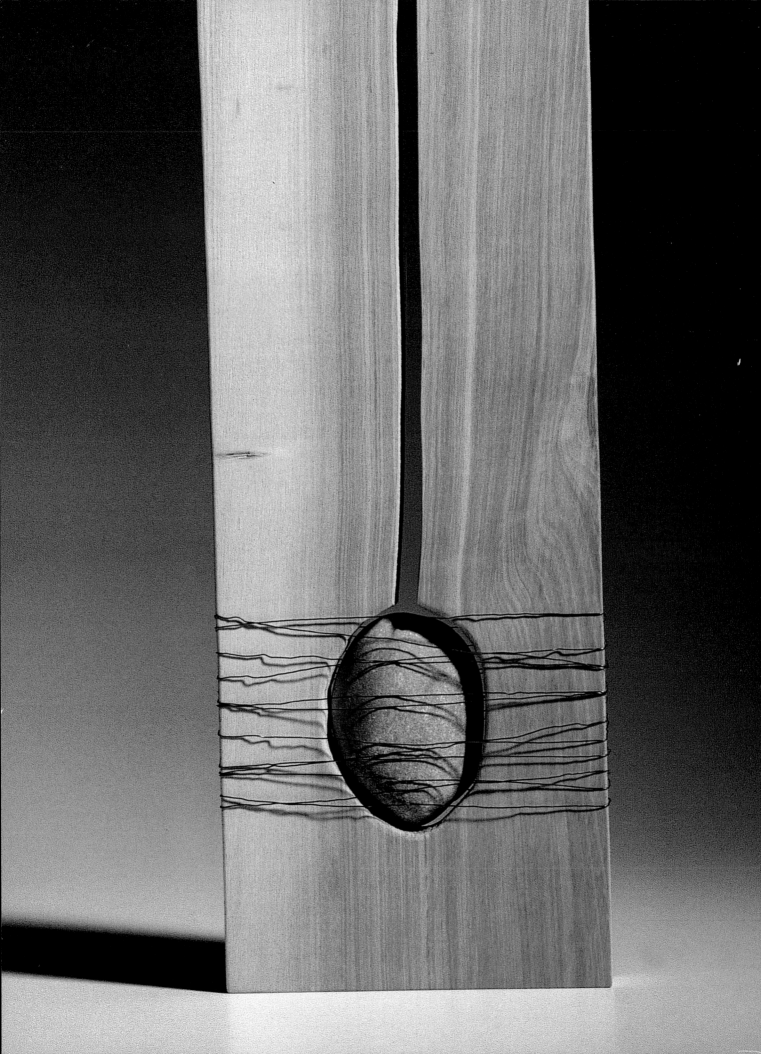

FIONA GRAY

Fiona Gray's geometric sculptures have a strong architectural bias; however, it is the wild coastline of Northumbria that acts as her main inspiration. The organized, regimented collections of found objects, stones and natural treasures are three-dimensional poetic translations of the artist's expeditions along the coastline. Embedded between artefacts and wrapped around stones, cryptic notes and relevant documents (tide timetables for that particular beach, or scraps of maps) record a sense of time and place. Gray's interest in stone and slate reveals a fascination with the layering of time in her work; she writes:

> I like the fact that the objects and materials I use could be hundreds or thousands of years old. They all have
> layers of history embedded in them, and are exposed by the erosion of time and the elemental forces of nature.

Wood forms a base material for much of Gray's work, which incorporates a wide variety of found and crafted material. A strong making sensibility underpins all her work, with skills from many disciplines combined to produce finely made sculptures. The detail demands a closer inspection by the viewer when hidden text may be glimpsed. She actively challenges the boundaries that traditionalists formulate by borrowing techniques and processes from other craft areas; metalwork, woodwork, ceramics and textiles are intrinsic to her practice. She can be found regularly routing, sanding, chiselling, inlaying, laminating, layering, wrapping and binding, and then adding further touches by burning or distressing the material.

In 'Silent Rhythm', the incongruity of large concrete blocks scattered randomly along the Northumberland coastline provided a foundation for exploration with wood, wire and ceramic materials. The inlaid tiles represent the concrete invaders set against the rhythms of the lapping waves, echoed by the wrapped wire.

Fiona Gray,
'FUSION', 2002.
Dimensions: 50 × 22 × 4.5cm.
Photographer: David Lawson.

Fiona Gray,
'SILENT RHYTHM', 2001.
Dimensions: 40 × 50 × 4cm.
Photographer: David Lawson.

MORAG COLQUHOUN

Morag Colquhoun's sculptures encapsulate and reflect a deep passion and understanding not only for the natural materials she uses, but also for the environment in which they are placed. Colquhoun's work has a strong environmental remit that is fuelled by her history and background. Since training as an archaeologist in the 1980s she has endeavoured to broaden her skills and her understanding of materials and the natural environment by embracing into her practice the traditional crafts of basketry, chair making and feltmaking and, unconventionally, forestry, chainsaw handling, permaculture and other agriculture-based activities. Her work articulates her philosophy with an organic richness that arouses fundamental senses. The sculptures are enchantingly simple, nurturing forms made from vernacular matter with strong tactile and odiferous qualities. Colquhoun's aim is to question the role of materials and how they link society to the landscape, and this questioning is an integral part of her approach. She writes:

> I like to investigate previous uses of materials and their place in traditional crafts. These aspects are often a pointer to properties and qualities that the materials hold, as well revealing ingenious ways of using them. However, my interest in the past is not nostalgic, it is more an interest in maintaining a continuum. A coppiced tree may have been cut down and harvested for centuries. A sheep is a result of centuries of bloodlines. Both are part of what may be termed a 'cultural landscape', and both are unique genetic resources. But what will happen to these resources in the future? When we harvest materials, or manage the environment for them, what impact does it have? Sustainable resources are under-utilized, dwindling or destroyed. I try to question this in my work, and also to explore and celebrate local resources.

In support of her philosophy she only uses local, renewable, biodegradable and sustainably harvested materials in her sculptures. Wood that she has collected herself, especially the discarded pickings from managed forests, is often married with wool. In 'Loom House', Colquhoun harvested ash poles and hazel sticks for the basic framework of the house, and then wove wool, brambles and briars between the timber. The attraction of pairing incongruous materials, such as wood and wool, is explained by the artist:

> Wool and wood, for me, fit well together in my sculptures. Apart from their environment-friendly potentialities as materials, both sheep and trees are intimately connected in the landscape. Textiles are increasingly providing the 'membrane' between the internal and outside space, and I am attracted to wool, in particular, as a medium that is local, renewable and biodegradable. When I learned to felt wool, it was as exciting as discovering that I could process wood myself by cleaving it down the grain, or use oak outside because of its natural durability.

Morag Colquhoun, 'LOOM HOUSE', 2000.
Dimensions: 2.5 × 1.5 × 1.4m.

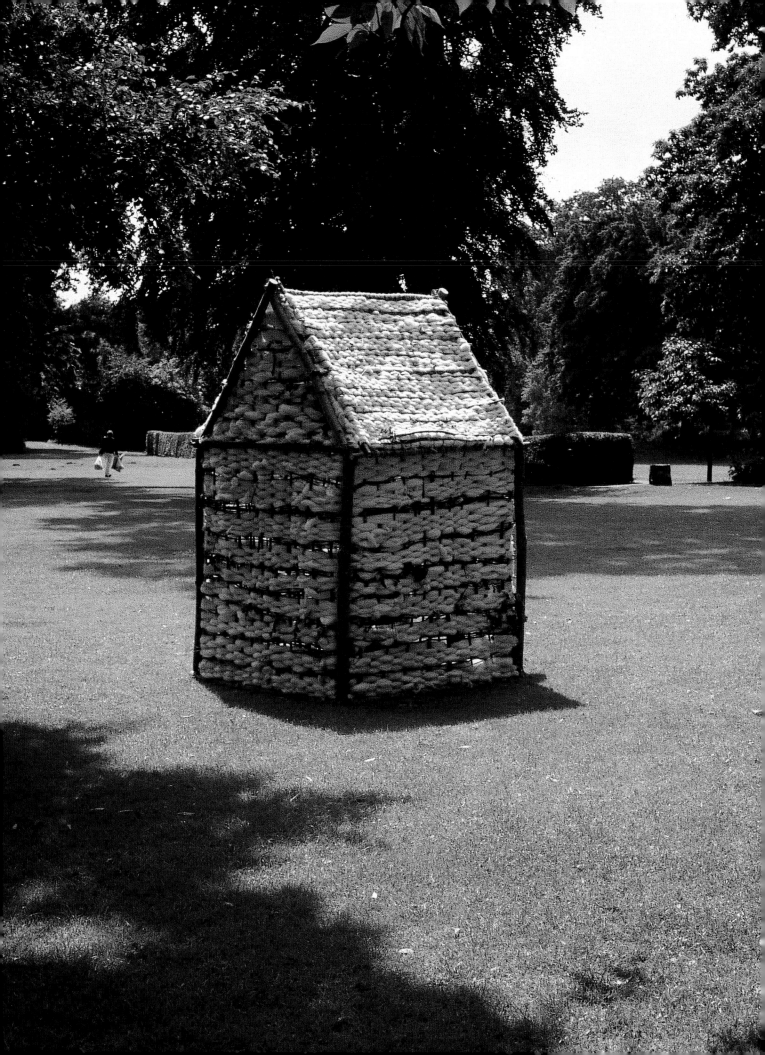

HILARY BOWER

Hilary Bower's sculpture reflects her personal journeys and travels, both physical and emotional, with responses to imagery and sign age. Her work embodies the exploration and growth of the self to discover a clearer language that nurtures textile statements of an abstract nature. The pared-down qualities of her sculptures have evolved gradually through the years of her practice: a beauty of omission. Bower's commitment to her practice is expounded in her views of her life as expressed in the metaphorical use of a circle:

I consider my life to be a circle. When my times and energies have to go into other areas of work and teaching, I often feel that the circle is incomplete: there is a space. When I get back to my own creativity the circle is whole once more, and I feel more at one …

For Bower there has been a huge distillation recently, the many years of gathering and travelling culminating in emergent work manifesting an obsession with carriage and a holding of a sense of place within the form.

The work often takes the form of multiple wall-based structures that could be described as a collection of vessels. The use of repetition for the artist refers to the repetitive nature of daily life: routines, journeys to work, and so on. Bower states:

We go over and over things, sometimes unaware of this. I sometimes feel that to create several of something, or multiples, reflects the way we have to keep trying or working at something, and finally it all falls into place with the last 'try' or last piece. I also enjoy the collective nature of more than one. That is often when they take on a life of their own, in a way, and they come to life. … the spaces inbetween: where there is nothing. I enjoy the feeling of the sense of another presence when there is a multiple of something. To repeat is to understand.

Construction has gradually grown in importance in Bower's work, and it now forms a vital part of her practice, taking equal priority to the creation of surface, colour and texture. In the early years she focused on containment through bags and purses, then four-sided vessels, through to softer-angled wall vessels made from simple natural materials. The choice of basic cottons and calico is made to underline a need to start from humble foundations, traditionally associated with utilitarian needlework. In speaking of her work, Bower writes:

… a desire to make constructed forms which are more minimal in surface and decoration … Their own forms playing a larger role, creating a space without and within. I often work in pairs or more, enjoying pushing the ideas of repetition, but also with an interest in the negative spaces created in and around. The employment of often simple and natural materials also has a key role.

The simple materials she chooses to use in her sculptures are embellished with wood, leather, metal, paper and acrylic paint. These adornments are again employed in a repetitive fashion to finish the work without an obvious decorative element, but as an enhancement that completes the statement.

Hilary Bower, 'LONG VESSELS THREE', 1999. Dimensions: 150 × 20cm. Photographer: Dick Makin.

Hilary Bower, 'KEEP I' and 'KEEP II', 2001. Dimensions: 95 × 48 × 10cm each. Photographer: Dick Makin.

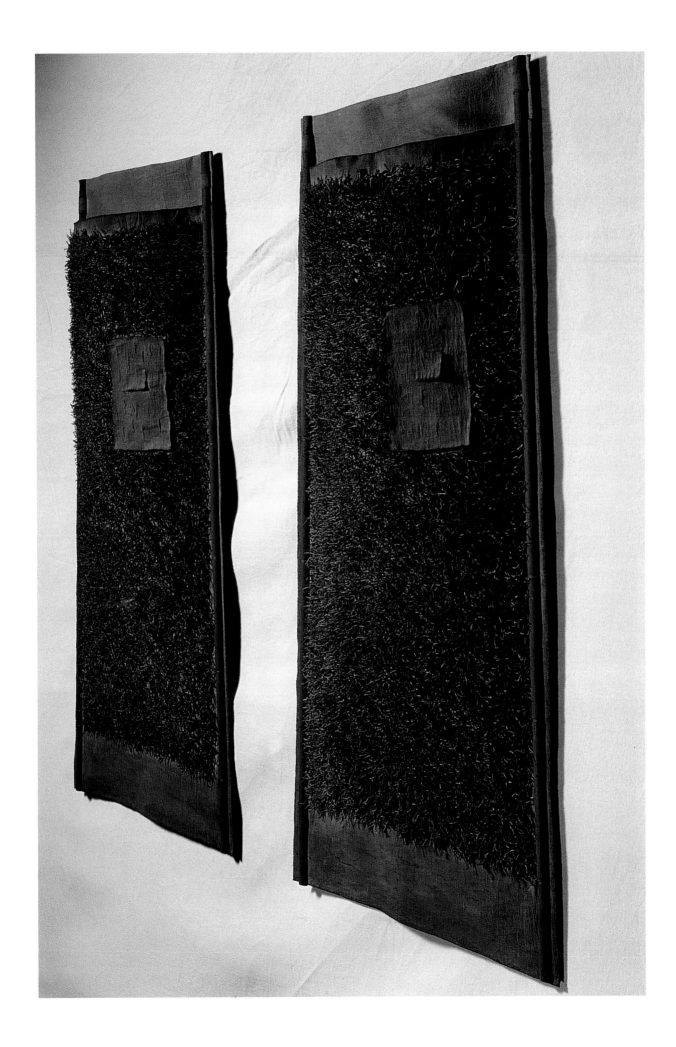

BELMA LUGIC

Belma Lugic's work is founded on a concern for the concept of loss, and how, through a sensitive selection of material and process, she can create minimalist sculptural forms that convey a sense of this meaning. Although simple in form, the sculptures are founded on a more complex notion of the reconciliation between two opposing states or materials. This exploration highlights the paradoxical conditions of disintegration and regeneration that form part of her investigation into her subject, through the employment of an acid and metal reaction and the embroidering of wool onto plasterboards. Lugic describes her thinking:

> Discovering an aggressive relationship between acid and metal, I found a medium that would 'work on its own', silently revealing the world under the surface. The work refers to disintegration, but because of the flower pattern and a symbiotic relationship between acid and metal, it becomes integration.

The textile element of her practice manifests itself in numerous ways: a transferring of a fabric design onto the metal sheet, the acid eating away the design, revealing a crusty new surface. In her most recent work she builds decorative relief panels by building up layers of plaster in patterns borrowed from wallpaper designs, or from architectural elements, or by the actual embellishing of the panels with stitch. The new series of work, titled 'Migration', uses materials normally associated with the building trade, and replaces the symbiotic metal–acid relationship with references to archaeological remnants and a renewal of intimate places. The artist combines the architectural stimulation, through material and image, drawing inspiration from ornamental elements of buildings and architectural antiquities. By repeating the elements through the construction, she renews the interest and thus reiterates the concept of lost and found.

Belma Lugic, untitled, 2001. Dimensions: 50 × 50 × 5cm.

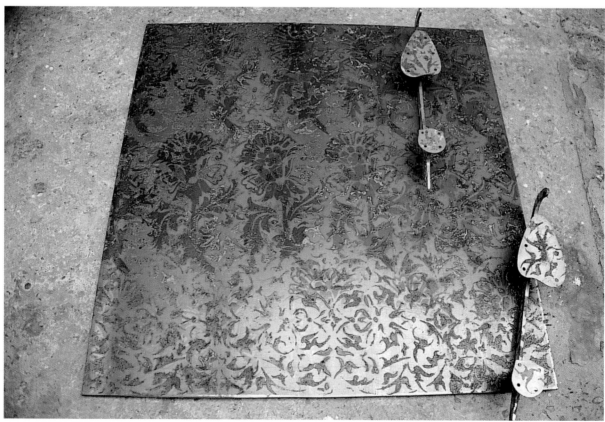

SUPPLIERS AND USEFUL ADDRESSES

Suppliers

Alec Tiranti Ltd
70 High Street, Theale, Reading, Berkshire RG7 5AR
(general sculptor's supplies of equipment and materials)

Artcrafts
107–109 Johnston Street, Blackburn, Lancashire BB2 1HY
(rubber products)

Fred Aldous Ltd
Department C, 37 Lever Street, Manchester M1 1LW
(general craft suppliers)

Holliday Dispersions Ltd
Holt Mill Road, Waterfoot, Rossendale, Lancashire BB4 7JB
(pigments for latex)

Jacobson Chemicals Ltd
Jacobson House, The Crossways, Churt, Farnham, Surrey
GU10 2JD
(chemicals for sculpture)

John Purcell Paper
15 Rumsey Road, London SW9 0TR
(paper and pulp)

Kemtex Colours
Chorley Business and Technology Centre, Euxton Lane,
Chorley, Lancashire PR7 6TE
(dyes)

Millstek
44 Denbydale Way, Royton, Oldham OL2 5TJ
(latex)

Potterycrafts Ltd
Kings Yard Pottery, Talbot Road, Rickmansworth, Herts
WD3 1HW
(clay)

Synthomer Ltd
Roundwood Industrial Estate, Wakefield Road, Ossett, West
Yorks WFS 9BQ
(latex manufacturer)

4D Rubber Co. Ltd
Heanor Gate Industrial Estate, Heanor, Derbyshire DE75 7SJ
(rubber products)

Useful Addresses

The Plastics and Rubber Advisory Service
6 Bath Place, Rivington Street, London EC2A 3JE

Royal Society of British Sculptors
108 Old Brompton Road, London SW7 3RA

Scottish Sculpture Trust
6 Darnaway Street, Edinburgh EH3 6BG

The 62 Group of Textile Artists
PO Box 24615, London E2 7TU

Publications

[A–N] Magazine for Artists
First Floor, Pink Lane, Newcastle upon Tyne NE1 5DW

Art Monthly
4th Floor, 28 Charing Cross Road, London WC2H 0DB

Art Review
Gleneford House, 23–24 Smithfield Street, London EC1A 9LF

Crafts
44a Pentonville Road, London N1 9BR

Embroidery
PO Box 42B, East Molesey, Surrey KT8 9BB

European Textile Forum (ETN)
PO Box 5944, D-30059, Hannover, Germany

Sculpture (USA)
1529 18th Street, NW, Washington DC 20036

The Textile Directory
Word4Word, 107 High Street, Evesham WR11 4EB

Textile Fibre Forum (Australia)
TAFTA, PO Box 38, The Gap, Q4061, Australia

BIBLIOGRAPHY

Books

Bachelard, G. (translated Maria Jolas), *The Poetics of Space* (Beacon Press, 1969)

Batchelor, A., and Orban, N. (eds), *Fibrearts Design Book Five* (Lark Books, 1995)

Bernadac, M.-L., *Louise Bourgeois* (Flammarion, 1996)

Braddock, S. E., and O'Mahony, M., *Techno Textiles* (Thames and Hudson, 1998)

Cannon, W., *How to Cast Small Metal and Rubber Parts* (McGraw-Hill, 1986)

Causey, A., *Sculpture Since 1945* (Oxford University Press, 1998)

Constantine, M., and Larson, J. L., *The Art Fabric: Mainstream* (Kodansha International Ltd, 1985)

Constantine, M., and Reuter, L., *Whole Cloth* (The Monacelli Press, 1997)

Curtis, P, 'The sculpture and drawing', in *Breaking the Mould* by C. Marshall (ed.) (Lund Humphries Publishing Ltd, 1997)

Dunnett, J. (translation), *Le Corbusier 1925 The Decorative Art of Today* (Cambridge Mass., 1987)

Fisch, A. M., *Textile Techniques in Metal* (Robert Hale Publishing, 1996)

Flynn, T., *The Body in Sculpture* (Orion Publishing Group, 1998)

Geijer, A., *A History of Textile Art* (Southeby Parke Bernet Publications in association with Pasold Research Fund Ltd, 1979)

Harris, J. (ed.), *Art Textiles of the World – Great Britain 2* (Telos Art Publishing, 1999)

Harvey, S., *Creative Plasterwork* (Anness Publishing Ltd, 1996)

Heller, J. *Papermaking* (Watson-Guptill Publications, 1978)

Heuman, J., (ed.), *Material Matters* (Tate Gallery Publishing, 1999)

Hicks, A., *New British Art in the Saatchi Collection* (Thames and Hudson, 1989)

Hohl, R., *Sculpture: The Adventure of Modern Sculpture in the Nineteenth and Twentieth Century* (Taschen, 1996)

Irving, D. J., *Sculpture – Material and Process* (Van Nostrand Reinhold Book Corporation, 1970)

Koumis, M. (ed.), *Art Textiles of the World – Great Britain 1* (Telos Art Publishing, 1996)

Marshall, C. (ed.), *Breaking the Mould* (Lund Humphries Publishing Ltd, 1997)

Meilach, D. Z., *Soft Sculpture and Other Soft Art Forms* (George Allen and Unwin Ltd, 1974)

Mills, J., *Encyclopedia of Sculpture Techniques* (Batsford, 1990)

Ong, W., 'The Shifting Sensorium' in *The Varieties of Sensory Experience; A Source Book on the Anthropology of the Senses* (ed. D. Howes, University of Toronto Press, 1991)

Panting, J., *Sculpture in Glass-Fibre* (Lund Humphries Publishers Ltd, 1972)

Padovano, A., *The Process of Sculpture* (Da Capo Press, 1981)

Roukes, N., *Sculpture in Plastics* (Watson-Guptill Publications, 1968)

Rowley, S. (ed.), *Reinventing Textiles* (Telos Art Publishing, 1999).

Saddington, M., *Making Your Own Paper* (New Holland Publishers Ltd, 1991)

Schoeser, M., *International Textile Design* (Laurence King Publishing, 1995)

Synott, A., 'The Senses from Plato to Marx', in *The Varieties of Sensory Experience: A Source Book on the Anthropology of the Senses* (ed. D. Howes, University of Toronto Press, 1991)

Waller, I., *Textile Sculptures* (Studio Vista, 1977)

Williams, R. J., *After Modern Sculpture* (Manchester University Press, 2000)

Catalogues

Bradley, F. (ed.), *Shedding Life* (Tate Gallery Publishing Ltd, 1996)

Celant, G. (curator), *Claes Oldenburgh: An Anthology* (The Soloman R. Guggenheim Foundation, New York, 1995)

Cooper, H. A. (organizer), *Eva Hesse: A Retrospective* (Yale University Art Gallery, 1992)

Fielding, A., *Passages: forms and baskets by Maggie Henton* (mac, 1999)

Glossop, C. (designer and producer), *Christo and Jeanne-Claude: Sculpture and Projects 1961–96* (Yorkshire Sculpture Park, 1997)

Johnson, P., *Under Construction: Exploring Process in Contemporary Textiles* (Crafts Council, 1996)

Millar, L., and Amundsen, A., *Invaders* (Maidstone Library Gallery, 2002)

Millar, L. (curator), *Textural Space: Contemporary Japanese Textile Art* (Surrey Institute of Art and Design, 2001)

Taylor, B., *Arttextiles* (Bury St Edmunds, 1996)

Taylor, B., *Arttextiles 2* (Bury St Edmunds, 2000)

Papers

Johnson, P. (ed.), *Ideas in the Making: Practice in Theory* (Crafts Council, 1998)

Gabo, N., *Sculpture: Carving and Construction in Space* (Circle: International Survey of Constructive Art, 1937)

Periodicals

Claes Oldenburg, Roy Lichtenstein, Andy Warhol: A Discussion *Artforum 4* no.6 (Feb.,1966)

Shirley, R., 'Connecting Threads', *[A-N] Magazine for Artists* (August, 2002)

INDEX